15

IRISH PAINTING

BRIAN P KENNEDY

Town House, Dublin

FOR MARY

Published in 1993 by
Town House and Country House
Trinity House
Charteston Road
Ranelagh
Dublin 6
Ireland

Reprinted 1997

ISBN: 1-86059-059-4

Front cover: *Mrs Lavery Sketching* by John Lavery, 1910 (Hugh Lane Municipal Gallery of Modern Art, Dublin).

Design: Bill Murphy
Printed in Hong Kong

ACKNOWLEDGEMENTS

A book such as *Irish Painting* is possible only as a result of the collective endeavours of many scholars, and tribute should be paid to all those cited in the extensive bibliography. Many friends and colleagues were kind enough to read the text at proof stage, and I am most grateful to them. I received helpful advice from Martyn Anglesea, Bruce Arnold, Nicola Gordon Bowe, Julian Campbell, Anne Crookshank, Denise Ferran, S B Kennedy, Adrian Le Harivel, Ciarán MacGonigal, Rosemarie Mulcahy, Nancy Netzer, Andrew O'Connor, Frances Ruane, Richard Wood and Michael Wynne. The following gave valuable assistance: Marie Bourke, W H Crawford, Barbara Dawson, Elizabeth Einberg, William Finlay, Ted Hickey, Paula Hicks, Catherine Kelly, Marie McFeely, Peter Murray, Cian O'Carroll, Philip O'Connor, Ann Reihill, Jenny Spencer-Smith, Duncan Thomson and Judith Wilson. The sixty-five paintings chosen for *Irish Painting* are from twenty different collections, and I am grateful to all those public institutions whose names are credited beside their pictures, and to those private collectors who generously permitted the inclusion of prized possessions. A special acknowledgement is due to Raymond Keaveney, Director of the National Gallery of Ireland, for agreeing to the inclusion of thirty works from the gallery's magnificent collection of Irish paintings. I owe thanks to my colleagues Michael Wynne and Adrian Le Harivel for their generosity in assisting with the book from its earliest stage, when they made useful suggestions about my proposed choice of pictures. It has been a delight to work with my publisher Treasa Coady, who combines competence with enthusiasm. Elaine Campion edited my text with intelligence and sensitivity, Bernie Daly sourced the illustrations and permissions, and Bill Murphy, as always, showed his natural flair for book design. My greatest debt is to my wife Mary, and I dedicate the book to her.

Brian P Kennedy

CONTENTS

INTRODUCTION

Irish Painting begins with a work of about 1640 and ends with one painted in 1953. Although the works of living artists are excluded, few will disagree that a book that closes with the work of Jack B Yeats ends on a high note indeed. The selection includes both favourite paintings and other lesser known examples. For those who know little of Irish painting, the aim of the book is simple: to encourage the conclusion that Irish talent has been as much in evidence in the visual arts as in the world of literature.

The first major contribution to the study of Irish painting was Walter Strickland's indispensable reference book, *A Dictionary of Irish Artists*, which was published in 1913. In subsequent decades Thomas Bodkin, Thomas MacGreevy and others researched and published valuable information and commentary about Irish artists, but it was not until the 1960s that the subject was advanced significantly with the publications of a number of specialists, including Anne Crookshank and the Knight of Glin, Desmond FitzGerald, whose rigorous research for the 1969 exhibition *Irish Portraits 1660—1860* was followed by an excellent survey book *The Painters of Ireland* (1978). In the 1970s and 1980s a number of talented researchers emerged from the History of Art departments of Trinity College, University College, and the National College of Art and Design, Dublin. The National Gallery of Ireland, the Hugh Lane Municipal Gallery of Modern Art, Dublin, the Crawford Gallery, Cork, the Ulster Museum, Belfast, and other institutions promoted the research of these scholars by hosting a series of exhibitions featuring the work of Irish artists. A National Gallery of Ireland exhibition, *The Irish Impressionists* (1984), researched and curated by Julian Campbell, opened the eyes of thousands to the exceptional talent of many Irish artists who had worked in France and Belgium in the second half of the nineteenth century. The catalogue of the exhibition *Irish Art and Modernism* (Hugh Lane Municipal Gallery of Modern Art, Dublin, 1991), compiled by S B Kennedy, provided an excellent and in-depth examination of the modernist trends in Irish art between 1880 and 1950. A succession of published monographs by Irish, British and American scholars has established that Irish painting is worthy of international attention. *The Irish Arts Review*, since its launch in 1984, has published the work of established and young Irish art historians. Ann Stewart's indexes of exhibitors at the annual exhibitions of the Royal Hibernian Academy and at other loan exhibitions held in Ireland have provided a splendid database for researchers. The growth of an art market for Irish painting has likewise contributed to its emergence internationally.

Given all this enthusiasm, it is surprising that there has been no full-colour introduction to Irish painting published to date. Michael Wynne's *Fifty Irish Painters* (1983), featuring works from the National Gallery of Ireland, sold out quickly. This publication, *Irish Painting*, is the first to present illustrations and large details of an extensive range of major paintings from public and private collections. The short biographical and explanatory text that refers to each illustration is based on the most up-to-date scholarship. It is intended that the sixty-five works selected and the text should help the reader to understand the major developments in the history of Irish painting.

In the manner of Walter Strickland, *Irish Painting* focuses not on the Irishness of the subject matter of paintings but on whether the artists who painted them were born in Ireland or worked there. For example, it embraces English artists such as Francis Wheatley, James Malton and Lady Butler (Elizabeth Thompson) who painted some of their most important works while living in Ireland. It also includes a longer list of artists who were born in Ireland but spent most or all of their careers in England, France or elsewhere, such as Charles Jervas, James Barry, Francis Danby, William Mulready, Daniel Maclise, Roderic O'Conor, William Orpen, John Lavery and Francis Bacon. Bruce Arnold, whose *A Concise History of Irish Art* (1969) was the first history of the subject, has commented wisely that 'Belief in the Irishness of Irish art should not be overstated'. Irish artists have often travelled abroad to study, to work or simply in search of inspiration. Thomas Hickey went to India and China, Andrew Nicholl to Ceylon, Nathaniel Hone the Younger to Egypt, Mary Swanzy to Samoa, and John Butler Yeats, Aloysius O'Kelly and Patrick Tuohy to the United States of America, and so on. Some emigrated, shaking the dust from their shoes, but they could never erase either the place of their birth or the country of their childhood.

Brian P Kennedy

The paintings in this book are in chronological order to illustrate the development and trends in the history of Irish painting. The biographical entries on the artists correspond to the sequence of their respective works. The dimensions of the paintings are given height before width.

ARTIST UNKNOWN
(SEE P 43)

The portrait *Máire Rua O'Brien* (Red Mary O'Brien), which was painted in the 1640s, corresponds in date to the period of 'High Baroque' in Italy, but it has the attributes of an English picture of the previous century. Few easel paintings survive from the seventeenth century in Ireland and there is no evidence that the art of easel painting was practised before then. It is possible that works of an earlier date were destroyed by fire during the wars of the seventeenth century. But it would appear that Ireland was slow to adopt easel painting, no doubt due to poverty, the suppression of the monasteries, lack of education, and political instability.

Máire Rua O'Brien was born about 1615, probably at Bunratty, County Clare, to Torlach Rua and Mary O'Brien, a daughter of the Third Earl of Thomond. Her father's property was secure from forfeiture because he had sided with the English during the Elizabethan wars. Máire Rua's daily language was Irish, but she could probably speak English also. In 1634 she married Daniel Neylon of Dysart Castle in North Clare, and they had four children. In June 1639 Daniel died and Máire Rua won control of the family estates from the Court of Wards. In October of the same year she married Conor O'Brien of Leamaneh Castle, a fifteenth-century tower house standing only seven miles (eleven kilometres) from Dysart, as the crow flies, but set on the edge of the magical

landscape of the Burren. The portrait of Máire Rua was painted about the time of her second marriage, because the coat of arms in the upper left corner is that of the O'Briens. The artist has presented Máire Rua to best advantage, but he also shows her to have been no beauty. She had strong eyes, an aquiline nose, a small mouth and chin, and dark red hair. It is likely that her marriage to Conor was a love match, and the couple had eight children. Together they extended Leamaneh Castle and transformed it into an impressive country mansion. In the portrait, Máire Rua is shown as a proud property owner, for she holds a key in her left hand. She wears a black broadcloth gown, Flemish pillowlace collar and cuffs, and a head-dress of silk and lace. The large Renaissance pendant around her neck depicts two figures, which have been interpreted both as Adam and Eve with the serpent and as a dolphin and a mermaid.

During the 1640s Ireland was in turmoil, with the English government seeking to confiscate the lands of the native Gaelic lords. In August 1649 Oliver Cromwell arrived in Dublin to begin his mission to reconquer Ireland. Despite the horrors that Cromwell inflicted on Ireland, the war had not ended by the time he left the country in May 1650. In a military expedition to Clare in September 1651, the Cromwellian army under General Edmund Ludlow engaged with the Irish forces, during which Conor

O'Brien was severely wounded. According to tradition, he was brought to Leamaneh Castle, where he died with his loving wife at his side. Máire Rua lost no time in seeking to protect her lands, and tradition says that in order to retain them she offered to marry any Cromwellian officer selected by General Ludlow. In reality she was not quite so mercenary. She did indeed marry a third time, to a Cromwellian officer, John Cooper, and they had one son (Máire Rua's thirteenth child). In the early 1660s Máire Rua was unjustly charged with the murder of the servant of a neighbouring property owner, and she was granted a pardon in 1664. The year of her death is not known. This extraordinary woman has remained the best known figure in the folklore of County Clare, and numerous legends portray her as a fierce, cruel, lustful and ruthless property grabber.

Crookshank and Glin 1969, 1978; Dunlevy 1989; MacNeill 1990.

JOHN MICHAEL WRIGHT
(1617–94) (SEE P 44–45)

The years 1660 to 1685, which mark the reign of King Charles II of England, constitute the only continuous period of peace in Ireland during the seventeenth century. The arrival of James Butler, Duke of Ormonde, as Lord Lieutenant of Ireland in 1662 coincided with the emergence of a period of prosperity. Public building works were much in evidence, especially in Dublin, which saw the construction of some of the Liffey quays, the Royal Hospital at Kilmainham, and the laying out of St Stephen's Green and the Phoenix Park. Domestic building in the countryside began in earnest and fine houses were constructed, like Beaulieu in County Louth and Eyrecourt in County Galway. It is likely that the seventeenth-century owners of such houses who desired to have their portraits painted did so in order to preserve an historical record for posterity, rather than from a keen interest in art. Professional artists joined with the cutters and stationers of Dublin in 1670 when a Royal Charter was granted to the Cutters, Painters, Stainers and Stationery Company of Dublin, known as the 'Guild of St Luke the Evangelist, Dublin'. The gathering of such divergent groups of skilled workers was probably due to the fact that each used gold leaf, and buying in bulk helped to keep the price down. Apprentices had to be 'of good conversation and Protestant religion'. They trained for seven years before being 'made free of the company'. Visiting artists had to apply to be

allowed 'free', and they usually paid a fee or contributed a painting to the company. In such circumstance portrait painters came to Ireland, among them John Michael Wright.

Wright, a Catholic, was born in London, but he trained in Edinburgh with the Scottish artist George Jamesone. In the early 1640s he departed to Italy and was enrolled in the Academy of St Luke in Rome in 1648. He then spent a few years in France and Flanders, before returning to England in 1656. Wright may have gained favour at the Royal Court when Maria d'Este (Mary of Modena) married James, Duke of York. In 1685 he accompanied the embassy led by Roger, Earl of Castlemaine, on behalf of James II, to Pope Innocent XI in Rome, and he returned to England in 1687.

It is possible that Wright made more than one trip to Ireland. He was certainly in Dublin in 1679 when he painted the double portrait, *The Ladies Catherine and Charlotte Talbot*. An inscription on the back of the canvas was transcribed onto new lining as 'James Michael Wright, a Londre, Pictor Regini / Pinxit, Dublin anno 1679', but this was probably a misreading of 'Jo[S]. [Johannes] Mich Wright Lon[sis] Pictor Regius pinxit Dublin Anno 1679'. The influence of Wright's years in France is evident in his portraits, and his superb picture of the daughters of Colonel Richard Talbot, later Earl and titular Duke of Tyrconnell, provides much information about the

fashionable French-style dress worn by upper-class Irish children at the time. Lady Catherine Talbot is seated on a chair, holding her hands out and taking a flower from the basket held by her younger sister, Lady Charlotte, who is standing beside her. Lady Charlotte is wearing a black silk chiffon veil, and it has been speculated that this is a reference to the death of the children's mother, Katherine Boynton, in 1679. The formal garden in the background may represent Carton, the house that was extended by the Duke of Tyrconnell during the 1680s.

Lady Catherine's lovely grey French dress is a scaled-down version of current adult fashions. It is made of silk, with gold brocade, and has jewelled clasps. Her fine linen smock is trimmed with needlepoint lace. The red machine-knit silk stockings and the gold shoes with red heels are probably French. Lady Charlotte is wearing a classical-style dress — a figured silk chiffon over cream flannel, with jewelled clasps and pendant pearls. On her feet she wears Roman sandals. The rendering of the textiles and the delicacy of the colours in this portrait show Wright at the height of his artistic powers.

Strickland 1913; Waterhouse 1953; Crookshank and Glin 1969, 1978; Stevenson and Thomson 1982; Wynne 1983; Fenlon 1987, 1989–90, 1991–2; ffolliott 1989–90.

GARRET MORPHY
(c. 1655–1715) (SEE P 46)

Garret Morphy (sometimes spelt Morphey) was the first Irish-born artist to gain prominence. The circumstances of his early life are obscure. He may have been from the Cork/Kerry region, where Morphy is sometimes found as a variation of the more common name Murphy. If he trained at all in Ireland it is likely that he was a pupil of Gaspar Smitz (died c. 1688), a Flemish portrait painter who painted many members of the Irish gentry during the last quarter of the seventeenth century. Morphy was possibly born in the mid 1650s because he was documented in London in 1773 as an assistant to the Catholic artist Edmund Ashfield (fl. 1669–76), who had trained with another Catholic, John Michael Wright (1617–94). Morphy tended to associate with his co-religionists, and he became the most noted portraitist to the so-called Old English in Ireland, those Catholic families who had retained their lands during the Reformation and the era of plantation settlements. Later in his career he became popular as a portrait painter to the prominent English administrators and military leaders in Ireland. Between 1673 and 1694 Morphy travelled between England and Ireland as a peripatetic artist. It would appear that he stayed in Ireland after 1694, and he may have died there. His will indicates that he died in 1715.

The fine three-quarter-length portrait, *Brigadier General William Wolseley*, signed 'Gar. Morphy 1692', is one of only a handful of known signed and dated works by the artist. The subject is shown standing, wearing armour, and in the distance, to the right, a skirmish is taking place. Wolseley (1640–97) was the fifth son of Sir Robert Wolseley of Staffordshire, England. He was a zealous proponent of the Church of England, and he was sent to Ireland to assist in the relief of Derry when the city was under siege in 1689. He commanded the Enniskillen Horse regiment and participated in a number of battles against the Catholic King James II. In 1690 he captured and torched the town of Cavan, and in the same year he fought in the Battle of the Boyne, although, due to disorganisation and confusion, his troops were left in an exposed position and many were killed. In 1692, the year of Morphy's portrait, Wolseley was appointed Master General of the Ordnance in Ireland. The following year he became Lord Justice of Ireland and was made a Privy Counsellor.

Morphy's portraits provide an important insight into fashions in Ireland in the late seventeenth century. The artist shows his obvious enjoyment of rendering materials in the sensitive painting of Wolseley's neckcloth, cuffs and sash, and the elaborate gilding on the military armour, which catches the light. The elongated fingers on the sitter's hands are typical of Morphy's style. Wigs were not his strong point, however, and Wolseley's wig is rather limp and flat. Morphy's portraits of women show his liking for rendering the textures of linen and especially lace, but his painting of silk and velvet is not so effective. Morphy, through the works of John Michael Wright and Henri Gascars, was influenced by major French artists, including Hyacinthe Rigaud and Nicolas de Largillière. The Old English had long associations with Catholic France and favoured that country's fashions, unlike the Protestant New English families, who tended to adopt the styles of England and Holland. After the Battle of the Boyne the Old English influence declined quickly.

Strickland 1913; Crookshank and Glin 1969, 1978; Fenlon 1991–2.

CHARLES JERVAS
(c. 1675–1739) (SEE P 47)

Charles Jervas was born in the parish of Shinrone in King's County (now Offaly) about the year 1675. He went to London and probably studied under the portrait painter Sir Godfrey Kneller. From there he went to Italy, where he sought to improve his drawing technique by copying the works of Raphael, Carlo Maratti and others. In 1709 he returned to London and quickly became part of the best literary and social circles. He married a wealthy widow and they entertained many friends at their residence at Hampton, including Joseph Adison, Jonathan Swift and Alexander Pope (to whom Jervas gave painting lessons). Jervas painted portraits of these and other distinguished contemporaries, such as Robert Walpole, Isaac Newton and Hester Johnson ('Stella').

Jervas made several visits to Ireland, during which he painted portraits of members of the Irish gentry, notably William Conolly, speaker of the Irish House of Commons and builder of Castletown House, Celbridge, County Kildare, the finest neo-Palladian mansion in Ireland. Jervas painted at least ten portraits of the great writer Dean Swift, who, in consequence, complained to a friend in 1716: 'Do you hear anything of Jervas going; for I hate to be in town when he is here.' In 1723, after Kneller's death, Jervas was appointed principal painter to King George I, a position he retained under George II. In failing health, Jervas revisited Italy in 1738 to buy paintings for the king, and he died in London the following year. He had a large art collection, and the sale in 1740 of his studio contents, comprising 2128 pictures, prints and drawings, lasted nine days.

The portrait of a lady, possibly the adventurer and travel-writer Lady Mary Wortley Montagu (1689–1762), is a typical example of Jervas's art. Montagu is best known for the diaries she wrote while accompanying her husband to Constantinople when he became British ambassador there in 1716, and also for the introduction of the smallpox inoculation into England. The mythology surrounding her is such that many unidentified eighteenth-century portraits of women in Turkish dress have been labelled 'Lady Mary Wortley Montagu'. There is no doubt that Jervas painted a number of portraits of Montagu. In 1913 Walter Strickland, the founder of Irish art studies, recorded two, one in the collection of Earl Spencer and another that appeared in the Earl of Blessington's sale in Dublin in 1838. In her account of a visit to the Women's Baths at Sophia, Montagu made a snide reference to Jervas: 'To tell you the Truth, I had the wickedness enough to wish secretly that Mr Gervase could have been there invisible. I fancy, it would have very much improv'd his art to see so many fine Women naked, in different postures.' Jervas's female portraits are indeed stylised and mannered but, whoever the sitter, his *Portrait of a Lady* is a flattering one. If the sitter is Montagu, then this is especially true, for in 1715 she had suffered an attack of smallpox which left her with pitted skin, poor eyesight and no eyelashes. The lady in Jervas's portrait has been idealised, given a perfect complexion, strong eyes and full eyelashes. She is standing beside a musical instrument known as a clavicytherium, an early type of harpsichord. The carved figure swinging towards the sitter emphasises the erotic quality associated with Turkish attire in eighteenth-century portraiture. In the background is a view of Constantinople, evoking thoughts of the way of life in that city, so different from London. The shimmering draperies and the strained yet attractive pose of the sitter are typical of Jervas.

Strickland 1913; Halsband 1956, 1966; Crookshank and Glin 1969, 1978; NGI 1980–81; Wynne 1983; Stewart 1984; Pointon 1993.

JAMES LATHAM
(1696–1747) (SEE P 48)

James Latham, whose family came from County Tipperary, was the most talented Irish artist of the first half of the eighteenth century. In 1913 Walter Strickland knew of only one work by Latham. More recent research, using the technique of stylistic comparison and the rediscovery of paintings that were engraved, has brought the total number of known works to over ninety. Nevertheless, biographical information about the artist is lacking. Anthony Pasquin in his *Memoirs of the Royal Academicians and an Authentic History of the Artists in Ireland* (1796) states that Latham studied at Antwerp, where he was recorded as a member of the Guild of St Luke in 1724–5. He returned to Ireland in 1725, and there is no evidence that he travelled abroad again. He died in 1747 in Dublin, and was survived by his wife, one son and four daughters.

Pasquin described Latham as the 'Irish Van Dyke', an exaggeration which at least showed that he was held in high regard. It has been speculated that he was trained by Garret Morphy, but there is no documentary proof of this. It is true, however, that Latham's late works have certain stylistic features in common with Morphy. Unlike Morphy, a Catholic, Latham was probably a Protestant, and this would have provided him with an easy entrée to the circle of patrons among the Irish aristocracy and the holders of high office in the Church of Ireland, although it did not prevent him from painting the

portraits of Catholics also. Latham is often said to have been influenced by the major portrait artists working in England, Godfrey Kneller, Charles Jervas, William Hogarth and Joseph Highmore, but his style also owes something to French art. His handling of draperies and of the hands of his sitters is similar to the style of French artists like Nicolas de Largillière and Pierre Mignard.

Latham's three-quarter-length portraits are among his most assured works, and the double portrait, *Bishop Robert Clayton and his Wife*, is no exception. Robert Clayton was a member of a wealthy Lancashire family. He studied classics at Trinity College, Dublin, and inherited his father's fortune in 1728, the year he married Katherine Donnellan, a daughter of the former Lord Chief Justice of the Exchequer. Clayton went on a Grand Tour of Italy, and on his return to Ireland family influences in London helped secure him the bishopric of Killala in 1730. He was a celebrated connoisseur, known to his contemporaries as a man who 'eats, drinks and sleeps in taste'. In 1735 he was appointed Bishop of Cork and Ross, and ten years later he was made Bishop of Clogher. Latham's portrait was probably painted in the early 1730s. The happy couple are shown seated at a table, but the figure of the bishop is excellent in contrast to the rather weak portrait of his wife. The picture was painted on two canvases, joined near the centre, and Latham may originally

have intended to paint the bishop alone. Other double portraits attributed to Latham are also painted on joined canvases, however, and it is possible that the artist simply could not find one canvas large enough for his purpose. The witty letter-writer Mrs Mary Delany nicknamed the couple 'the Cardinal and Cardinella', such was their enthusiasm for high living. The bishop's town house in Dublin, which is now the headquarters of the Department of Foreign Affairs, was built by Richard Cassels on the south side of St Stephen's Green. It was reconstructed and expanded during the nineteenth century, and named Iveagh House. In 1751 Bishop Clayton became embroiled in a religious controversy when he published an essay attacking the doctrine of the Holy Trinity. He might well have been declared a heretic by the Protestant ecclesiastic court were it not for his death at his Dublin home in 1758 before the court was convened.

Strickland 1913; Pasquin (1796) 1970; O'Connor 1974, 1975; Sheaff 1978; NGI 1982–3; Crookshank 1988; ffolliott 1989–90; Crookshank and Webb 1990.

STEPHEN SLAUGHTER
(1697–1765) (SEE P 49)

The many portraits painted in Ireland during the 1730s and 1740s by the English artist Stephen Slaughter demonstrated clearly the fondness of the Irish for expensive clothes. The English at this time, although they were much richer, were content with less elaborate dress, and concentrated instead on the construction of splendid houses, leading Bishop Berkeley to ask in 1735: 'What would be the consequence if our gentry attempted to distinguish themselves by fine houses rather than by fine clothes?'

Slaughter was born in London and trained as an artist in the academy founded in 1711 by Sir Godfrey Kneller, the first academy of art in England. Art historians have been able to trace Slaughter's movements by close examination of his dated works. He had probably been living in Paris for a number of years when, in 1732, he painted a portrait of a gentleman named Patrick Ross. The following year he was back in England, and in 1734 he painted the portrait of the Lord Mayor of Dublin, Nathaniel Kane, during a stay in Ireland. He was probably in England from 1735 to 1743, after which he returned to Ireland, where he remained until 1748. During his years in Ireland Slaughter painted portraits of the landed aristocracy, of bishops and earls, and, in particular, members of the Dunraven and Inchiquin families. The second period in Ireland was interrupted by a brief stay in England in 1744–5. He

was appointed keeper and surveyor of the King's Pictures in 1744, a post he held until his death in London in 1765. Few works are known from the last fifteen years of his life. Perhaps they have yet to be recognised, or maybe Slaughter ceased painting many pictures in his later career.

A Lady and Child is signed and dated 'Stepn. Slaughter pinxt 1745'. The identity of the sitters is not known, but they are clearly members of the upper strata of Irish society. Slaughter was first and foremost a costume painter, and his ability to render silk and satin is superb. From the 1720s to the 1740s the dresses worn by Irish ladies were quite plain, although the fabrics used were costly. Dresses tended to have a low-cut neckline which revealed the ruffles of a white underdress. In this portrait the elaborate bouquets of flowers on the dresses of the lady and her child provide a colourful contrast to the white, cream and grey of the costume material. Slaughter's figures have a tendency to be wooden, and his female faces are often somewhat unflattering. The backgrounds to his pictures are unimaginative and appear like theatrical backdrops. His portraits of children are better, however, and the painting of the little girl seated on her mother's lap is quite delightful. There is a delicacy and an intimacy in the gentle manner in which she is shown holding her mother's arm. The child's facial features, hair and bonnet are painted with great facility. There is no

jewellery in this picture, although brooches, earrings and necklaces were back in fashion by the 1740s. The lady is wearing a little pinner on her head to indicate that she is married — wedding rings had been condemned during the Cromwellian period and did not achieve popularity again until the nineteenth century.

Slaughter has been credited with being an important influence on later Irish portrait painters, who were attracted by his decorative style. This may overstate his significance, but the quality and technical competence of his draperies was the essential factor that attracted his patrons.

Strickland 1913; Sewter 1948; Crookshank and Glin 1969, 1978; Wynne 1983; Dunlevy 1989; ffolliott 1989-90.

THOMAS FRYE
(1710–62) (SEE P 50–51)

Walter Strickland stated, without citing documentary evidence, that Thomas Frye was born in 1710 'in or near Dublin'. Michael Wynne has proposed that he was most likely the second son of John Fry of Edenderry in King's County (now Offaly). Nothing is known about Frye's artistic training in Ireland. Like his contemporaries, James Latham, Stephen Slaughter and Philip Hussey, he specialised as a portrait painter. He had settled in England by the early 1730s and was considered to be such an expert painter that he was commissioned by the Saddlers' Company in 1736 to paint a portrait of their Perpetual Master, Frederick, the Prince of Wales. This portrait is known today only by the mezzotint that Frye made of it in 1741, a print technique in which he excelled. Mezzotint is essentially a tone-process in which a metal plate is roughened using a tool with a curved and serrated edge, called a rocker. The main feature that distinguishes mezzotint from other print methods is that the artist works from dark to light, from a black ground to the highlights and not from a white ground to shadows. The mezzotint technique was discovered in the seventeenth century but it became especially popular in England in the eighteenth century. It is sometimes know as *la manière anglaise* and it was used, first and foremost, for the reproduction of portraits. Frye's mezzotints are better known than his oil paintings, of which

approximately ninety have now been located.

In 1744 Frye helped to found the Bow porcelain works near London, where he was factory manager until 1759, when he was forced to retire due to ill-health. He suffered from gout and was consumptive, but his condition improved during a trip to Wales. He returned to London and, between 1760 and 1762, completed two series of mezzotints, the first a set of twelve prints of life-sized heads (eight male and four female), the second a set of six prints of 'Ladies very elegantly attired in the fashions, and in the most agreeable attitudes'. It is considered likely that while real people may have been used as models for these mezzotints, they are not portraits but fancy subjects designed to show a range of figure poses. Due to the quality and the wide circulation of his prints, Frye's work influenced many other artists, notably Joseph Wright of Derby (1734–97). Frye died from consumption in 1762 at the age of fifty-two.

Frye's oil portraits are uneven in quality, but his representation of the portly gentleman *Henry Crispe of the Custom House* (signed and dated 1746) is a fine example. Henry Crispe (1687–1747), the eldest son of the Reverend Henry Crispe, rector of Catton, Yorkshire, was Registrar of Certificates and Examiner of Debentures in the Custom House, London. He died in 1747 and was entombed in his family's traditional burial place at Birchinton in Kent. His monument states that 'in him was shewn that polite

literature and ev'n a poetical genius best form the man of business'. No poetical works by Crispe have been discovered, but his portrait certainly portrays him as a man of letters, holding his quill, while simultaneously giving him the rather haughty pose of a man of considerable wealth. The writing on the paper at his right hand looks legible, but close inspection reveals that this was never intended by the artist. Crispe's left hand rests on a carved leopard's head, an allusion to his coat of arms, which includes five leopards' faces.

Strickland 1913; Crookshank and Glin 1969; Wynne 1972, 1982, 1983.

PHILIP HUSSEY
(1713–83) (SEE P 52)

An *Interior with Members of a Family* is one of the finest eighteenth-century Irish paintings, and on stylistic grounds it has been attributed to Philip Hussey, who was born at Cloyne, County Cork. It is a conversation piece, a type of genre picture which shows portraits of a number of people, usually in a domestic setting.

Hussey's parents separated shortly after he was born, and while still a boy he went to sea and was shipwrecked on a number of occasions. He liked to draw the figureheads of the ships on which he sailed and he gained some proficiency as a portraitist. Lord Chancellor Bowes noticed his talent and encouraged him to become a professional artist. He visited England twice and studied old master pictures there. A talented botanist and musician, his house in Dublin was a meeting point for the writers and artists of the city. Anthony Pasquin (1796) tells that Hussey was a man of 'simplicity and suavity' who 'abstained from speaking of his own works as much as possible'. He died at his house in Earl Street, Dublin, in 1783.

Hussey completed portraits for a number of patrons in the Counties Clare, Limerick and Kerry, but the sitters in *An Interior with Members of a Family* have not been identified. Their house must have been of some importance because the room in which the couple and their two daughters are shown is a large and opulent one. The picture is most informative

about interior decoration and fashions in dress in Ireland around 1750. The elaborate English wallpaper, which displays an architectural design with temples visible through columns and canopies, was typical of the period, and similar patterns have been found in the USA at Massachusetts, Connecticut and Vermont. The key-hole fireplace is quite unusual, but, nonetheless, an Irish feature, and to either side of it is a firescreen, in this case a framed picture, mounted and adjustable on a pole with a tripod stand, and used to prevent a lady's make-up from melting before the heat. The carpet is oriental, and between the two casemented windows is a contemporary gilded French mirror. On the other side of the room is a row of five plain Irish-style Chippendale chairs with straight legs. It was customary in large eighteenth-century Irish houses to have a drawing-room cum dining-room in which the chairs were placed around a table in the centre of the room at meal times and brought back against the walls afterwards. The so-called 'coffin table' (now known as a hunting table) was most suited to this practice because its leaves could be dropped. The centre panel was large enough to fit a coffin, and the wake of a deceased member of a household could take place around the table. The mahogany door attests to the great age of Irish mahogany furniture and fittings between 1740 and 1760. Most of the wood was imported from the West Indies, with

which Ireland conducted considerable trade.

The fabrics worn by the sitters were expensive — heavy satin, broadcloth, lace and fine linen — but the fashions were relatively simple. The seated lady's blue dress and petticoat is robed to waist level only, but it emphasises, with lace stomacher, the low-cut neckline that was particularly fashionable in the 1750s. She wears a ribbon decoration in her hair and holds the hands of one of her daughters, who is dressed in a linen frock and headcap, and, like her sister, is seated on the floor holding a spaniel. Their father, who stands balancing a chair on its front legs, wears a frockcoat with turned-down collar and round cuffs, a long waistcoat, knee breeches, a stock and wig. There is a second spaniel seated in the lower left corner. The picture is a minor masterpiece, an exquisite and well-observed family portrait by a little-known Irish artist.

Strickland 1913; Crookshank and Glin 1969, 1978; Pasquin (1796) 1970; FitzGerald 1978; Wynne 1983; Dunlevy 1989; Pointon 1993.

GEORGE BARRET
(1728/32–84) (SEE P 53)

The Dublin Society was founded in 1731 for the purpose of 'improving husbandry, manufacture and the useful arts and sciences'. The society recognised the need for a school to train young Irish artists and it began to dispense prizes for drawing and painting. In about the year 1740 the society arranged with Robert West (d. 1770), a Waterford-born artist who had studied in Paris, to train twelve boys at the drawing school he had founded. In 1757 the society established its own school and West was appointed drawing master. The Dublin Society Schools became the premier teaching establishment for Irish artists until 1877, when the administration of the establishment was ceded by the Royal Dublin Society (which received its Royal Charter in 1820) to the Department of Science and Art, and it was renamed the Metropolitan School of Art.

One of the first students funded by the society to train with West was George Barret who was born in the Liberties of Dublin, probably in 1732, although some sources give the year as 1728. The noted writer, orator and philosopher Edmund Burke, then a student at Trinity College, encouraged Barret to study directly from nature and introduced him to the second Viscount Powerscourt, who owned a magnificent demesne in County Wicklow. Powerscourt House, remodelled from 1731 to 1740 to the designs of the German architect Richard Cassels,

was extended in the nineteenth century and, sadly, gutted by fire in 1974. Barret spent a few years at the Powerscourt estate painting the beautiful scenery there, the Dargle River and the celebrated waterfall, one of the highest in Ireland or Great Britain. *A View of Powerscourt Waterfall* is one of a number of paintings by Barret of the splendid cascade that falls nearly 380 feet (116 metres) down a steep precipice.

The view of Powerscourt waterfall reflects the influence on Barret of Burke's essay 'A philosophical inquiry into the origin of our ideas of the Sublime and the Beautiful' (1756). The Sublime in landscape was characterised by the awesome quality of nature, its capacity to instil wonder, lonesomeness and terror. The Beautiful stood for tranquillity, gentleness and repose. Barret's picture is clearly of the sublime variety. The figure group in the foreground is tiny in comparison with the huge trees, the high cliffs and the power of the waterfall. Barret ennobles the scene by his depiction of the heavily leaved trees of summertime, the golden light of evening, and the white foam on the water as it falls on the rocks below.

In 1762 Barret moved to London with his wife, bringing with him some of his best paintings. He showed these and others at exhibitions in the city and gained immediate acclaim. Numerous commissions followed and, such was his success, it was reputed that his annual income was about two

thousand pounds, an enormous sum at the time. He painted many landscape views in the Lake District of England, in Wales and Scotland, and on the Isle of Wight. In 1768 he was one of the forty foundation members of the Royal Academy, London. During the late 1770s, perhaps due to a profligate lifestyle, Barret was reduced to bankruptcy. In 1782 Edmund Burke helped him to secure the post of master painter to Chelsea Hospital. He died in 1784, leaving his wife and nine children in penury, but the Royal Academy, in recognition of his contribution to their institution, agreed to grant them a pension. Many of his oil paintings and pencil drawings have survived, but few of his superb watercolours. His son George Barret (1767/9–1842) was an accomplished watercolourist and one of the founders of the Old Watercolour Society in England in 1804.

Strickland 1913; Bodkin 1920; Crookshank and Glin 1978; Wynne 1983; De Courcy and Maher 1985; Gillespie, Mooney and Ryan 1986; Hutchinson 1989–90; Croke et al 1991.

THOMAS ROBERTS
(1748–78) (SEE P 54–55)

Thomas Roberts was the most gifted Irish landscape painter of the second half of the eighteenth century. Born in Waterford city in 1748, he was the son of John Roberts who designed the city's Catholic and Protestant cathedrals. Biographical information about Roberts is scarce, but since about 1970 when six pictures attributed to him came onto the Irish art market, art historical research has elicited some basic facts. His younger brother, Thomas Sautell Roberts (1760–1826), was a noted watercolourist. In 1763, while still a boy, Thomas Roberts enrolled in the Dublin Society Schools, where he studied under the master of the Ornament and Landscape School, James Mannin. He was apprenticed to the landscape painter George Mullins, and began to exhibit at the Society of Artists' exhibitions in Dublin in 1766, contributing to their annual show each year until 1773. He exhibited at the Society of Artists in London in 1775 and 1777. In the latter year he gave a London address, so he may have been living there. He gained a high reputation and received commissions from members of the great Irish landed families, including the Duke of Leinster, Viscount Powerscourt and the Earl of Rosse. Roberts suffered from consumption, and in 1777 he sailed for Lisbon in the hope that the mild climate there would improve his condition. He died the following year, aged thirty.

Unlike many landscape painters, Roberts could paint excellent figures and animals. His handling of paint was superb, combining a lightness of touch with meticulous attention to detail. There is a broad range of colours in his paintings and an admirable subtlety of approach to tonal value. Roberts was also capable of creating accurate views of large houses and their surrounding lands; the best works of this type are the four views of the landscaped park at Carton House, County Kildare, seat of the Duke of Leinster. Roberts' versatility was noted by his contemporaries. The lists of the paintings that he exhibited at the Society of Artists include *A Frostpiece*, *A Land Storm with a Waterfall*, *A Moonlight* and *Portrait of a Mare*. Like his teacher, Mullins, Roberts was especially talented as a painter of idealised landscapes. The large imaginary set-pieces, such as *An Ideal Landscape*, painted in the 1770s, have certain common characteristics. These well-ordered views, receding to a distant horizon, were painted in the manner of Claude Lorrain (1600–82), a French artist who worked in Rome. Claude established a set of rules for landscape painting in the classical style: the foreground should be painted in dark colours, the middle distance lighter and, in the background, the lightest colours; distance should be created by the device of placing trees or hills to either side of the picture, similar to the effect of the sides of a theatrical

stage (called *coulisses* in French); and human figures, animals, buildings (especially ruins), rivers, trees and shrubbery should be placed carefully within the composition to lead the viewer into the landscape. Roberts had a small output, given that he died so young, but as more of his paintings are being discovered or reattributed to him, his place among the best landscapists of his time, in Ireland and England, becomes ever more obvious.

Strickland 1913; Wynne 1977; Crookshank and Glin 1978; Wood 1984; Breeze 1985.

NATHANIEL HONE THE ELDER
(1718–84) (SEE P 56–57)

Nathaniel Hone the Elder was perhaps the best portrait painter Ireland has ever produced. He stands comparison with many of his English contemporaries, and was unsurpassed as a portraitist of children. He was born in 1718, the son of a merchant of Wood Quay, Dublin, but little is known of his early life. He may have been self-taught or perhaps he studied with Robert West in Dublin, and he shows some influence of the important Irish portraitist James Latham (1696–1747). It is not known exactly when he went to England, but in 1742 he married a young heiress, Mary Earle, at York Minster. He established himself in London as a portrait painter in oil and miniature. He painted many excellent enamel portraits and advised the Princess of Wales about her collection. His earliest known oil portrait is dated 1741. It was once thought that Hone had visited Italy, but this is now considered unlikely. He visited Paris for one month in 1753. From the 1750s to the 1770s he was a fashionable painter of the English nobility, and in 1768 he became a foundation member of the Royal Academy, London. Hone was a fiery individual, whose hot temper caused him to lose many friends and found him more than a few enemies. His large collection of prints and drawings was sold at auction in 1785, the year after his death.

The Conjuror, the best-known painting by Nathaniel Hone, caused a furore when it was first exhibited at the Royal Academy exhibition in London in 1775. Hone titled the picture The Pictorial Conjuror, Displaying the Whole Art of Optical Deception, and it was allowed to hang for a few days before its removal was requested. Hone was indignant about this and promptly organised a retrospective exhibition of his own work, the first one-man show ever held in England. The cause of the scandal was, as Hone explained, that 'it had been rumoured that I had made an indecent figure or caricature of an eminent female artist'. The artist in question was Angelica Kauffman, a leading portrait painter and a close friend of the president of the Royal Academy, Sir Joshua Reynolds. The previous year Hone had not endeared himself to Reynolds when he had proposed that Thomas Gainsborough would make a much better first president of the Royal Academy. Also, in 1774 Reynolds's theme for his annual 'Discourse' lecture at the Royal Academy was the copying by artists of the works of the great masters of the past. In April 1775, four months after Reynolds's lecture, Hone submitted The Conjuror, and it was quickly realised that he was accusing the president of plagiarism by satirising him as a magician conjuring up a picture out of old master prints given to him by the devil.

Hone's complex satire has only recently been unravelled by scholars. All of the artists represented in the many prints seen in The Conjuror had been used as source references by Reynolds, and some of them related directly to known works by him. The model for the old man was George White, who also posed for Reynolds. In his hand he holds a print of the Virgin with a Diadem by Raphael, in which Christ or truth is revealed to humankind, and with his other hand he uses a pointer to indicate a print of the disarming of the cupids, perhaps implying that Reynolds had borrowed this image to create one of his paintings, or possibly referring to the persistent rumours that Reynolds and Kauffman were involved in a relationship. The owl on the right is a symbol of folly. The young girl leaning on the conjuror's knee has been related convincingly to an engraving after Angelica Kauffman's self-portrait in the character of Hope, and it also recalls an engraving after Reynolds's Laughing Girl. In the top left corner Hone painted seven nudes cavorting in front of St Paul's Cathedral, an allusion to his own exclusion in 1773 from the list of artists proposed by the Royal Academy to decorate the cathedral with history paintings. Kauffman claimed that one of the nudes represented her — the figure wearing boots and waving an artist's brush and palette. Hone swore an affidavit denying the allegation, and agreed to paint over the section, replacing it with a scene of artists seated at a table. He knew, as no doubt Kauffman did, that the real reference to her was the little girl. The original nude figures are now visible only in X-rays and in the oil sketch for the picture (Tate Gallery, London). Viewing The Conjuror as a calculated insult, one cannot fail to admire Hone's nerve and his sophisticated bad manners.

Strickland 1913; Munby 1947; Butlin 1970; Newman 1986; Le Harivel 1992.

FRANCIS WHEATLEY
(1747–1801) (SEE P 58–59)

Francis Wheatley was born in London in 1747, the son of a master tailor. He trained at William Shipley's Drawing School in London and may also have spent some time under the tutelage of the landscape painter Richard Wilson. His output was large and included portraits, landscapes, conversation pieces and fancy pictures.

Wheatley's arrival in Ireland about 1779 coincided with the rise of the Irish Volunteers, a movement that promoted an independent Irish parliament and forced the English parliament to repeal all restrictions on Irish trade. Wheatley was fleeing his creditors in London, and he arrived in Dublin with the wife of a fellow artist, a lady named Elizabeth Gresse, whom he passed off as his own wife. During his four years in Ireland he painted many of his best pictures, including A View of Dublin with a Meeting of the Volunteers (1779, National Gallery of Ireland). The Irish House of Commons is important historically as it is the only accurate view of the interior of Edward Lovett Pearce's fine building, which was destroyed in 1803 as a consequence of the Act of Union. The picture is also a unique record of a famous speech made by Henry Grattan on 19 April 1780 during the debate on the repeal of Poynings' Law. Grattan opened the debate on the motion: 'That the people of Ireland are of right an independent nation and ought only to be bound by laws made by the King, Lords and Commons of Ireland.' Wheatley has done justice to the occasion by presenting a wide-angled view of the crowded scene, with elegantly dressed ladies and gentlemen listening from the galleries above the Members' chamber.

The picture lacks a sense of high drama because Wheatley attempted to give equal prominence to each of the Members. He was offered 'special facilities' so that he could gain a good likeness of each individual. From a professional standpoint, he was, of course, demonstrating his prowess as a portrait painter in order to attract commissions from the Irish gentry. He realised the business potential of this opportunity and he opened a subscription for an engraving of the picture, offering the sitters half-price. In The Life of James Gandon, published in 1846, there is an allegation that Wheatley engaged in sharp practice: 'several of the early subscribers, who had paid half-price as sitters for the picture, had been rubbed out to substitute others — who had also paid half-price ' The truth of this allegation cannot be determined because Wheatley failed to produce any engraving. It was not until 1906 that an engraving was published with a key to the identity of the sitters.

Wheatley's relationship with Ireland ended rather as it had begun. Once again he found himself in debt, and the true nature of his relationship with Mrs Gresse was discovered. This situation was unacceptable in eighteenth-century Dublin society and he was obliged to return to England late in 1783.

In 1790 Wheatley was elected an associate of the Royal Academy, and he became a member the following year. He died in London in 1801.

Strickland 1913; Webster 1970; Crookshank and Glin 1978; Croke et al 1991; Kelly 1993.

JAMES BARRY
(1741-1806) (SEE P 60-61)

James Barry was a central figure in European neo-classicism of the late eighteenth century. He reached the front rank of artists in England despite being a Roman Catholic, a friend of political reformers and social radicals, and an advocate of civil and religious liberty in his native Ireland. His immodest aim was to be the greatest painter of his age. He dedicated himself to 'history painting', which was considered to be the highest branch of painting. He believed that the purpose of art was to ennoble and instruct, that the artist was primarily a prophet and teacher. In his history paintings he attempted to promote the god-like virtues of heroic figures from history and mythology. Despite producing many outstanding works of art, he failed to satisfy his expectations, due to a combination of over-ambition, adversity and a most irascible temperament.

Barry was born in Cork in 1741, the son of a coastal trader. His father did not support his wish to become an artist, but Barry insisted on pursuing his vocation. He was encouraged by the works of the local landscape painter John Butts, which he described as 'my first guide and . . . what enamoured me with art itself'. In 1763, aged twenty-two, Barry moved to Dublin, where he quickly won the support of patrons, including Edmund Burke who arranged for him to travel to London. In 1765, with Burke's financial support, he set off on a continental tour,

spending ten months in Paris and four years in Rome, where he studied the great masters, especially Poussin, Michelangelo, Raphael and Titian. He arrived back in London in 1771, convinced of the merit of High Art. His talent was recognised immediately: he was elected an associate of the Royal Academy in 1772 and a member the following year. He spent seven years completing a series of six large canvases on the theme 'The Progress of Human Culture' for the Great Room of the Society of Arts in the Adelphi, London. In 1782 Barry was elected professor of painting at the Royal Academy. He became disenchanted with many of his fellow academicians, and in his lectures and published writings he lambasted them to such an extent that, in 1799, they formed a cabal which succeeded in having him expelled from the academy, the first and only artist ever to receive this unenviable fate. In his last years Barry suffered from depression and melancholia, and lived as a recluse in very poor circumstances. He preferred to remain in proud isolation rather than succumb to the temptation to paint fashionable society portraits. He died in 1806 and was interred in the crypt of St Paul's Cathedral, beside Sir Joshua Reynolds.

Barry was fascinated by the subject of *King Lear Weeping over the Body of Cordelia*. He first painted it in 1774, and in 1786–7 he completed a larger, more elaborate version for the Boydell Shakespeare

Gallery. This was Alderman John Boydell's project, designed to elevate popular taste by distributing engravings after a series of more than one hundred paintings illustrating scenes from Shakespeare's plays, which he commissioned from the best artists working in England at the time. Barry's painting of King Lear was highly original because in all acted versions of the play in the eighteenth century, a happy ending was obligatory and the king and his daughter Cordelia were not permitted to die. Barry was the first to illustrate the scene in the last act of Shakespeare's great tragedy, the moment when Lear dies of a broken heart, with the body of Cordelia in his arms. The painting is a *tour de force*, packed with incident: the mourning spectators, the dead bodies of Goneril and Regan strewn at their father's feet, the corpse of Edmund being carried off, and, in the tent, the soldier slain because he killed Cordelia. The wild drama is heightened by the high-pitched tonality, but a note of hope is struck in the detailed landscape, where a monumental structure similar to Stonehenge has been rendered in a classical style to prompt an association between the achievement of Greco-Roman civilisation and the genius of ancient Britain.

Strickland 1913; Crookshank and Glin 1969, 1978; Pressly 1981, 1983; Gibbons 1991; Barrell 1992; Christian 1992.

THOMAS HICKEY
(1741-1824) (SEE P 62)

Throughout the eighteenth century many Irish artists went to England to advance their artistic training, and some travelled as far as Paris or Rome. Thomas Hickey was something of an adventurer, for he established himself as one of the foremost portrait painters in India. He was born in Dublin in 1741, the son of a confectioner, and studied art at the Dublin Society Schools, where he won several prizes between 1753 and 1756. His first works were portraits in black and white chalk, but after a number of years spent studying in Italy during the 1760s, he returned to Dublin and began exhibiting oil portraits. Disappointed by his failure to receive patronage in Dublin, he went to London where he became a regular exhibitor at the Royal Academy. He was in Bath in 1778, and two years later he set sail from Portsmouth in a convoy of five ships destined for Calcutta. The convoy was captured by French and Spanish fleets and Hickey's ship was taken to Cadiz. He was released and given permission to return to England. After making his way to Lisbon, where he hoped to find a ship in which to travel home, he received so many portrait commissions that he stayed in Portugal until late in 1783.

Hickey arrived finally in Calcutta in 1784, and for the next seven years he painted the portraits of prominent members of the British community in India. He lived in a large house in the best district of Calcutta and became friendly with the leading

attorney, William Hickey, no relation, whose *Memoirs* provide a wealth of detail about the social life of British India. *An Indian Lady*, painted in 1787, is thought to be a portrait of Jemdanee, the *bibi* or mistress of William Hickey, who lived with the attorney until her death, in child-birth. As Captain Thomas Williamson wrote in 1810, a woman like Jemdanee 'under the protection of a European gentleman, is accounted not only among the natives, but even by his countrymen to be equally sacred, as though she were married to him; and the woman herself values her reputation'. William Hickey commented revealingly, 'Jemdanee lived with me, respected and admired by all my friends for her extraordinary sprightliness and good humour. Unlike the women in Asia she never secluded herself from the sight of strangers; on the contrary, she delighted in joining my male parties, cordially joining in the mirth which prevailed though never touching wine or spirits of any kind.' Like most Indian mistresses of European men, Jemdanee was a Muslim, and her portraitist has painted her in a dignified but passive pose, seated cross-legged on cushions on a colonnaded verandah.

In 1788 Thomas Hickey published the first and only volume of *History of Painting and Sculpture*. He returned to England in 1791, and travelled as official portrait painter on Lord Macartney's expedition to Peking from 1792 to 1794. He probably visited Dublin

in 1796, and he sailed for India again in 1798. He completed an historically significant series of portrait drawings, in chalks, of thirty-three British officers and sixteen Indians who participated in the British victory over Tipu Sultan, the so-called Tiger of Mysore, during the storming of Seringapatam in 1799. Hickey was in Calcutta from 1807 to 1812, and he then settled in Madras, where he died in 1824.

Strickland 1913; Crookshank and Glin, 1969, 1978; Archer 1975, 1979; Lynch 1988; Leeds 1989; Croke et al 1991.

HUGH DOUGLAS HAMILTON
(c. 1739–1808) (SEE P 63)

Hugh Douglas Hamilton was the most successful of the many Irish artists working in Rome during the second half of the eighteenth century. He entered the Dublin Society Schools in 1756, when he was 'just over sixteen', and gradually established himself in his native city as a painter of small oval portraits in crayon and pencil. By 1764 Hamilton was in London, where his portraits brought him success, but he also won prizes for his history pictures in oils. After fifteen years in England he went to Italy, arriving in Rome in 1779. He stayed there and in Florence for thirteen years, returning to Dublin in 1792. While in Rome, he became friendly with many of the leading foreign members of the colony of artists who resided there, such as the Irish painter Henry Tresham, the English sculptor John Flaxman, and the Italian sculptor Antonio Canova. This was the era of neo-classicism, the rediscovery and conscious imitation of the ancient art of Greece and Rome. Hamilton immersed himself in the study of history painting, especially the representation of classical history and mythology, but he also maintained a steady business as a portrait painter in crayon so that he could support his wife and daughter. Flaxman encouraged him to paint full-length portraits in oils, and during his last four years in Rome he produced several excellent works, including the large canvas *Frederick Hervey, Bishop of Derry and fourth Earl of Bristol, 1730–1803*, with his granddaughter, *Lady Caroline Crichton.*

The earl-bishop, a frequent visitor to Rome, was quite an eccentric, a distinguished clergyman and a patron of arts, about whom Flaxman said: 'The liberality of Lord Bristol has reanimated the fainting Body of Art in Rome.' In 1771 he had an audience with the Pope, at which he asked for a relaxation of restrictions placed on Protestants in Rome (where they were regarded as heretics), as an acknowledgement of his efforts to promote religious tolerance in his own diocese in Ireland. He was well regarded in Derry, where he gave generously from his family fortune to provide for the welfare of his flock. His opposition to the Act of Union and his support for Catholic Emancipation did not win him favour in England. The earl-bishop was a difficult patron, demanding, brusque, and erratic, but he favoured Hamilton with a number of commissions. His granddaughter, Lady Caroline Crichton (1779–1856), was in Rome between 1786 and 1790 with her mother, Lady Erne. In Hamilton's portrait the earl-bishop is shown standing with his granddaughter in the park of the Villa Borghese in Rome. The landscape background is a delightfully painted view of the lake in the park and the Temple of Aesculapius. Lady Caroline, in almost a dancing pose, points with her left hand towards her grandfather and, with her right hand, touches an ancient sculpture known as the Altar of the Twelve Gods, which was part of the Villa Borghese's collection of antiquities. The altar was later sold by Prince Camillo Borghese to Napoleon, and it is now housed in the Louvre.

Following his return to Dublin in 1792, Hamilton was in great demand as a portrait painter, but, in a number of letters to Canova, he lamented the lack of public interest in historical pictures. It was a difficult period for artists in Ireland, with few public exhibitions, political unrest and a declining number of patrons, especially following the Act of Union in 1800. Hamilton became depressed and developed a nervous complaint which caused him to give up painting in 1804. He longed to revisit Italy but never realised his wish, dying at his Dublin home in 1808.

Strickland 1913; Crookshank and Glin 1969, 1978; Ford 1974; NGI 1981–82; Cullen 1982, 1984 (1) & (2); Wynne 1983, 1984; Andrew 1986; Figgis 1986, 1988.

JAMES MALTON
(c. 1760–1803) (SEE P 64–65)

The Custom House in Dublin is arguably the city's finest public building. Its construction began in 1781 and took ten years to complete. It was designed by the architect James Gandon, whose commissions in Dublin included the Four Courts (1786–96) and the King's Inns (1795–1816). The elegant Custom House, built on the quays of the River Liffey, was unfortunately gutted by fire in 1921. It was refurbished by the Office of Public Works during the 1920s, and since the completion of the stone restoration and cleaning programme undertaken during the 1980s, it presents a spectacular sight, especially under floodlighting.

James Malton is renowned for his twenty-five views of Dublin, engraved in aquatint and published in 1799 under the title *A Picturesque and Descriptive View of the City of Dublin*. This has been called 'one of the most beautiful books of the art of aquatint', a printing process in which acid is made to pit a metal plate in such a way as to give the prints the fine effect of a watercolour.

The year of Malton's birth is not known, but he was the son of Thomas Malton, an English architectural draughtsman and engraver who died in Dublin in 1801. It is probable that James Malton came to Dublin to work as a draughtsman in James Gandon's office during the construction of the Custom House. Contemporary sources allege that Malton was dismissed for 'irregularities', and it is obvious that he disliked Gandon intensely. This explains why Malton's prints of the Custom House, and especially of the Four Courts, do not correspond fully with the buildings as they were constructed. Accuracy was Malton's strength, and it is likely that Gandon refused to allow him to study the architectural drawings.

Prior to the publication of the bound volume of his views of Dublin, Malton issued them individually from 1792 until 1799. *The Custom House, Dublin* was issued in July 1792. It was Malton's practice to paint a large watercolour of each of his subjects before printing the final aquatint. Most of these watercolours are now in the collection of the National Gallery of Ireland. The watercolour of the Custom House is dated 1793, a year later than the aquatint. Malton probably signed the watercolour at the later date in order to confirm its authorship.

Malton liked to include incidents of daily life in his views of the city. They convey an atmosphere of calm and elegance which seeks to ignore the harsher aspects of life in late-eighteenth-century Dublin. Nevertheless, the continued popularity of sets of Malton views, whether as wall-mounted prints or place mats, has done much to encourage the perception that the years of 'Grattan's Parliament' (1782–1800) marked the high point of Georgian Dublin, prior to the disastrous economic consequences of the Act of Union of 1801.

Strickland 1913; Craig 1981; De Courcy and Maher 1985; Croke et al 1991.

WILLIAM ASHFORD
(c. 1746–1824) (SEE P 66–67)

William Ashford was born in Birmingham, England, and came to Ireland in 1764, aged about twenty, having obtained a post in the Ordnance Office in Dublin. It is not known where he trained, but in 1767 he exhibited flower pieces at the Society of Artists' exhibition in Dublin. This society was founded in 1764 following the success of the Society of Artists in London, which had been established in 1760. The Dublin society held its first exhibition in 1765 in George's Lane, and subsequent exhibitions were held in specially constructed rooms in William Street. A schism occurred in the society in 1773, and under the burden of debts it disbanded in 1780. Ashford specialised as a classical landscape painter and was a regular contributor to the society's exhibitions until its demise. No exhibitions were held in Dublin between 1780 and 1799, but Ashford exhibited in London during this period and his work was much admired. He was among the foremost landscape painters of his time and he made a great deal of money from his painting. About 1790 he commissioned his friend James Gandon to design a villa for him, Sandymount Park, where he lived for the rest of his life.

In 1800 a new organisation was founded, the Society of the Artists of Ireland, and an exhibition was held in rooms at 32 Dame Street, Dublin. Six more exhibitions were mounted until, in 1812, a division occurred and two societies were formed, the

Society of Artists of the City of Dublin, and the Irish Society of Artists, of which Ashford was president. The societies amalgamated in 1814, split again the following year, and reamalgamated in 1816. The artists then decided to seek the establishment of a national institution, independent of any other body and governed by a constitution. After several years of campaigning, the Royal Hibernian Academy was incorporated by a charter dated 5 August 1823. Three artists, William Ashford, William Cuming and Thomas Sautell Roberts, were chosen by the first general assembly to select fourteen founder-member academicians and ten associates. Ashford was elected as the first president of the academy, but he died a year later, in 1824, aged seventy-eight. The academy held its first annual exhibition in the spring of 1826.

A View of Dublin from Chapelizod was commissioned for the Marquess of Camden, Lord Lieutenant of Ireland from 1795 to 1798. The view of Dublin is seen from a hill in the Phoenix Park, above the man-made weir at Islandbridge, to either side of which there are animals and labourers in the fields. In the left foreground is a stag, and behind the trees is the Magazine Fort with a flag flying from it; down a slope, horse-drawn gun carriages are proceeding towards the Chapelizod gate. The arch spanning the river Liffey is the Sarah Bridge, which was erected during the 1790s. In the middle distance the village of Kilmainham is distinguishable, with its great

buildings, the Royal Hospital and the jail. The architecture of the city of Dublin is difficult to discern because it is painted on a small scale, but on close inspection numerous structures are visible: the spires of St Patrick's and Christchurch Cathedrals, St Michan's Church and St Werburgh's, and James Gandon's impressive dome of the Four Courts. At the top of the picture, seagulls are soaring in the clouded sky. This splendid view is but one example which gives merit to the claim that, in the latter half of the eighteenth century, Irish landscape painters were among the best in Europe.

Strickland 1913; Crookshank and Glin 1978; Wynne 1983; Breeze 1985; De Courcy and Maher 1985.

FRANCIS DANBY
(1793–1861) (SEE P 68–69)

When Francis Danby died in 1861, an obituary declared that 'a life more sad has been rarely led by a man of undoubted genius'. Danby was born near Killinick, six miles (nine kilometres) south of Wexford. His childhood memories were 'filled by fear, distress and bloodshed', having been marred by the 1798 insurrection. In 1799 Danby's family moved to Dublin, his mother's native city. His father, a small landed proprietor, died in 1807, leaving Francis, the youngest son of his second marriage, penniless.

Danby studied for a time at the Dublin Society Drawing Schools and began to specialise as a landscape painter. He became friendly with two other landscape painters, James Arthur O'Connor and George Petrie, and together they went to London to the Royal Academy exhibition of 1813. Their money soon ran out and Petrie returned to Ireland, while Danby and O'Connor set off on foot for Bristol, where they hoped to take a ship to Cork. O'Connor returned to Ireland but Danby, having attracted some local patrons, remained in Bristol. Despite having declared himself 'an English artist', his work shows the influence of O'Connor and indeed of the eighteenth-century Irish landscapists Thomas Roberts and William Ashford.

In 1814 Danby married an illiterate girl and began

what he described as 'a precarious and unhappy life'. He spent eleven years in Bristol before being forced to flee from his creditors. In 1824 he moved to London, and the following year he made a short trip to Norway. His paintings were much admired, but in 1829 he was defeated for election to full membership of the Royal Academy by one vote, by John Constable. Danby's private life had become a cause for scandal and, 'on the brink of ruin', he left for Paris with his mistress, the governess of his children; the children joined them before long, having been deserted by their mother. For the next ten years Danby's family lived in poverty in various European cities. Danby returned to London in 1839, and in 1846 he moved to Devon, where he spent the rest of his life.

Disappointed Love is one of the most popular pictures in the Victoria and Albert Museum. It was the first work shown by Danby at the Royal Academy in London. One critic observed that 'a deep, gloomy and pathetic influence pervades the picture', while another praised the artist's 'poetical invention'. Danby was still in his twenties, and this picture showed 'how from the first the painter had a higher aim than mere landscape painting; sought indeed to treat his picture as a poem'. This type of sentimental painting was a difficult theme for an

artist because it could easily become mawkish. Danby's success is his clever composition: the sad pose of the disappointed lover attracts the viewer's sympathy before attention is diverted to the details of the torn pieces of a letter, the miniature portrait, the loose bodice strap and the tear in her dress. Like many of Danby's exhibition paintings, *Disappointed Love* is very dark, and the deep vegetation of brambles and drooping plants serves to highlight the young lady in the muslin dress. It has been suggested that the subject of the picture may have been inspired by two of Samuel Taylor Coleridge's poems, 'The Picture: or the Lover's Resolution' and 'To an Unfortunate Woman, Whom the Author Had Known in the Days of Her Innocence', both of which were published in Bristol in the volume *Sibylline Leaves* (1817).

Strickland 1913; Adams 1973; Greenacre 1973, 1988; Crookshank and Glin 1978.

GEORGE PETRIE
(1789–1866) (SEE P 70)

The Irish tradition of watercolours and drawings dates only from the 1690s, when the English artist and antiquary Francis Place (1647–1728) visited Dublin, Drogheda, Kilkenny and Waterford. During the nineteenth century the tradition was maintained by many talented artists, most notably George Petrie. He was born in Dublin in 1789, the only child of James Petrie, a miniature painter, and his wife Elizabeth Simpson, both of Scottish parentage. He studied with his father and at the Dublin Society Schools, where in 1805 he won a silver medal for figure drawing. Landscape painting interested him particularly, and he made many sketching trips in Ireland, painting places of scenic beauty, antiquities and folk customs of the people. In 1813 he travelled to London with Francis Danby and James Arthur O'Connor, with whom he had trained at the Dublin Society Schools. There he visited the major private and public collections before returning to Dublin at his father's request. He resumed his travels in Ireland, where he painted watercolour views, especially of Counties Dublin, Wicklow and Kerry. Although he was a slow, fastidious worker, the accuracy of his pencil drawings of old castles, churches, monasteries and graveyards give them an important value for the study of archaeology. For example, during a tour of the west of Ireland in 1818 he visited the ancient monastic site of Clonmacnoise, County Offaly (then King's County), and made over three hundred drawings of its monuments, onto which he transcribed their inscriptions.

In 1816 Petrie sent two landscapes of County Wicklow to the Royal Academy exhibition in London, the only time he showed there. He visited the Aran Islands for the first time in 1821, and throughout the 1820s he painted many illustrations for travel books about Ireland. In 1826 he was elected an associate of the Royal Hibernian Academy, Dublin, and he became a member two years later, the first artist who painted exclusively in watercolours to be so honoured. The RHA appointed Petrie their librarian in 1829, and in 1833 he joined the Ordnance Survey of Ireland as head of the Antiquities Section. He made numerous scholarly contributions to the *Transactions of the Royal Irish Academy*, wrote a treatise on 'The Ecclesiastical Architecture of Ireland' (1845), and arising from his special interest in Irish songs and music he published *The Petrie Collection of the Native Music of Ireland* (1855). In 1857 Petrie was elected president of the RHA amid acrimony following a schism that had lasted for nearly one year. A Government Inquiry into the academy's affairs gave rise to the granting of a new charter, which increased the membership from fourteen to thirty, leaving the number of associates unchanged at ten. Petrie objected to some of the terms of the charter, and when it was accepted by the membership in 1859 he resigned the presidency. He died in Dublin in 1866, and a retrospective show of nearly one hundred of his watercolours was held that year during the RHA exhibition.

The Last Circuit of Pilgrims at Clonmacnoise, Co. Offaly was painted for the album of a Mrs Haldiman and exhibited at the RHA in 1828. Petrie painted a larger version for the Royal Irish Art Union about ten years later (now in the National Gallery of Ireland), which has fewer figures and a ruin with an elaborate gateway on the left, instead of the tree. The pilgrims went to Clonmacnoise on 'Pattern Day', the feast day in June of the patron saint, Ciarán (died AD 545). The monastic site was destroyed during the Reformation, that great religious revolution of the sixteenth century, but the pilgrims observed a much older tradition. They emerge, as if from graves, to signal the destruction of the culture of Celtic Ireland. Petrie commented in his journal: 'There is not, perhaps, in Europe, a spot where the feeling heart would find more matter for melancholy reflection than among the ancient churches of Clonmacnoise.'

Stokes 1868; Strickland 1913; Crookshank and Glin 1978; Murray 1980; Sheehy 1980 (1) & (2); Wood 1984; Butler 1984, 1990; Gillespie, Mooney and Ryan 1986; Croke et al 1991; Gillespie 1993.

ANDREW NICHOLL
(1804–86) (SEE P 71)

Andrew Nicholl's watercolours of wild flowers are among the most popular images produced in Ireland in the nineteenth century. He was born in Belfast, the second son of a boot and shoe maker. He undertook no formal artistic training but he probably received some instruction from his elder brother, William, who was an amateur painter. When he was about eighteen, Nicholl began a seven-year apprenticeship as a compositor with a Belfast printer by the name of Francis Dalzell Finlay, who in 1824 launched a newspaper called *The Northern Whig*. In 1828 Nicholl completed a series of 101 watercolours of the Antrim coast. In Belfast about 1830 he met his main patron, James Emerson, later, by marriage, James Emerson Tennent, who took him to London. There he spent many hours copying paintings at the Dulwich Picture Gallery, which then held the only old master collection on public view in the city. He was particularly influenced by the work of Aelbert Cuyp, Peter de Wint and Copley Fielding, and by the watercolour techniques of J M W Turner. On his return to Belfast he established himself as a landscape painter and began to take some pupils.

In 1832 Nicholl exhibited for the first time at both the Royal Academy, London, and the Royal Hibernian Academy, Dublin. He received commissions to make a series of drawings in the western highlands of Scotland (1832) and another series published as *Five Views of the Dublin and Kingstown Railway* (1834). He was fascinated by Irish antiquities, such as megalithic tombs, round towers and castles, and he made a series of drawings of topographical or antiquarian interest. He was acquainted with the prominent artist and antiquary George Petrie (1790–1866), and with Henry O'Neill (1798–1880) with whom he collaborated on *Fourteen Views in the County of Wicklow* (1835). Nicholl contributed to the *Dublin Penny Journal* and was one of a team of artists working between about 1834 and 1840 on *Hall's Ireland* (1841–3), which included over one hundred engravings after his drawings. He was elected an associate of the Royal Hibernian Academy in 1837 and a full member in 1860.

Nicholl moved regularly between London, Belfast and Dublin until 1846, when he decided to accept a position as 'teacher of landscape painting, scientific drawing and design' at the Colombo Academy in Ceylon. Sir James Emerson Tennent had been appointed Colonial Secretary for Ceylon in 1845 and had encouraged Nicholl to travel with him. Nicholl was probably back living in London by 1849 when he exhibited a series of views of Ceylon at the Royal Academy. His later career is not well documented, and as he rarely dated his work it is difficult to establish a chronology from his extensive output. He died in London, aged eighty-three, in 1886.

During the 1830s Nicholl produced many watercolours of an original type, usually depicting a bank of wild flowers, with a landscape or seascape in the background. His colourful poppies, daisies and marigolds are a delight, and the effect of distance is created by the painting technique of scraping or cutting through a layer of colour in order to expose an underlying layer or layers of colour. *A Bank of Flowers, with a View of Bray, Co. Wicklow* is inscribed on the verso: 'Bray and the Valley of the Dargle from Killiney Hill, Co. Dublin.' It is signed 'A Nicholl RHA', and while this would suggest that it was painted after 1860 when he was elected to full RHA membership, it is more likely that the signature was added later, and not necessarily by Nicholl himself.

Strickland 1913; Barrett 1971; Andrew Nicholl 1973; Crookshank and Glin 1978; Adams 1984; Anglesea 1989; Butler 1990; Croke et al 1991.

JAMES ARTHUR O'CONNOR
(c. 1792–1841) (SEE P 72–73)

A Thunderstorm: the Frightened Wagoner is one of James Arthur O'Connor's finest works. It was painted during his late romantic phase and shows a wagoner standing isolated in a wooded landscape, frightened by thunder and lightning. O'Connor has used every possible device to emphasise the theatrical quality of the incident. The awesome power of nature is evoked by the windswept tree, the bolt of lightning, the noisy waterfall, and the puny size of the wagoner and his horses against the landscape. The picture complies with the aesthetic requirements of Edmund Burke's theories on the sublime and the beautiful. The 'sublime' was that awe-inspiring feeling experienced in the face of magnificent natural phenomena. O'Connor adds another dimension as he stimulates the viewer's sympathy for the frightened wagoner by his use of dramatic lighting, agitated movement and bold brushwork.

O'Connor was born in Dublin, probably in 1792, the son of a print-seller and engraver. It would appear that he was self-taught as an artist, and there is no contemporary evidence to support the traditional view that he studied under William Sadler and at the Dublin Society Drawing Schools. He became friendly with the artists George Petrie and Francis Danby, and they went to London together in 1813. This was the trend among talented Irish artists at the time, there being little patronage available at home. Although Danby remained in Bristol, Petrie returned to Ireland at his father's request, and O'Connor returned after a few months in order to support his orphaned sisters. O'Connor remained in Ireland for about ten years, working as a landscape painter, but there was little demand for his work, and in 1822 he moved back to London, accompanied by his wife Anastatia.

In London O'Connor exhibited at the Royal Academy, the British Institution and the Society of British Artists. He showed landscapes, including Irish scenes and views of the south of England. In 1826 he travelled to Brussels, where he remained for one year. He was influenced particularly by the Dutch landscapists Ruisdael and Hobbema, the French artist Claude Lorrain, and the English artist Thomas Gainsborough. O'Connor's subject matter was dominated, however, by the magnificence and romanticism of the Irish landscape, especially that of County Wicklow. He may have returned to Ireland in 1828, and he certainly spent a few months there in 1830. He travelled to Paris in 1832, and throughout Germany the following year. Many of his best works were painted about this time, including *A Thunderstorm: the Frightened Wagoner*. Contemporaries of O'Connor concur that he was a pleasant and agreeable man who, through lack of purchasers for his landscapes, was forced to live in poverty. He died in 1841, leaving his wife in such 'circumstances of embarrassment' that his friends felt compelled to arrange a subscription fund to support her.

Strickland 1913; Crookshank and Glin 1978; Hutchinson 1985, 1989–90.

WILLIAM MULREADY
(1786–1863) (SEE P 74–75)

The charming paintings of William Mulready have justifiably retained the popularity they enjoyed during his successful career as a Royal Academician in London. Mulready was born in Ennis, County Clare, the son of a leather-breeches maker who emigrated to London with his family about 1792. He was sensitive about his poor Irish background, which was a handicap to a young artist whose career was marked by a determined drive up the social ladder of English society. He trained for a year in the studio of the sculptor Thomas Banks, before enrolling at the Royal Academy Schools in London where, at the age of sixteen, he won the silver palette of the Society of Arts. At eighteen he married Elizabeth Varley, an artist and sister of John Varley, the landscape painter. The marriage broke up in 1810 due, his wife alleged, to Mulready's tendency to violence and infidelity. Unlike the scandal-ridden Francis Danby, Mulready succeeded in keeping his private difficulties away from the public eye. He was elected an associate member of the Royal Academy in 1815 and a full member the following year. In 1855 he was awarded the *Légion d'Honneur* when he exhibited at the Exposition Universelle in Paris, and he was greatly admired by the Pre-Raphaelites. He made a good living by selling his paintings and by teaching and illustrating children's books, although he never travelled outside England. He exhibited at the Royal Academy nearly every year until his death in 1863.

Mulready was a master of so-called subject painting. His works are attractive in theme and technically competent, and it would be easy to make the mistake of dismissing them as superficial. His subject paintings are carefully worked presentations, which often contain a moralising message. The narrative is sometimes light-hearted, at other times dark and seamy. *Choosing the Wedding Gown* caused a sensation when it was first exhibited, and it was regarded by John Ruskin as a rival to the paintings of the best masters of Holland. The picture is based on designs for Van Voorst's 1843 edition of Oliver Goldsmith's *The Vicar of Wakefield*, which Mulready illustrated. Goldsmith related how the vicar chose his wife with the same care that she adopted when choosing the material for her wedding gown. The painting has been described as an essay on the themes of dialogue and transaction. The composition is drawn together 'by a sequence of controlled looks and gestures': the shopkeeper is looking at the vicar, who is watching the reaction of the fiancée to the cloth proposed for her wedding gown; in the background a young boy is in dialogue with the shopkeeper's wife. The painting is a masterpiece of details: the elaborate wallpaper, the sleeping dog, the bunch of snowdrops, the items of shopping in the boy's pocket, the lady's head-dress, the glove that has fallen to the floor.

It was Mulready's procedure to work up his compositions in a series of preparatory drawings. He first prepared ink or pencil sketches, then a cartoon-like finished drawing in chalk, and finally an oil study. The polished and highly crafted effect of his finished oils, as evidenced in *Choosing the Wedding Gown*, was the result of careful and dedicated artistic practice.

Strickland 1913; Crookshank and Glin 1978; Heleniak 1980; Pointon 1986; Croke et al *1991.*

ERSKINE NICOL
(1825–1904) (SEE P 77)

Erskine Nicol was born in Leith, Scotland, in 1825, and studied art at the Trustee's Academy, Edinburgh, where his teachers included Sir William Allan and Thomas Duncan. He worked for some time at the Leith Academy before moving to Ireland for a four-year period between 1846 and 1850. There he received a teaching appointment from the Department of Science and Art in Dublin. The pictures Nicol painted during his Irish sojourn explore the social life of the country, often in a humorous and satirical manner. Many of the Irish characters in his well-composed and meticulously executed genre scenes are not far removed from the world of the stage and farce. He could be offensive and coarse, stretching his humorous spirit too far.

Nicol returned to Edinburgh in 1850 and was elected an associate of the Royal Scottish Academy in 1855 and a full academician in 1859. While living in Scotland he continued to paint Irish scenes. He had an excellent memory for detail and he posed his studio models in a theatrical way, which heightened the emotional response evoked by his subjects. The racial humour of many of Nicol's Irish scenes sometimes yields to sympathy and compassion. The pathetic scene in *An Ejected Family* (painted in Edinburgh in 1853) shows a young workman with his wife and baby, an elderly man, his head bowed, holding a long walking stick, and two children to the right lying against a grass mound and staring at the

thatched cottage from which the family has been evicted. The young labourer is characterised in the stereotype Irish costume of breeches, long coat, shirt and hat. He is staring at his former home with a forlorn expression on his face. His wife looks up at him for guidance, but he appears to have none to offer.

The strongest feature of Nicol's paintings is frequently the landscape background. In *An Ejected Family* the leaden sky overhangs a brooding landscape, which has been rendered precisely and efficiently. The colours are strong and luminous, the effects of light and shade worked to suit the sad mood of the scene.

Despite the horror of events in poverty-stricken Ireland in the mid-nineteenth century, an era of famine, evictions and emigration, few oil paintings were produced that provide a visual record of historical happenings. Local artists produced some paintings from their own areas, and magazines like the *Illustrated London News* sent artists into the most depressed regions to produce graphic illustrations to accompany the reports of their correspondents. Professional artists painting works for exhibition at official shows, like the annual exhibitions of the Royal Scottish Academy, Edinburgh, the Royal Academy, London, and the Royal Hibernian Academy, Dublin, were careful to avoid overtly political statements that could be viewed as criticism

of the British government. *An Ejected Family*, which was shown at the Royal Scottish Academy exhibition in 1854 (No. 364), was not interpreted as a political and social statement about evictions because it was disguised as an emotional, stage-Irish scene.

Nicol settled finally in London in 1863, and in 1868 he was elected an associate of the Royal Academy. He retired due to ill-health in 1885, and died in Feltham, Middlesex, in 1904.

Caw 1908; Irwin 1975; Crookshank and Glin 1978; Anglesea 1989; Macmillan 1990.

JAMES MAHONY
(1810–79) (SEE P 76)

James Mahony, sometimes spelt Mahoney, was born in Cork in 1810, the son of a carpenter. He is reputed to have spent a number of years in Rome before returning to Cork in 1842, where he established himself as a watercolourist. He travelled again in Europe in the late 1840s, and was elected an associate of the Royal Hibernian Academy, Dublin, in 1856. He moved to London in 1859, where he gained a reputation as an excellent watercolourist and illustrator. He died of apoplexy in 1879.

The Irish Industrial Exhibition of 1853 was promoted and financed by the railway magnate William Dargan, in an attempt to accelerate the industrialisation of the country by focusing public attention on the benefits of education and technological advancement. The Royal Dublin Society had organised modest triennial exhibitions since 1834, and there was a large exhibition in Cork in 1852, but it was the success of the London Great Exhibition of 1851 that most prompted the efforts of Dargan and his enthusiastic committee. The temporary building constructed to house the Irish Industrial Exhibition was sited on the lawn of Leinster House, the headquarters of the Royal Dublin Society. Designed by the Sligo-born architect John Benson, the building was known as the Temple of Industry, and covered an area of six and a half acres (2.6 hectares). Approximately one million visitors

attended the exhibition, which was open to the public from 13 May to 31 October 1853. The Great Hall, built of wood, glass and iron, was an enormous structure, 425 feet (129.5 metres) long, 100 feet (30.5 metres) wide and 105 feet (32 metres) high. Following the example of the Cork exhibition of 1852, which unlike the Great Exhibition in London had a special section devoted to fine arts, the organisers in Dublin decided that their display should incorporate Irish antiquities, contemporary art and a loan exhibition of old master paintings. This feature was such a success that when the exhibition closed it was decided to honour Dargan by contributing some funds to the Irish Institution, which had been formed in 1853 for the purpose of establishing a National Gallery. Legislation was enacted in 1854, a board of governors and guardians was appointed, some paintings were acquired, a building was constructed on Leinster Lawn, and the National Gallery of Ireland opened to the public in 1864.

Mahony's finely executed and meticulously detailed large watercolour *The Visit by Queen Victoria and Prince Albert to the Fine Art Hall of the Irish Industrial Exhibition* illustrates the second of four visits by the royal couple on consecutive days between 30 August and 2 September 1853. On the morning of 31 August, before the crowds were permitted entry, Queen Victoria and Prince Albert toured the Fine Art Hall, which housed a display of

contemporary art. The hall was 325 feet (99 metres) long, 40 feet (12 metres) wide and 38 feet (11.5 metres) high. Prince Albert complimented John Benson on the way he had controlled the lighting of the Picture Gallery. Mahony has placed the royal couple in the centre of the picture; Dargan, who was presented to Queen Victoria, is standing on the left, and the Prince of Wales and Prince Alfred are to the right, wearing kilts. The red-cloaked figures in the left foreground are the members of the Royal Hibernian Academy. Many of the paintings and sculptures in the hall have been identified, but Mahony has taken liberties by omitting some works and including others that were not in the exhibition. In the border of the watercolour there is a coat of arms and a relief medallion of Dargan, garlanded with shamrock and inscribed 'An uair is dorcha sé an uair roimh breacadh an lae' (The darkest hour is the hour before the dawn). Mahony's picture is an optimistic historical document, recording a great and inspiring occasion which, it was hoped, would encourage prospects of a more prosperous future for Ireland.

Strickland 1913; Bence-Jones 1973; Crookshank and Glin 1978; Crookshank 1979; De Courcy 1985; Croke et al 1991; Netzer 1993.

MICHAEL ANGELO HAYES
(1820–77) (SEE P 78–79)

There can be no doubt that in naming their son after the great master of the Italian High Renaissance, Michael Angelo Hayes's parents intended that he should become a painter. He was born in Waterford and trained with his father, Edward Hayes (1797–1864), a portrait painter in watercolour and miniature. The younger Hayes was a talented draughtsman and, when he was aged sixteen, the businessman Charles Bianconi paid for the publication in London of his drawings entitled *Car-Travelling in the South of Ireland in the Year 1836*. He specialised as a painter of horses and military subjects, and exhibited at the Royal Hibernian Academy in Dublin for the first time in 1837. In 1842 he was appointed painter-in-ordinary to the Lord Lieutenant. Hayes spent the next few years in London, where he exhibited watercolours. On his return to Dublin he became involved in the administration of the Royal Hibernian Academy and in city politics. He was elected an associate member of the RHA in 1853, a full member the following year, and secretary in 1856. The affairs of the RHA were in a chaotic state at the time, and Hayes and others attempted to resolve the situation. A schism occurred in 1856–7 and Hayes was removed from his post. He was reinstated in 1860 following the grant of a new charter to the academy. Hayes became secretary to the Lord Mayor of Dublin — his brother-in-law, Peter McSwiney — and he was appointed City Marshal in

1867. He died in 1877 in a tragic drowning accident.

Hayes painted in oils but he was most accomplished as a watercolourist. *Sackville Street, Dublin* presents a view of Dublin's premier street in the 1850s. (It was renamed O'Connell Street in 1924, after 'The Liberator', Daniel O'Connell, 1775–1847.) The street was broadened about 1750 to its present width of 150 feet (46 metres). Hayes's view shows the portico of the General Post Office (designed by Francis Johnston, 1814–18) on the left, the Nelson Pillar (designed by William Wilkins, 1808, and destroyed following a bomb explosion, 1966) to the centre left, the Imperial Hotel in the centre, and to the right the recently constructed store of McSwiney, Delany and Company (designed by William Deane Butler, 1853). The store is featured prominently because it belonged to Hayes's brother-in-law. The premises was acquired in 1884 by Clery's, whose present store was constructed between 1919 and 1922.

The scene offers a veritable social documentary of life in Dublin. Shoppers go about their business while horse-drawn carriages and carts make their way along the street. The horse-drawn No. 2 omnibus from Portobello is about to reach its terminus at the Nelson Pillar. Hayes made a particular study of horses in motion, and in 1876 he published his conclusions in an illustrated pamphlet, *The Delineation of Animals in Rapid Motion*. The

contemporary dress fashions for ladies, gentlemen and children can also be examined by close inspection of the scene. *Sackville Street, Dublin* was probably painted in 1853 because it was exhibited at the Royal Hibernian Academy exhibition of 1854, and the McSwiney, Delany and Company store was constructed the previous year. Hayes's view gained widespread popularity when it was lithographed by W Simpson and published by Day and Son, London.

Strickland 1913; Crookshank and Glin 1978; De Courcy and Maher 1985; Croke et al 1991.

DANIEL MACLISE
(1806–1870) (SEE P 80–81)

Daniel Maclise was born in Cork in 1806, the son of a shoemaker. He worked in a bank for a short time before deciding, at the age of twenty, to enrol in the recently established School of Art in Cork, a city that gained an enviable reputation in the early nineteenth century through the work of distinguished physicians, writers, lawyers and antiquaries. Maclise first achieved recognition as a portrait draughtsman. Although he worked mainly in Dublin and Cork, he undertook a number of sketching tours throughout Ireland. In 1825 he made a pencil drawing of Sir Walter Scott, when the famous writer was on a visit to Cork. He then showed entrepreneurial flair in producing a successful edition of lithographs from his drawing. Scott was impressed by the young artist and encouraged him to pursue his chosen career.

Maclise moved to London in 1827, where he supported himself by producing portrait drawings, including a series of over eighty for *Fraser's Magazine*, which were later published as *The Gallery of Illustrious Literary Characters*. He was a bookish man who loved to research his subjects in detail. He began to acquire a reputation as a history painter, and was influenced by French painting on visits to Paris, and also by his German contemporaries. He moved in literary circles in London, and William Thackeray and Charles Dickens were among his many friends. Maclise painted Irish subjects regularly and was strongly

nationalist in sentiment. In 1844 he was one of six artists selected to decorate the houses of parliament at Westminster, and his career culminated in his large murals there, executed between 1858 and 1865, including *The Meeting of Wellington and Blücher* (1861) and *The Death of Nelson* (1865). He was disappointed with the level of public attention that these major works received, and he became a recluse, refusing the presidency of the Royal Academy in 1866 and also the offer of a knighthood. He died in London in 1870.

The Marriage of Strongbow and Aoife, which was exhibited at the Royal Academy, London, in 1854, is one of Maclise's most accomplished paintings. This huge, dramatic picture tells the story of the King of Leinster, Dermot MacMurrough, who sought the assistance of the Norman leader Richard de Clare, known as Strongbow, to support him in his battles against rival Irish lords. In return for Strongbow's help, MacMurrough promised the Norman that he could marry his daughter Aoife and, after his death, become King of Leinster. The Normans arrived in Ireland in 1169 and besieged Wexford. The following year Strongbow arrived and captured Waterford. Maclise's painting depicts the wedding of Strongbow and Aoife which took place on the blood-soaked battlefield after the capture of Waterford. In the foreground lie the heaped bodies of the dead Irish. Maclise consulted his antiquary friends in Ireland to

ensure that all the details of the costumes, metalwork, weaponry and so forth were archaeologically correct.

The contemporary impact of Maclise's great painting should not be forgotten. Only a few years beforehand, in 1848, the rebellion of the Young Irelanders had been quashed, and this painting served as a reminder to its viewers that the history of foreign domination of Ireland was a long one. This is symbolised by the figure of the old harper whose harp-strings are broken, and by the arrogant pose of Strongbow, whose foot tramples a fallen cross decorated with early Christian motifs.

Strickland 1913; Ormond 1968; Crookshank and Glin 1969, 1978; Turpin 1970; White 1970; Ormond and Turpin 1972; Wynne 1983; Gillespie, Mooney and Ryan 1986; Croke et al 1991.

EDWIN HAYES
(1820–1904) (SEE P 82–83)

Although Ireland is an island and fishing has always been an important industry, there have been few marine painters of quality. One of the best was Edwin Hayes who was born in Bristol, England, in 1820. His family moved to Ireland when he was about thirteen and his father opened a hotel in the centre of Dublin city. He studied at the Dublin Society Schools and decided that he would become a marine painter. In a determined effort to become acquainted with the sea he sailed around the Irish coast in a yacht, which he used as his studio. He then took a job as a steward's boy aboard a ship bound for America, an experience that served him well in his artistic career. In 1842 he exhibited at the Royal Hibernian Academy, Dublin, for the first time, and he contributed to all but five of the next sixty-three annual exhibitions, a total of 255 pictures. For a time Hayes was apprenticed to an artist called Telbin, who specialised in painting scenery for theatres. In 1853 he began exhibiting at the British Institution, London, and he moved to London permanently in 1854. That same year he exhibited at the Royal Academy, and he became a regular and prolific contributor to successive annual exhibitions. He was elected an associate of the Royal Institute of Painters in Watercolours in 1860 and a member in 1863. He had been elected an associate of the RHA in 1853, and in 1871 he was made a member. Apart from sea views of the coasts of

Ireland and Great Britain, Hayes completed many pictures of subjects witnessed in France, Belgium, Holland and Italy. A one-man show of 150 of his works took place in London in 1888. He died in 1904, aged eighty-four.

Man Overboard is an intense painting of an incident that took place on the maiden voyage of HMS *Shannon*, under Captain W Peel, VC, when the master's assistant, J Coaker, fell overboard off the Cape of Good Hope in May 1857. It is probable that Coaker drowned, because the lifeboat crew members are depicted expressing horror and disbelief as the sailor fails to reach the lifebelt they have thrown to him. Hayes uses the device of the oars in the foreground to focus attention on the frightened crew. A negro sailor stands in the prow of the boat, his arm outstretched, while another sailor attempts to reach the drowning man by extending his grappling hook. *Man Overboard*, which was exhibited at the Royal Academy in 1862, is a remarkable example of Hayes's ability to convey the awesome power of the sea. The sailors, who are anxiously gathered on the decks and in the rigging of the ship, watch helplessly as the tragedy unfolds before them, the dark waves and the leaden sky emphasising the sadness of the moment. As in many of Hayes's works, however, there is a note of hope, here depicted in the sun that is attempting to break through the clouds near the centre of the painting. This is a typical feature of

academic pictures exhibited in Victorian England, where artists were aware of the need to elevate popular taste and to encourage the hope that a life of honest endeavour would lead to a heavenly reward.

Strickland 1913; Barrett 1971; Crookshank and Glin 1978; Wynne 1983; Wood 1984.

MATTHEW JAMES LAWLESS
(1837–64) (SEE P 84–85)

The promising career of Matthew James Lawless was cut short by his death in 1864 from consumption, at the young age of twenty-nine years. Lawless was born in Dublin, the son of a prosperous Catholic solicitor. His family moved to London in 1845 and he attended a private school near Bath. He was a delicate child and his schooling was 'interrupted by deafness and ill-health'. He studied art in London under Francis Stephen Cary, James Mathews Leigh, and with the Irish painter Henry O'Neill. He also spent time at the Langham School in London. His father considered that he 'should devote himself to illustration — which . . . he thought promised more remuneration than picture painting'. Lawless was an able draughtsman and contributed illustrations to a number of periodicals, including *London Society*, *Once a Week* and *Punch*. He exhibited at the Royal Academy, London, each year from 1858 to 1863. The oil paintings that he submitted were narrative and genre scenes, with titles like *A Cavalier in his Cups*, *A Man About Town* and *The Widow of Hogarth Selling her Husband's Engravings*. The whereabouts of all his oil paintings, with the exception of *The Sick Call*, is unknown. His talent as an easel painter can, consequently, be judged only by this one work. It was exhibited at the Royal Academy in 1863, the year before his death. The theme of the painting is most likely a conscious reflection on his state of ill-health.

He was a pious artist, described by one contemporary as 'a rattling good Catholic'. The full title of the picture is *The Sick Call: Is any man sick among you? Let them bring in the priest of the Church, and let them pray over him, anointing him with oil in the name of the Lord* (James, 5:14) and it may have been prompted by the experience of receiving the Catholic sacrament of Extreme unction.

Lawless was influenced by the French artists Couture, Delaroche, Gérome, Tissot and particularly Meissonier. He met Meissonier about 1860 while on a trip to Paris, and he may also have visited Belgium at this time. Lawless's technique is indebted to the highly polished method of Meissonier's finely executed panel paintings. The absorbing narrative quality, the subtle colours, the architectural background, the attention to detail and the excellent composition, mark *The Sick Call* as a minor masterpiece. The prayerful priest, attended by his robed acolytes, has been called out by the weeping woman to attend to a dying person. A memoir written in 1898 tells us that the architectural setting was inspired by a view of the city of Prague. Some of the buildings are certainly close in style to prominent sites in Prague, but there is also something of the mood of the medieval city of Bruges, which Lawless may have visited. The name of the model for the priest figure in the painting was Richardson, and it has been proposed that he was Sir Benjamin Ward

Richardson, a prominent London physician who was appointed to the Royal Infirmary for Diseases of the Chest in 1856. If he was Lawless's doctor during his last years of deteriorating health, it would have been appropriate to have cast him in the ministering role. Whether this is true, or idle speculation, *The Sick Call* was a popular success when exhibited in Manchester in 1887, and it was engraved for the *Illustrated London News*.

Strickland 1913; Crookshank and Glin 1978; Wynne 1983; Bailey 1987.

FREDERIC WILLIAM BURTON
(1816–1900) (SEE P 86–87)

Sir Frederic William Burton worked almost exclusively in watercolour, although his style was so tight and controlled that his works, at first glance, have the appearance of oil paintings. This is especially true of his masterpiece, *Hellelil and Hildebrand* or *The Meeting on the Turret Stairs*, which illustrates an episode from a Danish ballad, translated by Whitley Stokes and published in *Fraser's Magazine* of January 1855. Hellelil fell in love with Hildebrand, the Prince of Engellend, who was one of her bodyguards. Her father did not approve, and ordered his sons to kill Hildebrand. Burton depicts the final meeting of the lovers. The drama ended when Hildebrand, having slain seven of Hellelil's brothers, died at the hand of the youngest. The writer George Eliot wrote to Burton: 'The subject might have been the most vulgar thing in the world — the Artist has raised it to the highest pitch of emotion.' Burton worked slowly and meticulously, preparing numerous studies in pencil and watercolour for each of his major works; there are several dozen known studies for *Hellelil and Hildebrand*. It is tempting to consider Burton as Ireland's Pre-Raphaelite artist, but this would be a mistake. He was influenced by Dante Gabriel Rossetti in particular, and although he shared similar ideals, he was never a member of the Pre-Raphaelite movement.

Burton was born in Corofin, County Clare, in 1816, the son of an amateur landscape painter. He studied drawing at the Dublin Society Schools with Henry Brocas and Robert West. In 1837, at the age of twenty-one, he was elected an associate of the Royal Hibernian Academy in Dublin, and he became a full member in 1839. Burton's interests were scholarly, and he was friendly with leading historians, writers and antiquaries, like Thomas Davis, Lord Dunraven, Professor Eugene O'Curry, Sir Samuel Ferguson and George Petrie. He visited the Aran Islands with Petrie on a number of occasions between 1838 and 1841. Burton spent seven years in Germany, from 1851 to 1858, where he immersed himself in art research. He was a member of the Royal Irish Academy, a founder member of the Archaeological Society of Ireland, and a Fellow of the Royal Society of Antiquaries of Ireland. He ceased to paint following his appointment in 1874 as the third director of the National Gallery, London. This appointment was a surprise to the English public, but Burton more than justified the position by organising a succession of astute acquisitions, which greatly enhanced the National Gallery's collection. During his twenty years as director, the gallery acquired such celebrated works as Leonardo's *The Virgin of the Rocks*, Holbein's *The Ambassadors*, Van Dyck's *Charles I on Horseback*, Vermeer's *A Young Woman Standing at a Virginal*, and Hogarth's *The Shrimp Girl*. Burton was knighted in 1884. He was unmarried but he reared the orphan family of his brother, the Reverend Robert Burton, who had died young. Burton himself died in London in 1900 and was buried in Mount Jerome Cemetery, Dublin.

Strickland 1913; Crookshank and Glin 1969, 1978; Potterton 1974; MacFarlane 1976; Gillespie, Mooney and Ryan 1986; Bourke 1987; Butler 1990; Croke et al 1991.

NATHANIEL HONE THE YOUNGER
(1831–1917) (SEE P 88)

The *Boundary Fence, Forest of Fontainebleau* is one of the most important early works by Nathaniel Hone the Younger, the Dublin-born painter of the Barbizon School. He was a grand-nephew of Nathaniel Hone the Elder (1718–84). Hone the Younger was born into a wealthy Dublin family. He studied engineering and science at Trinity College, Dublin, graduating with honours in 1850. He began his career as an engineer on the railways in Ireland, but then changed his mind and in 1853 headed off to Paris to study art. This was to be a significant decision for the history of Irish painting. Hitherto, artists who had travelled abroad to study had usually gone to England or to Italy. Hone's training in Paris began with intensive study of the life model and long hours of copying the works of the old masters in the Louvre. He studied with Thomas Couture, who instilled in him the importance of spontaneity in painting, good technique, keen draughtsmanship and the necessity of making painted sketches. While in Paris he became acquainted with many notable artists, including Édouard Manet and George Watts. In about 1857 he settled in Barbizon, a small village on the southern edge of the forest of Fontainebleau which had become popular with those French artists who favoured landscape painting. Hone stayed at Barbizon for nearly thirteen years and met all the celebrated painters who gathered there, Corot, Courbet, Harpignies, Jacque, Millet, Rousseau and Ziem. These artists dedicated themselves to careful study of nature and founded a hugely influential school of naturalistic landscape painting.

Hone did not date his work but *The Boundary Fence* is typical of the fashion during the 1860s for forest scenes with deer grazing; Courbet and Sisley each painted works that are close in subject and mood to Hone's picture. He was also influenced by the painting methods of his young artist friends, Bazille, Cézanne, Monet and Renoir, especially their treatment of light. He never became an Impressionist, however, but remained rooted in the spirit of the Barbizon painters. It has been proposed, credibly, that *The Boundary Fence* is the same picture as that exhibited in 1868 at the Paris Salon, entitled *Lisière de bois*. The careful and calculated composition, the confined palette and yet the magnificent array of greens and browns, the atmosphere of light penetrating the dense forest, and the inspired application of paint, make this picture as good as any by the more renowned Barbizon artists.

In 1872, aged forty, Hone returned to Ireland and married Magdalen Jameson of the well-known distillery family. The combined wealth of the Hones and the Jamesons assured the couple of a most comfortable lifestyle and they settled at Malahide in north County Dublin. While he was living in France, Hone had journeyed to Italy, and he continued his travels after his marriage, with trips to England, France, Holland, Greece and Egypt. He became a master of the seascape as well as the landscape, and was the first painter to introduce French naturalism into Irish art, influencing a whole generation of artists. Hone was elected an associate member of the Royal Hibernian Academy, Dublin, in 1879, an academician in 1880, and professor of painting at the academy in 1894. He exhibited at virtually every academy exhibition from 1876 until his death in 1917. In 1901 Sarah Purser organised a joint retrospective exhibition of his works and those of John Butler Yeats. In 1919 Hone's wife bequeathed the entire contents of his studio to the National Gallery of Ireland.

Bodkin 1920; Aspects of Irish Art 1974; Crookshank and Glin 1978; Campbell 1984, 1991 (1); Croke et al 1991.

WILLIAM OSBORNE
(1823–1901) (SEE P 89)

Although Ireland is renowned for the breeding of horses and dogs, there have been few enough animal painters of quality. Michael Angelo Hayes (1820–77) was perhaps the best Irish animal painter, but others of talent include Thomas Robinson (c. 1770–1810), George Nairn (1799–1850) and William Osborne. Born in Dublin in 1823, Osborne was employed as a warehouseman until 1845, when he decided to train as an artist and enrolled at the school of the Royal Hibernian Academy. He established a studio in Pleasants Street in Dublin and exhibited at the annual RHA exhibition for the first time in 1851, exhibiting annually there for forty-one of the next fifty years. He was elected an associate of the RHA in 1854 and a member in 1868. Osborne specialised as a painter of horses and especially of dogs. He had an excellent knowledge of the anatomy of animals and his groups of dogs are painted with sympathy and understanding. He delighted in showing the character of animals, posing them in suitable settings to portray their alertness and usefulness to their owners.

Osborne was commissioned by Irish huntsmen to paint group portraits and individual studies of their prize animals. He exhibited many paintings of hunting dogs: setters, terriers, retrievers,

staghounds, bloodhounds and greyhounds. He also painted some pictures of hawks, and of lions and tigers in Dublin Zoo. *The Ward Hunt*, painted in 1873, shows the famous North County Dublin stag hunt, known today as the Ward Hunt, gathered ceremoniously for their group portrait. The Ward Union Hunt was founded about 1854 with the amalgamation of the Ward Hounds (established in 1830) and the Dublin Garrison Staghounds (formerly Lord Howth's Staghounds, brought by him from England in 1840). The formality of the hunt is emphasised in Osborne's picture by the dress of the proud gentlemen, with their jackets and hats or riding caps. Their horses are magnificent animals, and the staghounds form a well-trained pack. The huntsman was Charles Brindley (1817–79), who is shown in the foreground, the ninth rider from the left of the picture. Each of the members of the hunt can be identified from an engraving published by Thomas Cranfield of Grafton Street, Dublin. The twelfth rider from the left is Leonard Morrogh, field master of the Ward Union Hunt from 1866 to 1883. The portraits are good likenesses and demonstrate Osborne's ability in this genre. He continued to have a successful career as an animal painter throughout the 1880s, and he died in Dublin, aged seventy-eight, in 1901.

He was the father of the painter Walter Osborne (1859–1903).

Strickland 1913; Brindley 1923; Greaves 1950; Crookshank and Glin 1978; Wynne 1983.

LADY BUTLER (ELIZABETH THOMPSON)
(1846–1933) (SEE P 90–91)

Elizabeth Thompson was the most famous painter of military subjects in late-nineteenth-century England. She was born in 1846 at Lausanne, Switzerland, to well-to-do parents who moved in artistic circles. Her mother, Christiana, was a talented musician and singer, her father, Thomas, a friend of writers such as Charles Dickens and John Ruskin, and her sister was the poet Alice Meynell. She studied in London at the South Kensington School of Art and in Florence with the painter Giuseppe Bellucci. Her keen interest in European history led to her decision to specialise as a military painter. This was a most unusual choice for a female artist in Victorian England, and acceptance came slowly. She received popular acclaim following the huge success of *The Roll Call* (1874), a painting of Grenadier Guards during the Crimean War. It was acquired by Queen Victoria for the Royal Collection.

In 1877 Elizabeth Thompson married a highly ambitious professional soldier, a Catholic Irishman, Major William Butler. They spent their honeymoon at Glencar, County Kerry, and toured in the west of Ireland. Elizabeth was captivated by the beautiful landscape: 'its freshness, its wild beauty, its entrancing poetry, and the sadness.' She set out to

create a painting that would celebrate her new surroundings. The result was *Listed for the Connaught Rangers* (1878), which was exhibited at the Royal Academy, London, in 1879. The picture shows a British Army recruiting party and two Irish peasants, all of whom are walking directly towards the viewer, while behind them a ruined cottage is evocative of poverty and eviction. One of the peasants, smoking a pipe, is indifferent to the events, but his companion casts a last, sad and thoughtful glance at his homeland. There can be no doubt that the artist was making a political point. She agreed with her husband's view, argued in an essay written in 1878 and entitled 'A Plea for the Peasant', that if the British government was serious about improving recruitment to the Army, the living conditions of Irish peasants would have to be improved. Many young Irishmen were emigrating to America, and those who remained at home were frequently undernourished. In her autobiography, published in 1922, Elizabeth Butler described the men she employed as models for the two peasants in *Listed for the Connaught Rangers*: '. . . the elder of the two had the finer physique, and it was explained to me that this was owing to his having been reared on herrings as well as potatoes,

whereas the other, who lived up in the mountains, away from the sea, had not known the luxury of herrings.'

William Butler's army career was a successful one, despite his critical opinions of British government policy, and he was knighted for his services. Lady Butler travelled with him on his tours of duty in Africa and Canada. The couple had six children and they frequently returned to William's family home in Ireland, Bansha Castle, County Tipperary, and to a house in Delgany, County Wicklow. Their youngest daughter, Eileen, married Viscount Gormanston, and Lady Butler spent the last eleven years of her life in Gormanston Castle, County Meath. She died in 1933 and is buried in Stamullen, County Meath.

McConkey 1986, 1990; Usherwood 1987; Usherwood and Spencer-Smith 1987.

ALOYSIUS O'KELLY
(1851–1926) (SEE P 92)

France held a strong attraction for Irish artists during the second half of the nineteenth century and the early twentieth century. In the 1850s Nathaniel Hone the Younger was the first modern Irish painter to go to Paris to study art. In the next decade the Dublin-born George Joy (1844–1925) enrolled as a student in the city, followed in the 1870s by a number of Irish artists, including Frank O'Meara, Sarah Purser and Aloysius O'Kelly. During the 1880s many Irish artists settled in Paris and Antwerp, for example Roderic O'Conor, John Lavery, Walter Osborne, Richard Moynan and Dermod O'Brien. In the first decade of the twentieth century Paris was host to artists like Paul Henry, Mary Swanzy and William Leech, and during the 1920s to Evie Hone, Mainie Jellett and Norah McGuinness. France was the scene of many exciting developments in painting — academicism, realism, orientalism, naturalism, pleinairism, Impressionism, Fauvism and Cubism. It has been remarked that 'isms' have a tendency to become 'wasms', and Irish painters showed a remarkable eclecticism by their interest and participation in many of these styles. There was no school of 'Irish Impressionists' for example, but there are paintings by Irish artists that were executed in the Impressionist manner. The capacity of Irish-born artists to shift between divergent styles is perhaps best demonstrated in the work of Aloysius O'Kelly.

Aloysius O'Kelly was born in Dublin. He went to Paris in 1874, where he became a student of Léon Bonnat and Jean Léon Gérome at the École des Beaux Arts. From 1876 to 1895 he exhibited harbour, beach and market scenes of Brittany, especially of Concarneau, at the Royal Academy and the Royal Society of British Artists in London, and at the Royal Hibernian Academy in Dublin. Many of these pictures showed O'Kelly's skill at creating tonal harmonies and his assured lightness of touch, which could be described as 'Impressionistic' in style. He also exhibited a small number of scenes from the west of Ireland, based on close observation and a realistic but sensitive approach to his subjects. He worked as a graphic artist for the *Illustrated London News* and produced many drawings of life in Connemara. O'Kelly visited Egypt during the 1880s, where he painted the mosques, bazaars and the desert. The benefit of his academic training is evident in these paintings, which are orientalist in approach, in the manner of his master Gérome. During the 1890s O'Kelly was based in London, and in about 1909 he moved to America. He settled in New York and exhibited at the MacBeth Gallery there. It would appear that he continued to paint Breton subjects based on his earlier sketches. In 1912 he spent much of the year in Maine and he held exhibitions in New York, Chicago and Milwaukee.

Girl in a Meadow is possibly the same picture as that exhibited at the Royal Hibernian Academy in 1889 and titled *Among the Poppies*. It is painted in the 'square-brush' technique promoted by the pleinairist Jules Bastien-Lepage (1848–84), a method involving the use of large, interlocking brushstrokes to create dense paint effects. The identity of the red-haired young girl is not known, but her portrait is delightful. She was perhaps Irish or Breton and is shown, three-quarter length, in a white dress amid a field of poppies and grasses. She has a wistful, abstracted look on her face, her hands joined as if in prayer, and it has been suggested that she is kneeling.

Crookshank and Glin 1978; Campbell 1984; McConkey 1982, 1990.

AUGUSTUS BURKE
(1838–91) (SEE P 93)

Augustus Nicholas Burke was born at Knocknagur, Tuam, County Galway. His family were local landowners and he was educated at a private Catholic school in England. He trained as an artist in London and began exhibiting at the Royal Academy in 1863. In 1869 he moved to Dublin, where he gained a reputation as a fine painter of landscapes, animal studies and portraits. He was elected an associate of the Royal Hibernian Academy, Dublin, in July 1871, and the following month he became a member. Between 1870 and 1891 he exhibited 149 paintings at the RHA's annual exhibitions, and he was professor of painting at the academy from 1879 to 1883.

Burke visited Belgium during the 1860s, and some time between 1870 and 1872 he went to Holland. He was in Pont Aven in Brittany in 1875–6. This was before the widespread popularity of pleinairism, or painting in the open air. Burke's pictures are quite defined, with strong contrasts of light and shadow compared with the diffused quality of the light in the works of *plein-air* painters of the 1880s, such as Aloysius O'Kelly or Frank O'Meara. Burke exhibited fifteen Breton scenes at the RHA between 1876 and 1878. During the 1880s he visited various scenic areas of England and Wales, and he exhibited his landscapes at the RHA, where they were much admired. In May 1882 his brother Thomas Henry Burke, Under-Secretary for Ireland, and Lord Frederick Cavendish, the Chief Secretary, were brutally murdered while walking near the Viceregal Lodge in the Phoenix Park in Dublin. The culprits, members of an extremist nationalist group called the Invincibles, were apprehended following information received from an informant, and in 1883 five men were executed for the crime and eight others were given long jail sentences. Augustus Burke was so horrified by his brother's murder that he left Dublin in 1883 and settled in London. He lived there until 1889 when, due to poor health, he sought the warmer climate of Italy. He died in 1891 at his home in Florence, aged fifty-three.

The Connemara Girl was probably painted in the late 1880s after Burke had moved to London. It is a charming picture of a barefooted young girl wrapped in a shawl and carrying an apron filled with heather. A goat stands on either side of the girl, amid a rugged mountain landscape of rock and heather. Burke has chosen to represent a romanticised view of peasant life in Ireland, perhaps to suit English taste. William Henry Bartlett, the English author and illustrator of travel books, including *Scenery and Antiquities of Ireland*, observed that 'the Connemara Folk carry off the palm for picturesqueness'. Burke obviously agreed. The cult of the proud peasant gained even greater currency after 1900, especially in the works of Jack Butler Yeats, William Orpen, Seán Keating and Charles Lamb.

Strickland 1913; Crookshank and Glin 1978; Campbell 1984; McConkey 1990; Stratton-Ryan 1990–91.

HENRY JONES THADDEUS
(1859–1929) (SEE P 94–95)

Henry Jones Thaddeus was among the many Irish artists to go to France during the 1880s for further artistic training. Born in Cork in 1859, he was christened Henry Thaddeus Jones, but in his early years he signed himself as T Harry Jones. Some time in the mid 1880s, after he had established himself as a portrait painter, he inverted his name, inscribing his pictures 'H Jones Thaddeus'. He studied at the Cork School of Art and won a free studentship in 1875, but he complained later: 'There was divil a thing in the place except a lot of plaster casts.' The award of a Taylor Prize at the Royal Dublin Society enabled him to go to London, where he studied at Heatherly's Academy in 1879–80. He went to Paris about 1880 and enrolled at the Académie Julian, where he was taught by Gustave Boulanger and Charles Lefebvre.

In 1881 Thaddeus sent a Parisian scene to an exhibition at the RDS, and he also had a picture accepted at the Paris Salon. This was *Le Retour du Bracconier*, known in English as *The Wounded Poacher*, and it was noticed by the art critic of *Le Figaro*, who must have recognised that the twenty-two-year-old artist had exceptional talent. He signed the painting 'Thaddeus Jones', and it is obvious that, in every respect, he was attempting to show off his ability. The poacher is seen, foreshortened, slouched across a chair in a dark room. An attractive young woman tends his wounds, her calm attention contrasting with the pained expression on his face, his head resting against her bosom. A chair has been overturned, and the poacher's hat, gun and two rabbits have been dropped casually on the floor. To the other side of the painting there are a number of objects on a table, each painted with great facility — a bowl, a glass, a clay pipe and a half-filled bottle. The artist seeks anxiously to sustain the interest of his viewers by the use of details: the long-handled spoon hanging on the wall by the fireplace, the poacher's loose shoelaces, the raised veins on his arms, the makeshift extension to the table leg, the carrots and cabbage that have fallen from a basket, the flower pots in the small window. The muted, earthy colours suit the subject, and the paint is laid on in a different way in various parts of the picture; it is blurred on the woman's skin, vigorous on the poacher's arm, flecked on his trousers and heavy on the dusty floor.

Thaddeus was a master of realism and an intelligent subject painter. In 1881 he left Paris and went to Pont Aven in Brittany, 'a tranquil, sleepy village with one long street'. After a week he decided to move to the medieval, walled city of Concarneau. The following autumn an outbreak of smallpox killed all the children of the city, an event that Thaddeus never forgot. He returned to Paris in 1882, and later that year he went to Florence to study the art of the Italian Renaissance. During the 1880s he returned to France on a number of occasions to paint in the open air. To survive as an artist, however, he became a studio painter, specialising in portraiture, and his highly polished paintings of many distinguished individuals of his time brought him much success. He was elected an associate of the Royal Hibernian Academy in 1892 and a member in 1901. In 1912 he published an autobiography, *Recollections of a Court Painter*, which contains a useful account of what it was like to be an art student in France in the 1880s. He died in 1929.

Thaddeus 1912; Campbell 1984; NGI 1984–6; Murray 1992.

SARAH PURSER
(1848–1943) (SEE P 96–97)

Sarah Purser was a pivotal figure who was responsible for many crucial developments in the history of Irish art. She was born in Dublin in 1848 to a wealthy merchant family. Through her mother she was related to the artists Frederic William Burton and William and Walter Osborne. She spent two years at school in Switzerland, where she studied French, Italian and music, and when her father's business collapsed in 1873 she decided to train as an artist. Although not documented, it is likely that she spent some time at the Metropolitan School of Art in Dublin. During the winter of 1878–9, however, she attended the Académie Julian in Paris, where she met many young artists of different nationalities, including the Swiss student Louise Breslau, with whom she shared an apartment and became a life-long friend. She endured considerable hardship in Paris, but was determined to benefit from her training. When she returned to Dublin she established herself as a portrait painter and, as she said herself, she went through the aristocracy in Ireland and Britain 'like the measles': during her lengthy career she estimated that her income from portrait commissions was something in the region of thirty thousand pounds.

While some of her later oil portraits are lacking in originality and vigour, her pastel portraits, particularly those of children, are spontaneous and technically excellent. Many of her early works in oils are superb, notably *Le Petit Déjeuner* which was painted on one of her frequent visits to Paris, probably in 1882. The lady with the sad, contemplative expression, seated at breakfast, is the Italian singer Maria Feller, who was a close friend of Purser and Breslau. Purser had met Degas, and his influence is apparent in the informal pose and the snapshot effect of the composition. The picture has often been praised for the clever way in which it evokes the lazy atmosphere of Paris in the 1880s, with artistic people passing hours in cafés, preoccupied only with the events of their own immediate circle.

Success as a portraitist brought Purser many special distinctions. In 1890 she was elected an honorary member of the Royal Hibernian Academy, Dublin, which at that time did not admit women to full membership. When the academy changed this rule in 1923 Purser was the first woman to be admitted as an associate, and the following year she was elected a member. By then she was seventy-five years of age and had been exhibiting at the RHA for fifty years. In May 1923 she had arranged a critically acclaimed exhibition of eighty of her own paintings under the title 'Pictures Old and New'. She involved herself in so many activities that it is difficult to mention just a few. In 1901 she organised an exhibition of the works of John Butler Yeats and Nathaniel Hone the Younger, which so impressed Hugh Lane that he resolved to do something for the arts in Ireland, and when he decided to promote the foundation of a modern art gallery for Dublin, she supported him wholeheartedly in his efforts. In 1903 she established the important stained glass studio 'An Túr Gloine' (the Tower of Glass), and managed and financed it until her death in 1943. She was appointed to the board of the National Gallery of Ireland in 1914. Following the purchase of Mespil House she began her renowned 'second Tuesdays', when members of Dublin's intelligentsia were invited for tea and sandwiches. In 1924 she was the leading activist behind the establishment of the Friends of the National Collections of Ireland, and in 1933, aged eighty, she secured political approval for the allocation of Charlemont House in Parnell Square, Dublin, as the Municipal Gallery of Modern Art. She campaigned unceasingly for the return from London of the thirty-nine modern paintings that Sir Hugh Lane had left to Dublin in an unwitnessed codicil to his will. Also in 1933 she joined with her relative Sir John Griffith in endowing a History of Art Scholarship, as well as a programme of lectures and an examination in art history to be held in alternate years at Trinity College and University College, Dublin. This was the catalyst that led ultimately to the appointment in 1965 of Dr Françoise Henry as Ireland's first full-time professor of art history, responsible for the Department of the History of Art at University College, Dublin, and to the growth of history of art studies at Trinity College from an occasional lecture series to an academic department under Professor Anne Crookshank.

MacGreevy 1949; Coxhead 1965; Aspects of Irish Art 1974; O'Grady 1974, 1977; Crookshank and Glin 1978; Campbell 1984; McConkey 1987 (2); Irish Women Artists 1987.

WALTER OSBORNE
(1859–1903) (SEE P 98–99)

The paintings of Walter Osborne have a special charm and have won him great popularity. He avoids sentimentality, even when his works can be described as pretty. *Apple Gathering, Quimperlé* was painted in Brittany when Osborne was twenty-four years of age. Two girls wearing traditional Breton costumes are shown gathering apples in an orchard. In the distance the rooftops of Quimperlé are visible through the trees. This is a humble scene, painted with affection and enjoyment by an artist who was exploring the range of his palette. There are greens, beiges, greys, and hints of pink and white. The figure of the girl in the foreground is somewhat stiff, but the leaves and the grass are treated with an admirable lightness of touch. Osborne uses the 'square-brush' technique, especially in painting the apple tree.

Osborne was born in Dublin in 1859, a son of the well-known animal painter William Osborne (1823–1901). He studied at the Royal Hibernian Academy Schools in Dublin and at the Dublin Metropolitan School of Art. In 1881 he won the Taylor Scholarship at the Royal Dublin Society, which allowed him to travel to Antwerp. There he enrolled at the Académie Royale des Beaux Arts and joined the *Natuur* or 'painting and drawing from life class' given by the animal painter Charles Verlat (1824–90). After the completion of his training

Osborne went to Brittany, which had become a popular area for painters who wished to paint *en plein air*. Osborne worked around Pont Aven, Dinan and Quimperlé. He became friendly with many artists and was influenced in particular by Jules Bastien-Lepage, the French naturalist painter who used a grey, even light in his paintings, and promoted the 'square-brush' technique. Osborne was also influenced by two English *plein-air* painters, George Clausen and Stanhope Forbes.

Following his return from France, Osborne spent most of the next nine years or so in small English towns. He worked in the open air all day and lived frugally. He spent the winter months in Ireland, and showed the results of his labours annually at the Royal Hibernian Academy exhibition, where he also became an influential teacher. In 1883 he was elected an associate of the RHA and he became a full member in 1886. He settled in Dublin when he assumed responsibility for the upbringing of his niece Violet, who, on the death of her mother in childbirth, was sent from Canada to be reared by her grandparents. Osborne continued to paint outdoors in and around Dublin, but these works proved difficult to sell. He was forced to enter the more lucrative area of portrait painting, with great success. His works were always popular at the RHA and at the Royal Academy exhibitions in London.

Osborne had a very attractive personality and was well liked by a wide circle of friends. In 1900, for reasons unknown, he rejected the offer of a knighthood. His career ended tragically in 1903 when, aged forty-three, he died of pneumonia. It is with some justification, especially in view of his last works painted outdoors, that Osborne has been called 'the Irish Impressionist'.

Crookshank and Glin 1978; Campbell 1980 (1) and (2), 1984; Sheehy 1974, 1983, 1991.

FRANK O'MEARA
(1853–88) (SEE P 100–101)

Frank O'Meara was Ireland's most important *plein-air* painter, and his sensitive landscapes were among the finest produced at the French village of Grez-sur-Loing, near Fontainebleau, during the 1880s. He was born in Carlow in 1853, the son of a medical doctor, and it is likely that he was educated at the local Knockbeg Diocesan College. He was in Dublin in 1869–70, but it is not known if he studied art there. A sketchbook from his early years contains landscapes drawn in the environs of Carlow, and a number of other drawings indicate that he was in France and Wales in about 1871. Two years later he went to Paris to train in the atelier of Carolus-Duran (Charles Durand, 1838–1917), an artist who 'emphasised colour and technique as much as solid draughtsmanship'. In 1875 he visited Grez-sur-Loing, where an artists' colony had been established in the 1860s. He obviously enjoyed life in this small French community because he stayed for thirteen years, longer than any other artist. The painters who settled at Grez differed from those at the better-known colony at Barbizon: their group was smaller, younger, mostly non-French, and had no great leader figure. In contrast to the Impressionists who were painting along the banks of the Seine, capturing the effects of sunlight, the artists at Grez preferred a grey day with overcast skies. The writer Robert Louis Stevenson described Grez as 'a pretty and very melancholy village', and the colony attracted many

talented individuals. O'Meara was much admired among his contemporaries: John Singer Sargent said he was 'irresistible' among 'a veritable nest of bohemians', and Will H Low in his memoirs *A Chronicle of Friendships* described him as 'a pure type of Celt . . . with the capricious moodiness of his race'. John Lavery, who arrived in Grez in 1883, said that his time there was the happiest period of his life, adding that of the many artists he had met there, O'Meara had influenced him most.

In *Towards Night and Winter*, painted in 1885, O'Meara's subject is a young girl burning leaves on the river-bank of the Loing. In the background the forms of houses are defined strongly, and their reflections can be seen in the river. The restricted palette — green, red, brown, grey and silver — and the pale tonality are typical of the artist. He applied his paints thinly and did not use the square-brush technique favoured by other *plein-air* painters. O'Meara was a very slow worker, who produced only one or two large pictures each year, but despite his small output it is intriguing how many pictures he completed on the theme of women beside the water's edge, each of which has an 'autumnal' title, like *Autumnal Sorrows*, *The Widow*, *Twilight* and *October*. The sense of isolation and melancholy in these paintings is perhaps an echo of O'Meara's own circumstances. He had two failed love affairs, was often short of money and suffered from ill-health.

The atmosphere that he created in his pictures is quite remarkable. They are silent, dream-like and lyrical, so much so that even though he spent his career in France he has long been recognised as the artist who best encapsulates the mood of the 'Celtic Twilight'. Low saw him as the visual predecessor of the poet William Butler Yeats, because in his paintings he made the first tentative efforts 'to express the national characteristics of the Irish . . .

In late 1887 O'Meara visited the artists' colony at Étaples on the Pas-de-Calais coast, where, he told Lavery, 'living is cheaper than Grez'. He made a large drawing, in charcoal or pencil on canvas, for a painting entitled *On the Quays, Étaples*, which he never completed. He returned to Carlow in the spring of 1888 and died the following October, aged thirty-five. It is probable that he went home to die because his death certificate states that he had been suffering from malaria for seven years.

Caw 1908; Campbell 1980 (1) & (2), 1984, 1989; McConkey 1982, 1986, 1990.

DERMOD O'BRIEN
(1865–1945) (SEE P 102)

Dermod O'Brien's family were landowners at Cahirmoyle, Ardagh, County Limerick, and he was sent to school in England, at Harrow and Trinity College, Cambridge. Unlike his Irish contemporaries he did not study art in Dublin, but instead went to Paris in 1886 to study the paintings in the Louvre, and the following year he visited the galleries of Italy. During the summer of 1887 he enrolled at the Royal Academy, Antwerp, one of the last Irish students to study there, his predecessors being, among others, Walter Osborne, Richard Moynan and Roderic O'Conor. He received a solid academic training and followed the advice of his master, Charles Verlat: 'Draw what you see, don't draw what isn't there.'

The Fine Art Academy, Antwerp, painted in 1890, shows a group of students in Verlat's life class attempting to paint a woman and child who are modelling before them. Studies of male models hang in rows on the wall in the background. The handling of the figures of the students and models, and the rendering of light and shade, demonstrate O'Brien's debt to the old master tradition rather than to the innovative developments in French painting in his day. In the foreground there are brushes, a knife, a palette, a dipper, a bottle and a paint rag, each of which is initialled or monogrammed, probably by fellow students or tutors. The identifiable markings are 'W.L', 'P.V.L.', 'R.T.', and a monogram in the shape of a wine glass. O'Brien signed and dated the picture in a vertical line, graffiti-like, on the wall

behind the models. It has been suggested that the bearded student standing at his easel may be a self-portrait, but his son thought this unlikely.

In 1891 O'Brien left Antwerp and moved to Paris, where he continued his studies at the Académie Julian and associated with a number of English students, including William Rothenstein. By this time, however, he was, in the words of his biographer Lennox Robinson, 'too set in his method', and he showed little interest in new painting techniques. He settled in London in 1893 and attended the Slade School. O'Brien was friendly with most of the major figures in the London art world, like Rothenstein, John Singer Sargent, Wilson Steer and John Lavery, and he shared a studio with Henry Tonks for three years.

In 1894 O'Brien sent a portrait of his grandfather, the 'Young Irelander' William Smith O'Brien, to the Royal Hibernian Academy exhibition in Dublin, the first of 229 pictures that he exhibited at the academy during his lifetime. He moved to Dublin in 1901, married the following year, and after the death of Walter Osborne in 1903 and John Butler Yeats's departure to America in 1908 he became one of the leading portraitists in Ireland, the rival of Sarah Purser. He was elected an associate of the RHA in 1906, a member in 1907, president in 1910, and an honorary member of the Royal Academy, London, in 1912. In 1907 he inherited the family estate at Cahirmoyle and became a proponent of agricultural reform. His portraits of this time are formal and

competent, but generally unexciting, and his attempts to paint large allegorical pictures seem to have over-stretched his imagination. In 1920 he sold Cahirmoyle and acquired a house in Fitzwilliam Square, Dublin. In later life he painted many attractive, airy landscapes in Ireland and on his regular trips to the south of France. His still-life paintings are among his best, and he revelled in the precise depiction of flowers, vases and household objects. O'Brien was not narrow-minded, and he campaigned in 1942 in support of Mainie Jellett and against his fellow academicians, Seán Keating and Leo Whelan, to have a painting by Georges Rouault accepted by the Dublin Municipal Gallery's Art Advisory Committee, to whom it had been offered as a gift by the Friends of the National Collections of Ireland. He succeeded in purchasing a new premises for the RHA in 1938, at 15 Ely Place, but, despite his own tolerance of new approaches to painting, the Selection Committee's rejection of avant-garde works for the annual show in 1943 alienated young artists and prompted the launch of the first Irish Exhibition of Living Art. He remained as president of the academy until his death in 1945.

Robinson 1948; MacGreevy 1949; Pyle 1975; Hobart 1982; Arnold 1981, 1991; Sheehy 1983; Campbell 1984; McConkey 1990; Kennedy (S B) 1991 (2).

RICHARD THOMAS MOYNAN
(1856–1906) (SEE P 103)

Military Manoeuvres, an attractive genre picture by the Dublin-born painter Richard Thomas Moynan, was exhibited at the Royal Hibernian Academy exhibition in 1891 and at the Chicago World's Columbian Exposition in 1893. The title is humorous, for the manoeuvres referred to are those of a group of children pretending to be soldiers while a young trooper (or private) and his girlfriend walk past them. A near-contemporary Lawrence Collection photograph (National Library of Ireland) indicates that Moynan's scene is set in the main street of Leixlip, County Kildare. Moynan includes the local forge, the two-storey gabled house to the left of it, and the grocer's to its right. Although the church spire is the result of artistic licence, the proof that Moynan was representing Leixlip is in the placing of a distinctively shaped ironwork sign on a gatepost above the forge, precisely where it can be seen in the photograph.

The soldier has been identified as a member of the 4th (Royal Irish) Dragoon Guards, a regiment that was stationed in Newbridge, County Kildare, from the late 1880s until 1893, when it was moved to Aldershot in England and from there to India in 1894. A trooper of the cavalry regiment, he is wearing so-called walking-out dress. The single chevron on his left sleeve, above his cuff, indicates that he has served for two years. The man walking in front of the

forge, accompanied by a lady, is dressed for tennis and carries a square tennis racket. The boy on the extreme right, who plays the role of drum major, is wearing a brass helmet with a black horse-hair plume. This type of helmet was worn by members of the Dragoon Guards' regimental band. There are no girls in the band, but three girls, perhaps sisters of the young boys, look on with interest from the pavement, and one, on the far left, is dressed in traditional costume and carries a basket of heather. Moynan emphasises the children's poverty and also their ability to amuse themselves. They are dressed in ragged clothes and only two of them are wearing shoes. Their musical instruments are made from household objects — for drums an empty tin and a bucket, for cymbals two saucepan lids. They are trying to tease the soldier, who ignores them despite his girlfriend's efforts to make him see the joke. *Military Manoeuvres* is a carefully worked, finely executed painting, and a number of sketches for it exist, including one that shows an alternative composition, with the young drum major conducting the band instead of adopting the frustrated pose seen in the final version.

Richard Thomas Moynan was born in Dublin in 1856. He studied medicine at the Royal College of Surgeons but before completing his course he opted instead for a career as a professional artist. He studied at the Dublin Metropolitan School of Art and

at the Royal Hibernian Academy School. In 1883 he was awarded the Albert Prize for the best picture to be shown by a student at the RHA. That same year he travelled to Antwerp with Roderic O'Conor, and they shared lodgings for a time. For six months Moynan attended Charles Verlat's *Natuur* or life study class, as Walter Osborne had done two years before, and in 1884 he won first prize for painting from the living model. The following year he moved to Paris and remained there until 1886, when he returned to Ireland. He gained a reputation as a portrait painter, but his best pictures, like *Military Manoeuvres*, are of scenes from everyday life, which, while humorous, reflect his considerable sympathy for the poor. Moynan was elected an associate of the RHA in 1889 and a member the following year. Strickland wrote of Moynan that 'unfortunately he gave way to intemperance which gradually affected his powers and his health and ultimately ended his career'. For the last few years of his life he painted very little, and he died in Dublin in 1906.

Strickland 1913; NGI 1981–82; NGI 1982–83; Wynne 1983; Campbell 1984.

RODERIC O'CONOR
(1860–1940) (SEE P 104)

Roderic O'Conor has been described as Ireland's first modernist painter, and he participated eagerly in what became known as the post-Impressionist movement. O'Conor was born in County Roscommon, the son of well-to-do parents. He was sent to school in England, to the Benedictine-run Ampleforth College in Yorkshire, where he received a classical education and excelled as a student. He then returned to Ireland, and in January 1879 enrolled at the Metropolitan School of Art in Dublin. He spent many hours in the National Gallery of Ireland, studying and copying old master paintings, and was rewarded for his efforts by winning the Cowper Prize for study from the antique. In 1881–2 he attended the Royal Hibernian Academy School in Dublin, where he won four prizes for his year's work. The following year O'Conor enrolled again at the Metropolitan School of Art. He was runner-up to Richard Moynan in the Albert Prize competition, but his entry, a landscape painting of Rathfarnham Park, so impressed the judges that he was given a special award.

In 1883 O'Conor and Moynan travelled to Antwerp and enrolled in the *Natuur* or life study class given by Charles Verlat at the Antwerp Academy. The two artists were following a trend set by a number of Dublin students, including Nathaniel Hill, Joseph Malachy Kavanagh and Walter Osborne, who had come to Antwerp in 1881. O'Conor did not excel at Antwerp, but he was invigorated by exposure to modern trends in painting. He returned to Dublin in 1885, but the city had little to offer him. He was drawn to Paris, the focal point for new trends in art. Unlike many other young artists, O'Conor was fortunate enough to have a private income and he never had financial worries. In Paris he studied under Carolus-Duran, a fashionable portraitist who favoured a direct approach to painting, exploration of the intensity of colours and the expressive power of oil paints. Seeing the work of the Impressionists in the Parisian galleries, O'Conor was anxious to be among the modern painters, and so he moved to the artists' colony at Grez-sur-Loing, in the vicinity of Fontainebleau. During the 1890s he became inextricably linked with the so-called School of Pont Aven, named after a small village in Brittany. The presiding genius there was Paul Gauguin, who sought to liberate his fellow artists to use form and colour in the exploration of surface rhythms. In 1904 O'Conor settled in Paris. He travelled regularly in Europe and, during the 1930s, lived for a time at Torremolinos in Spain. He died in 1940. O'Conor was a most complex character, intelligent, spontaneous, erratic, irascible and introverted, and always something of a mystery.

La Ferme de Lezaven, Finistère is a meticulously composed landscape, illustrating a site well known to the artists of Pont Aven. The vibrant colours and the stripe-like technique of the brushstrokes recall van Gogh, whose style of painting was a powerful influence on O'Conor. There is a strong case for nominating O'Conor as Ireland's most international artist. His legacy of portraits, nude studies, still life and, especially, landscape painting, reveals him as the Irish artist who was most in tune with avant-garde developments in Europe.

Crookshank and Glin 1978; Wynne 1983; Campbell 1984; Johnston 1984, 1985 (1) & (2); Benington 1992; Murphy 1992.

JOHN BUTLER YEATS
(1839–1922) (SEE P 105)

John Butler Yeats was a talented portrait painter and the father of a brilliant family. His son William was a Nobel prize-winning poet, his son Jack a gifted painter, and his daughters Elizabeth ('Lollie') and Susan ('Lily') were leading members of the arts and crafts movement in Ireland, the founders of Dun Emer Industries and its successor, the Cuala Industries. His own father was a Protestant rector in County Down. John Butler Yeats was educated in Liverpool and on the Isle of Man. He read metaphysics and logic at Trinity College, Dublin, before studying law. He practised as a barrister until 1867, when he moved to London and enrolled at Heatherley's Art School and then at the Royal Academy School. Between 1880 and 1897 he moved to and fro between Dublin and London, and exhibited regularly at the Royal Hibernian Academy, of which he was elected an associate in 1887 and a member in 1892. He settled in London in 1897, but following the death of his wife Susan in 1900 he returned to Dublin again. In 1901 he showed forty-four works in an important joint exhibition with Nathaniel Hone the Younger, which was organised by the indomitable Sarah Purser. This exhibition brought Yeats commissions, and during the next seven years he painted many of the distinguished Irish men and women of his day. In 1908 he emigrated to the United States and became a much-liked member of the artistic community in New York.

He remained there for the rest of his life, earning a meagre living by lecturing, writing and painting portraits. Although he never returned to Ireland, he kept in close touch with events there by letter. His son William visited him in New York, but he never saw Jack or his daughters again. There was no member of his family present when he died in New York in 1922, aged nearly eighty-three.

A free thinker and an admired conversationalist, John Butler Yeats was an infuriating artist. He painted best when he liked his sitters, and he could stop to chat with them for hours. He was rarely content with his pictures and insisted on reworking them, often spoiling a good portrait by overpainting it. He was hopeless at organising his finances, and never made much money from his work. In Dublin he was supported financially by Sir Hugh Lane. In New York the lawyer and art collector John Quinn advanced him money, protected and advised him, and finally paid for the headstone on his grave. In 1911 Quinn asked the artist to paint a self-portrait for him, to take his time and to name his price. For the next eleven years the portrait was worked and reworked, but was never finished.

John Butler Yeats told his son William that he agreed with the friend who said: 'In Dublin it is hopeless insolvency. Here [in New York] it is hopeful insolvency.' The elder Yeats and William were on close terms with each other. William was always agitated, taut, serious, intense, and his father often found it difficult to deal with him. The fine oil portrait of 1900 reveals much about the personality of the thirty-five-year-old poet and dramatist. In that year William was collaborating with George Moore on the play *Diarmuid and Grania*, and he was working too hard. His father urged him to spend Christmas in London, so that he could get some much-needed rest. The portrait, which was painted during that time, portrays William as a delicate-looking, refined, bookish, bespectacled and absent-minded man. There are hundreds of pencil sketches that demonstrate John Butler Yeats's spontaneity and facility as a draughtsman. In his best oil portraits he offers some justification for the claim that he was the most gifted portraitist of his time.

White 1972; Crookshank and Glin 1978; Cullen 1978; Murphy 1978; Wynne 1983; Croke et al 1991; Potterton 1993.

WILLIAM ORPEN
(1878–1931) (SEE P 106–107)

Sir William Orpen was one of the most successful portrait painters of this century. He was a superb draughtsman and an influential teacher of a generation of Irish artists. He was born in Dublin in 1878, the son of a lawyer, and from his early boyhood it was evident that he was destined to be a painter. His natural talent for drawing was not lost on his father, who allowed him to enrol at the Dublin Metropolitan School of Art before he had reached his thirteenth birthday. He won prize after prize there, and he repeated the performance when he moved to the Slade School of Art in London. Orpen was an Irishman, who knew that his native country could not offer him the opportunities for advancement that were available in England to an artist of his great ability. He lived in London but enjoyed visiting Dublin, and in 1902 he began teaching at the Metropolitan School of Art where, during regular visits over the next decade or so, he revolutionised teaching practice. He was elected an associate of the Royal Hibernian Academy in 1904 and a member in 1907. In 1910 he became as associate of the Royal Academy in London, and he was elected to full membership in 1919. Orpen produced sensitive and intimate paintings of many women, including his wife Grace (née Knewstub) and his models Emily Scobel, Lottie Stafford, Yvonne Aubicq, Flossie Burnett and Vera Hone. A great romantic, Orpen had relationships with a number of beautiful women, notably the elegant Mrs St George, whose portrait he painted many times. He was a generous man who enjoyed the high life, for example he purchased a black and white Rolls Royce in 1914 but surrendered it soon after for use as a war vehicle. He had an obsessive need for critical self-examination, and his numerous self-portraits, some of which are outstanding paintings, have been described as 'a kind of visual diary'. The professional portraits, which represent the bulk of his output, provide an unsurpassed record of the major figures of the upper echelons of society in England and Ireland at the time.

Orpen's relationship with the Royal Hibernian Academy ended abruptly in 1915 when a personality clash with the president, Dermod O'Brien, led him to resign his post. During the First World War Orpen rejected appeals by his friends to return to Ireland. He became an official war artist and produced a powerful stream of pictures that revealed the horror and tragedy of the conflict on the Western Front. He was knighted for his services in 1918. During the 1920s, although his portrait practice continued to be successful, Orpen became a tragic figure, ravaged by drink, separated from his family and deserted by his friends.

The Mirror was painted in 1900 when Orpen was twenty-one years of age. He was self-consciously showing off his talent and potential. The painting is superb, although it is admittedly a 'too obvious' reference to tradition, recalling Jan van Eyck's *The Arnolfini Marriage* (1434, National Gallery, London), the views of interiors by the masters of Dutch seventeenth-century painting, and the late-nineteenth-century portraits by Whistler. It presents a mundane enough subject, a girl seated on a chair in a room, but it is treated with intelligence and panache. The girl is Emily (Amelia) Scobel, who modelled for a number of important paintings by Orpen. They were to be married, but Emily broke off the engagement because she thought him too ambitious. The details of *The Mirror* contribute to the determined composition: the clever use of light, the robust pose of the model, the shadow of the hat on her face creating a sense of seduction and mystery, the sweet-peas in the glass vase, the mirror itself with its portrait of the artist. The painting was a great success, reviewers praised it, and it served as the cornerstone for a brilliant career.

Orpen 1924; Crookshank and Glin 1978; Hutchinson, Ryan and White 1978; Turpin 1979, 1991–92; Arnold 1981, 1991; McConkey 1979, 1987 (1), 1990.

JOHN LAVERY
(1856–1941) (SEE P 108–109)

Sir John Lavery, like Sir William Orpen, had a very successful career, but he did not share Orpen's comfortable upbringing. Lavery was born in Belfast in 1856, the son of a failed wine merchant who drowned in a shipping disaster in 1859. His mother died three months later, and he was raised by an uncle until the age of ten, when his aunt's cousin took him to Scotland to be educated in Ayrshire. After five years of misery he ran away to Glasgow, where he took a job tinting and retouching photographs. He enrolled in art classes at night, and in 1881 he went to Paris where he studied in Colarossi's studio and at the Académie Julian. In 1883 he stayed at the artists' colony of Grez-sur-Loing, and became friendly with the older Irish artist Frank O'Meara and the French painter Jules Bastien-Lepage, both of whom influenced his work. Lavery returned to Glasgow in 1885 and established a reputation as a sophisticated modernist. He was commissioned to record the visit of Queen Victoria to the Glasgow International Exhibition in 1888 and, although the resulting picture was not acclaimed, it strengthened his determination to specialise as a portraitist. In early 1890 Lavery married Kathleen McDermott, a pretty flower girl whom he had met in Regent Street, London. She claimed to be of Irish extraction, but was probably Welsh. Kathleen died a year after their marriage, following the birth of their daughter. In 1896 Lavery moved to London and set up a studio. The attractive ease of his society portraits won him many admirers, and he established an international reputation by exhibiting widely in Europe and America. He was elected an associate of the Royal Hibernian Academy, Dublin, in 1906 and a member in 1907.

In 1910 Lavery married Hazel Trudeau, a beautiful lady who was thirty years younger than him. Hazel's previous husband, a Chicago industrialist, had died a few months after their marriage, and before their daughter was born. Hazel was a formidable and inspiring woman, and Lavery, obsessed by her beauty, painted her many times, the most notable portrait being that which adorned the Irish pound note until the 1970s. It is still to be found in the watermark of all Irish paper currency. Lavery had first met Hazel in 1904 in Brittany, which she had visited because she wished to be among artists. None of her own oil sketches of this period have survived, but a number of works that she painted during the 1920s are extant. The Laverys travelled widely together and regularly spent the winter in Morocco. These winter trips allowed Lavery to experiment out-of-doors with the effects of light and shade, and to expand the colour range of his oil palette.

Mrs Lavery Sketching was most probably painted *en plein air*. It was purchased by Sir Hugh Lane for the Municipal Gallery of Modern Art, Dublin, in 1910. It is a rather formal full-length oil portrait, delightful in composition and tone, and intimate in the knowing look exchanged by Hazel with her artist husband. The almost strolling pose and the sunshade umbrella were devices used by the French Impressionists. Lavery's method was never founded in theory, however, and he once remarked that 'no one ever knew less why he did what he did than I'. During the First World War Lavery was appointed as an official war artist attached to the Royal Navy. His experience of the war was much less harsh than that of Orpen, but they were both knighted in the Honours List of 1918. The Laverys became involved peripherally in the Anglo-Irish Treaty negotiations of 1921 through their friendship with many of the Irish leaders, especially Michael Collins. Also in 1921 Lavery was elected as a royal academician, and he and his wife became leading members of British 'high society'. Hazel and Lavery's own daughter Eileen died in 1935, and in 1941 Lavery himself died at the home of his stepdaughter Alice, in County Kilkenny.

Lavery 1940; Irwin 1975; Crookshank and Glin 1978; McConkey 1979, 1984 (1) and (2), 1990; Campbell 1984.

WILLIAM JOHN LEECH
(1881–1968) (SEE P 110–111)

William John Leech was born in Dublin in 1881, the son of a professor of law at Trinity College. He was educated privately in Dublin and later in Switzerland, where he spent a year becoming a proficient French speaker. In 1898 he enrolled at the Dublin Metropolitan School of Art, and the following year he moved to the Royal Hibernian Academy Schools in Dublin, where he studied under Walter Osborne. In 1901 Leech entered the Académie Julian in Paris, and he remained there for two years. He moved to Brittany in 1903 and was captivated by the magnificent landscape. Unlike other Irish artists, Leech did not settle at Pont Aven, but chose instead the medieval walled town of Concarneau. His style of painting was at first formal and academic, but he changed gradually to a more fluid and self-assured manner. He was elected an associate of the Royal Hibernian Academy in 1907, and a member in 1910, the year in which his parents had moved from Dublin to London. From then until 1921, when his father died, he divided his time between France and England. He held his first one-man exhibition in 1911 in London. In 1912 Leech married Elizabeth Saurine Kerlin (née Lane), but towards the end of the First World War they agreed to a separation.

Leech had been conscripted into the British Army in the spring of 1918, and he spent the last six months of the war in a detention camp in France. He returned to England in a state of depression and was unable to bring himself to paint. In 1919 he met May Botterell, the wife of a distinguished London lawyer. The relationship between them blossomed, but they were very discreet for fear of scandal. May Botterell supported Leech financially and emotionally, although their involvement forced the artist to avoid publicity by curtailing the exhibition of his works in London. He sent many of his paintings to Dublin, and in 1944 Leo Smith of the Dawson Gallery became his agent. When Percy Botterell died in 1952, May was free to marry Leech. They settled near Guildford in Surrey and had a studio constructed in their garden. Leech painted happily there until 1965, when May died. He became very depressed after her death, and in 1968 he fell from a railway bridge near his home and died from his injuries.

A Convent Garden, Brittany was presented to the National Gallery of Ireland in 1952 by May Botterell. The painting includes a portrait of Leech's first wife, Elizabeth Saurine Kerlin; she is the young novice holding a prayer book who appears to glide past in the right foreground. The picture was painted about 1911 when the artist and Elizabeth were planning their marriage, but she had first to obtain a divorce. This situation would have precluded a white wedding in a church, so the painting represents a wishful dream. Elizabeth is shown wearing a traditional Breton wedding dress and bonnet. The white of the costume and the lilies in the foreground symbolise purity. There is a direct correlation between the bride-to-be and the nuns behind her, the brides of Christ. The painting was first titled *Les Soeurs du St Esprit*, the name of the order of nuns that ran the local hospital at Concarneau. *A Convent Garden, Brittany* demonstrates Leech's skill as a colourist. His palette is strong and vivid, his composition clever but strangely static. It has been suggested that he was attempting a grand garden painting in the tradition of the French Impressionists. He loved to paint flowers and plants, especially in close-up. The convent garden at Concarneau was in fact a delightful secret garden hidden behind high stone walls. The painting is deservedly one of the most popular and frequently reproduced works by an Irish artist.

Denson 1968–9; Wynne 1983; Campbell 1984, 1991 (2); Croke et al 1991; Ferran 1992, 1993.

SARAH CECILIA HARRISON
(1863–1941) (SEE P 112)

The best portrait paintings by Sarah Cecilia Harrison are small oils on wood, with tight brushwork and an enamel-like surface. The portrait of her close friend Sir Hugh Lane, painted in 1914, is an excellent example. Harrison was born at Holywood House, County Down, to a prosperous family. When her father died in 1873 the family moved to London. Celia Harrison, as she was known to family and friends, studied at the Slade School of Art in London from 1878 to 1885 and won a number of student prizes. In 1889 she settled in Dublin and began her career as a portrait painter. The following year she spent some time in France, painting in Étaples and Brittany. She exhibited at the Royal Hibernian Academy's annual exhibition regularly from 1889 to 1933. Harrison was interested in politics, a family tradition; her brother Henry Harrison was a Member of Parliament for Tipperary and a strong supporter of Charles Stewart Parnell, leader of the Irish Parliamentary Party. She was a formidable lady, six feet two inches in height, and an active proponent of social reform in Dublin. In 1912 she was elected as the first ever female city councillor of Dublin Corporation, a post she retained until 1915, during which time she campaigned on a number of issues, including urban poverty, unemployment, and the efforts of Hugh Lane to establish a permanent gallery of modern art in Dublin.

Hugh Lane was born at Ballybrack, County Cork, in 1875. His father was a Church of Ireland rector and his mother was one of the Persse family from Galway and a sister of the dramatist Lady Gregory. Lane was a delicate child and he received an informal private education. During a visit to Plymouth in the south of England he was fascinated by the work of a local picture restorer, and at the age of eighteen he was apprenticed to the London art dealers Martin Colnaghi. He then joined the Marlborough Galleries for a time, before establishing himself as a 'gentleman dealer'. His natural talent brought him spectacular success and a considerable fortune. Following a visit in 1901 to an exhibition of the works of Nathaniel Hone the Younger and John Butler Yeats, organised by Sarah Purser, Lane determined to do something for art in Ireland. He commissioned Yeats to paint portraits of distinguished Irishmen, and later, after Yeats's departure for New York, William Orpen completed the series. Lane began to purchase fine paintings which he intended to offer to Dublin Corporation, provided that a permanent gallery was made available in which to exhibit them. In 1902 he organised an exhibition of old master paintings at the Royal Hibernian Academy, and in 1904 he was responsible for a landmark exhibition of 465 *Works by Irish Painters* at the Guildhall, London. Later that same year Lane organised an exhibition of Irish and modern European art at the Royal Hibernian Academy. In 1908 the Dublin Municipal Gallery of Modern Art was opened in temporary premises at 17 Harcourt Street, and Lane was honoured by being declared a Freeman of the City. The following year he was knighted for his services to art. His enthusiasm and commitment, despite many difficulties, led eventually to the provision by the Irish authorities of the fine premises, opened in 1933, which is now named the Hugh Lane Municipal Gallery of Modern Art, in Parnell Square, Dublin. In 1914 Lane became director of the National Gallery of Ireland, and during the thirteen months he held this post he made gifts of twenty-four paintings to the national collection. He drowned tragically, aged thirty-nine, in the *Lusitania* disaster of May 1915, and in his will he bequeathed forty-three pictures to the National Gallery, including works by Chardin, Claude, Gainsborough, Hogarth, Poussin and Titian. An unsigned codicil to his will left in dispute a further thirty-nine works, which continue to be subject to short-term loan arrangements between the Municipal Gallery, Dublin, and the National Gallery, London. These included celebrated works by Degas, Manet, Monet, Morisot and Renoir.

After Lane's death Celia Harrison claimed that they had been engaged to be married and had intended to make a public announcement following his return from America. His death came as a terrible shock to her, and she embarked on a long and fruitless campaign to prove her singular belief that his will was a forgery. She died in Dublin in 1941, aged seventy-eight.

Bodkin 1932; Hugh Lane 1961; Crookshank and Glin 1978; Wynne 1983; O'Neill 1989.

PATRICK TUOHY
(1894–1930) (SEE P 113)

Patrick Tuohy was the son of John Joseph Tuohy, a respected Dublin surgeon, and of Máire Murphy from Roundwood, County Wicklow. His parents were ardent Irish nationalists, and at the age of fourteen Patrick was among the first pupils to attend Pádraig Pearse's school, St Enda's, in Rathfarnham, County Dublin. Despite the disability of being born without a left hand, Tuohy's natural aptitude for drawing was recognised by the art teacher at St Enda's, the sculptor William Pearse (Pádraig's younger brother). Tuohy was encouraged to attend night classes at the Dublin Metropolitan School of Art, where the influence of William Orpen had led to an emphasis on life drawing and drawing from the nude. He learned quickly and gained a thorough understanding of human anatomy, which helped establish his reputation as a portrait artist of exceptional talent. He won the Taylor Art Scholarship at the Royal Dublin Society in 1912, and again in 1914 and 1915.

It has often been claimed that Tuohy was a member of the Irish Citizen Army and that he fought with Pádraig Pearse in the General Post Office in Dublin during the 1916 Rising. There is no evidence for this assertion, and Tuohy appears not to have adopted the strong political views of his parents. There are no contemporary political subjects in his small œuvre of about two hundred works. It is likely that Tuohy went to Spain in 1916 to study painting,

and not to avoid detention by the police as has sometimes been suggested. In Spain he visited the Prado regularly, where he was influenced by the seventeenth-century masters Velázquez and Zurbarán. He exhibited at the Royal Hibernian Academy, Dublin, for the first time in 1918, and he also began teaching at the Metropolitan School of Art in Dublin. He was elected an associate of the academy in 1926.

Tuohy completed a number of portrait commissions of political and religious leaders. He also painted some large religious works which are ambitious in concept and rigorously unsentimental. His series of pencil drawings of luminaries of the Irish theatre, completed between 1922 and 1926, demonstrate his superb ability as a draughtsman. He made a number of trips to Italy and France, and while in Paris in 1924 he painted the portrait of James Joyce. The writer sat for Tuohy nearly every day for a month, and after twenty-eight sittings Joyce was moderately pleased: 'I like the folds of the jacket and the tie.' Joyce later acknowledged Tuohy by characterising him in *Finnegans Wake* as 'Ratatuohy'.

In 1927 Tuohy emigrated to the United States, having become disillusioned with his career prospects in Ireland. He went first to South Carolina and then settled in New York. Tuohy was a complex personality, at times witty but also moody and subject to bouts of depression. In August 1930, just as

he was beginning to win the attention of American critics, he took his own life. His body was brought back to Ireland and was buried at Glasnevin Cemetery in Dublin.

The Little Seamstress was painted in 1914 when Tuohy was twenty years of age. It is quite a large watercolour painting, a medium Tuohy handled expertly but, for some reason, abandoned after a few years. The artist's choice of colours complement each other and the composition is courageous — the sitter (Mai Power, a sister of the sculptor Albert Power) is seated sideways on a chair, with her left arm stretched forward. It is little wonder, given the competence that Tuohy displayed so early in his brief life, that Orpen should have singled him out as one of his most gifted pupils.

Crookshank and Glin 1978; Turpin 1979; Arnold 1981; Mulcahy 1989–90; Croke et al 1991.

HARRY CLARKE
(1889–1931) (SEE P 114–115)

Harry Clarke has been described as Ireland's only great symbolist artist. His magnificent stained-glass windows are among the crowning glories of the visual arts in Ireland. He was born in Dublin, the son of Joshua Clarke from Leeds and Bridget MacGonigal from Sligo. In 1886 his father established the firm of J Clarke & Sons in North Frederick Street, Dublin, specialising in ecclesiastical decoration. Harry Clarke attended the Jesuit-run Belvedere College until he was fourteen, at which time he was apprenticed to his father's business. He learned the basic techniques of stained glass from William Nagle, and he impressed his father with his artistic ability. He received a scholarship to study stained glass with Alfred Ernest Child at the Dublin Metropolitan School of Art, where he won several student prizes. In 1914 he obtained a travel scholarship, which he used to visit France. There he was influenced in particular by the richly coloured windows of Chartres Cathedral. Also in that year he married Margaret Crilley, an excellent portrait painter.

Clarke's first public commission was to design a set of eleven windows for the Honan Chapel in University College, Cork. This commission established his style: a secular manner, fantastic, ambiguous and sensual, drawn from a broad range of literary sources. He was a strange genius, whose thin, ominous, somewhat decadent figures are

impressive and memorable. He was responsible for a large number of commissions during the 1920s; these were in Ireland, England, Scotland, Wales, Australia and the United States of America. He eventually took over his father's studio and made a success of it, employing twenty-seven assistants. The most famous secular windows by Clarke are *The Eve of St Agnes* (1923–4, Hugh Lane Municipal Gallery of Modern Art, Dublin) and *The Geneva Window* (1927–9, Mitchell Wolfson Museum, Miami, Florida). His output of graphic and illustrative work includes illustrations for Alexander Pope's *The Rape of the Lock*, Samuel Taylor Coleridge's *The Rime of the Ancient Mariner*, Hans Andersen's *Fairy Tales* and Edgar Allen Poe's *Tales of Mystery and Imagination*. He also completed a number of textile designs. In 1924 Clarke was elected an associate of the Royal Hibernian Academy, Dublin, and he became a member the following year. He had a tendency to overwork, despite continuous ill-health, and in 1931 he died of consumption in a Swiss sanatorium before he had reached the age of forty-two.

One of Clarke's earliest admirers was Thomas Bodkin (Director of the National Gallery of Ireland, 1927–35) who became his closest friend. In 1917 Bodkin commissioned Clarke to design a miniature glass panel, and they decided that it should illustrate the poem 'The Song of the Mad Prince' by Walter de la Mare. The panel marked a significant technical

achievement by Clarke: he used two sheets of glass, one blue, the other ruby, and plated them together. They were then treated with acid, stained and painted. The brilliant glowing colours and the intricate surface patterning are handled with a masterly facility. The prince stands staring with a melancholy gaze at the flower-strewn grave of his loved one. To the left and right, his parents, the king and queen, appear to float mysteriously and silently. They are seen in profile, the king surrounded by a blue moonlight and the queen by a ruby-gold light. This exquisite and haunting image is ample evidence of the unique talent of Harry Clarke.

Bowe 1979, 1983, 1985, 1989, 1989–90, 1990–91; NGI 1986–88; Bowe, Caron and Wynne 1988; White et al 1988.

WILLIAM CONOR
(1881–1968) (SEE P 116)

William Conor spent his long life recording the daily activities of the people of his native Belfast. He was born in 1881, the fourth of seven children of a Presbyterian family who lived near the city's Old Lodge Road. He was educated locally, and when his music teacher noticed his artistic ability he was enrolled at the age of thirteen in the Belfast School of Art. In 1904 he was apprenticed to David Allen and Sons, a Belfast firm of lithographers. He worked in the poster design department, drawing with black wax crayon on a slab of limestone. Throughout his career Conor continued to draw with wax crayons, and he used rough papers to simulate the effect of stone. This technique carried through to his oil paintings, in which he created a grainy effect by applying his paints thickly in a very individual fashion. He developed the habit of making sketches of people in the streets of Belfast, and he later turned these into compositions for paintings by adding in a suitable background. It is in this context that the writer George Russell's comment that Conor was 'a Belfast counterpart to Jack Yeats' can be best understood. Over a period of sixty years Yeats filled numerous notebooks with sketches of life in Ireland. Similarly, Conor had the keen eye of the artist observer, providing sympathetic and often humorous glimpses of the lives of urban dwellers in Northern Ireland. He avoids sentimentality and caricature, and presents a realistic, optimistic outlook on life.

Between 1907 and 1909 Conor used the Irish form of his name, 'Liam'. During this period he lived for a short time on the Great Blasket Island off the Kerry coast. He resigned from his job as a lithographer about 1910, and over the next few years he lived in Dublin for a few months, made sketching trips to Donegal, and visited Paris where he met the French artist André Lhote. After the outbreak of World War I Conor was appointed as an official war artist, making sketches of munitions factories and the everyday life of soldiers in the many army camps of Ulster. In 1918 he exhibited for the first time at the Royal Hibernian Academy's annual show in Dublin. He continued his pre-war custom of sketching in the streets of Belfast. *The Twelfth* is an appealing work of this type, showing bandsmen marching at Wellington Place, Belfast, on the twelfth of July, to commemorate the victory of King William of Orange at the Battle of the Boyne in 1690. The picture was shown under the title *Le Cortège Orangiste à Belfast* at the 'World Congress of the Irish Race', an exhibition held in 1922 at the Galérie Barbazanges in Paris.

Despite his growing reputation Conor found it difficult to make a living as an artist, and he decided to move to London in 1921. He was befriended by Sir John and Lady Lavery, who arranged for him to receive a commission to paint the opening of the first Northern Ireland parliament in June 1921. Although he exhibited his paintings at the Royal Academy and with the Royal Society of Portrait Painters in London, Conor chose to return to Belfast, where he acquired a studio and held a one-man exhibition in 1922. Although he never made more than a modest living from his painting, he became the most popular artist in Belfast. He completed a large number of portraits, some of which are excellent, but many of which are rather over-worked from a technical aspect. In 1930 he was a founder member of the Ulster Academy of Arts. In 1938 he was elected an associate of the Royal Hibernian Academy, and in 1947 he became a member. During the Second World War he was appointed once again as an official war artist. In 1957 he was elected president of the Royal Ulster Academy, a position he retained until 1964. He was granted a civil list pension in 1959, and he died in 1968 at the age of eighty-seven.

Wilson 1981; Kennedy (S B) 1991 (2).

MARY SWANZY
(1882–1978) (SEE P 117)

Mary Swanzy was a fine artist and a remarkably disciplined lady, eccentric, intelligent and formidable. She was born in Dublin, the second of three daughters of Sir Henry Swanzy, a distinguished ophthalmic surgeon. Her upbringing was strict and formal, being a child of an upper-class Protestant 'Victorian household in a Georgian house in a Georgian town'. She went to school at Alexandra College in Dublin, and at the age of fifteen was sent to finishing school, first at Versailles in France and then at Freiburg in Germany. In 1900 she entered the studio of May Manning in Dublin and attended evening classes with the sculptor John Hughes at the Metropolitan School of Art. In 1905 she made her début at the Royal Hibernian Academy exhibition, and that same year she visited Paris, where she studied under the painter Delacluse. During her second visit to Paris in 1906 she studied with the portrait artists Antonio de la Grandara and Lucien Simon, and attended art classes at the private studios, Colarossi's and La Grande Chaumière. In the city's many commercial galleries she studied the paintings of Cézanne and Gauguin, as well as the more contemporary works of Braque, Derain, Matisse and Picasso.

When Swanzy returned to Dublin she found that there was little appreciation of the modernist trends in painting that she had seen in Paris. She was encouraged by her father to specialise as a portrait painter, but after a few years she found the genre inhibiting. In 1913 she held her first one-woman show in Dublin, exhibiting conventional portraits and scenes in which she adopted a modernist style. In 1914 she was represented at the Salon des Indépendants in Paris, where *avant-garde* painters like Delaunay were attracting attention. She held another one-woman show in Dublin in 1919, which received mixed reviews for its eclectic use of divergent styles, from Fauvism to Cubism. The following year she was one of the ten founder members of the Society of Dublin Painters.

The deaths of her parents gave Swanzy the financial independence to indulge her desire to travel widely. In 1919–20 she visited Yugoslavia and Czechoslovakia, where she joined one of her sisters in Protestant missionary work. In 1923–4 she travelled to Hawaii and Samoa, attracted by 'everlasting curiosity' and 'stunned at how many greens there were in the world'. As she had done in Czechoslovakia, she made many sketches of the native people and the landscape. In Samoa she was fascinated by the exotic environment, the coconut groves, the papaya and banana trees, the humid tropical climate, and the strong contrast of light and shade caused by the intense sunlight. While in Paris, Swanzy had seen examples of the paintings Gauguin had made on Tahiti, and her Samoan pictures, like *Samoan Scene*, have his high-pitched coloration and his delight in decorative surface patterns. Swanzy's paintings of the Tropics are more lyrical, however, and her naturalistic response avoids the symbolism and personalised approach of Gauguin.

In 1924 Swanzy showed some of her Samoan canvases at exhibitions in Honolulu, Hawaii, and Santa Barbara, California. She returned to Dublin in 1925 and from there she visited Paris, where she showed more Samoan scenes. In 1926 she took up residence in Blackheath, south London, and lived there for the rest of her long life. During the 1920s and 1930s Swanzy explored individualised versions of Fauvism, Cubism, Futurism and Surrealism. She contributed occasionally to exhibitions in Dublin, London and Paris. In September 1943 she participated in the first Irish Exhibition of Living Art. The tragedy of the Second World War affected her deeply, and for the last thirty years of her life her work became more figurative and imaginative. Her palette darkened and her imagery became fantastical, in the tradition of Bosch, Goya, Blake and Daumier. She was also influenced by the strong pictures that Orpen had painted as a war artist during World War I. In 1949 she was elected an honorary member of the Royal Hibernian Academy. Swanzy died in 1978 at the age of ninety-six.

Pyle 1975; Brennan 1983; Campbell 1986; Ruane 1986; McConkey 1990; Kennedy 1991 (2).

LEO WHELAN
(1892–1956) (SEE P 118)

Leo Whelan was born in Dublin in 1892 and educated at Belvedere College. He studied at the Dublin Metropolitan School of Art, where Orpen singled him out as a promising young artist. Orpen was admired greatly by his best students, to whom he gave most of his attention, but less talented students considered him a poor teacher because he tended to ignore them. In 1911 Whelan exhibited a painting at the Royal Hibernian Academy's annual exhibition, the first of 264 works that he showed there during his lifetime. In 1916 he was awarded the Taylor Art Scholarship of the Royal Dublin Society for his painting *The Doctor's Visit* (National Gallery of Ireland). Whelan developed a portrait style that was influenced by Orpen's insistence on academic rigour, strong composition and a realistic approach to his sitters. He admitted also to a great admiration for the Spanish artist Velázquez, and for the American virtuoso portrait painter John Singer Sargent.

Indebtedness to tradition may have curbed Whelan's originality but, nonetheless, he produced many competent portraits and some excellent interior studies. *The Kitchen Window*, painted about 1926, is a fine example, in which a woman standing beside a table pauses momentarily, as if distracted from her daily chores. As in other interiors by Whelan, the model was almost certainly his sister Frances, and the setting was probably the basement of his house in

Eccles Street, Dublin. The window to the right creates strong effects of light and shade (usually called 'chiaroscuro'). Whelan delights in the effects of light, its direction, and the handling of shadows and reflections. The red and white check-patterned cloth contrasts admirably with the yellowish cupboard doors and the woman's blue spotted blouse. There are clever details, such as the flaking paint on the cupboard. The large silver trophy on the table presents Whelan with an opportunity to show his prowess as a still-life painter. The picture is obviously based on the seventeenth-century works of Dutch artists like Vermeer and Metsu, but Whelan provides a variant of their subject matter, which often featured men and women reading, writing letters or playing musical instruments in a small room lit by a large window to the side.

Whelan was elected an associate of the Royal Hibernian Academy in 1920, and a member in 1924. He was one of the Irish artists who participated in the *Exposition d'Art Irlandais* which was shown at the Galérie Barbazanges in Paris from 28 January to 25 February 1922. In 1926 he was awarded a medal at the Tailteann Games for his portrait of the vice-provost of Trinity College, Dublin, Dr Claude Louis Purser, who commented that it was 'absurdly' like him. In 1930 Whelan helped to organise an exhibition of Irish art in Brussels on behalf of the Musées

Royaux des Beaux Arts de Belgique. During the 1930s and 1940s he established himself as one of the best portrait painters in Dublin. He died in 1956.

Pyle 1975; Arnold 1981; NGI 1981–3; Kennedy (S B) 1991 (2); Murray 1992.

SEÁN KEATING
(1889–1977) (SEE P 119)

Seán Keating has been called 'virtually the painter-laureate' of independent Ireland. His paintings are often seen as important historical and social documents about Ireland during a tumultuous period in its history. In some respects Keating was an ideologue, a propagandist for the new regime. The powerful images he created have the static intensity of icons, and they add immeasurably to a deeper understanding of the social concerns of the period.

Born in Limerick in 1889, Keating attended drawing classes at the technical school there, and in 1911 he won a scholarship to the Dublin Metropolitan School of Art. In 1912 and 1913 he studied life painting and drawing under William Orpen, becoming his favourite pupil. Keating's proficiency was rewarded in 1914 with a free year at the school, and it was during this period that he visited the Aran Islands for the first time. He described the Aran islands as 'a revelation', a place where 'there was a wonderful background of barren landscape with very agile handsome men'. These heroic figures became the archetypes for a series of quasi-political paintings, the first of which, *Men of the West* (Hugh Lane Municipal Gallery of Modern Art, Dublin), was exhibited at the Royal Hibernian Academy, Dublin, in 1917. Keating went to London in 1915 as Orpen's studio assistant. He tried unsuccessfully to persuade Orpen to return with him

to Dublin in 1916. In 1918 Keating was elected an associate of the Royal Hibernian Academy and he became a member the following year. During the 1920s and 1930s he was awarded several public commissions and he contributed to exhibitions in a number of countries. In 1938 he exhibited a huge picture, 24 feet (7.3 metres) high by 72 feet (21.9 metres) wide, in the Irish Pavilion at the New York World Fair. Also in New York he was awarded first prize for his painting *The Race of the Gael*, in an international competition sponsored by the IBM Corporation, among artists representing seventy-nine countries. Keating had been appointed in 1918 as an assistant teacher at the Dublin Metropolitan School of Art, and when it was reconstituted in 1937 as the National College of Art he was appointed professor of painting. He gained a formidable reputation as a trenchant critic of modernism, and advocated rigorous artistic training based on academic principles. He was president of the Royal Hibernian Academy from 1950 to 1962.

Of the few commissions awarded to visual artists by state-sponsored bodies in the years of the Irish Free State, none was more impressive than that completed by Seán Keating between 1926 and 1929, when he charted the development of the Electricity Supply Board's Hydro-Electric Scheme on the river Shannon. The series comprises twenty-six paintings and drawings. *Night's Candles are Burnt Out*, painted

in 1928–9 and exhibited at the Royal Academy, London, in 1929, is an allegory showing Ireland emerging from economic deprivation, enduring the war of independence and a civil war, and progressing to economic prosperity. The businessman contractor (centre foreground) looks at the gunman with disdain. The big dam that is generating electricity will supplant the oil lamp held by the workman (centre left) and the candle used by the priest (bottom right). The young family (centre right) gesturing towards the dam represents the new era, and the skeleton (top left) represents the old redundant past. The bearded man is a self-portrait of the artist. This didactic image proves Keating's capacity as a social realist and marks him out as the painter who did most to create, in visual terms, a 'corporate identity' for independent Ireland.

Irish Art Handbook 1943; Seán Keating 1981; Turpin 1988; Seán Keating 1989; McConkey 1990; Kennedy (B P) 1990, 1992; Kennedy (S B) 1991 (2).

CHARLES LAMB
(1893–1964)　　　　(SEE P 120)

Charles Lamb was born in Portadown, County Armagh, in 1893, the eldest of seven children. He was apprenticed to his father, a painter and decorator, and at the age of fourteen he was sent to the local technical school. In 1913 he won a gold medal as the school's best apprentice house painter. He enrolled for evening classes in the Belfast School of Art, and in 1917 he won a scholarship to the Dublin Metropolitan School of Art. In 1921 he visited Carraroe in Connemara, County Galway, and was captivated by the beautiful scenery there. The thatched cottages, traditional costumes and simple lifestyle of the Irish-speaking people of the area supplied him with ready subject matter for his paintings. In 1923 he was elected an associate of the Royal Hibernian Academy in Dublin, and he held his first one-man exhibition. He acquired a cottage in Carraroe in the same year. Lamb was in Brittany in 1926–7, and he spent most of 1928 living in a caravan on the Aran Islands.

Throughout the 1930s Lamb's paintings of the landscape and the people of Connemara were shown at exhibitions in Ireland, England and the United States. He was one of the artists selected to participate in the Irish Exhibition in Brussels in 1930, and some of his landscapes were used as illustrations in the *Saorstát Éireann Official Handbook* published by the Irish government in 1932. He exhibited at the Royal Hibernian Academy virtually every year from 1919 to 1964, and he was elected to full academy membership in 1938. In 1935 he built a house in Carraroe, and from there he launched an Annual Exhibition and Summer School, where he taught the principles of landscape painting to visiting students. He spent the winter of 1938–9 in Germany, and throughout the 1940s and 1950s he made regular painting trips to Northern Ireland. By the time of his death the rustic Ireland that he represented in so many paintings had, for the most part, already disappeared amid a tide of industrial, social and environmental changes introduced by the government under the leadership of Seán Lemass.

Although he shared the enthusiasm of Seán Keating and Paul Henry for the west of Ireland, Charles Lamb had a more contemplative personality. His art was unintellectual, rooted firmly in the solidity of peasant life. *A Quaint Couple*, which was exhibited at the Royal Hibernian Academy in 1931, was painted in an iconographic style. Just as Keating and Henry had selected the Irish peasant as the symbol of national life and the struggle for independence, Lamb portrayed an aged couple who embodied what he termed 'the national essence'. Their faces are tired but noble, and it is implied by the resolute way they sit side by side that their marriage has survived well though their way of life is not easy. Lamb's painting technique — simple, unencumbered and fluid — contributed to the air of sympathy for his subjects that is apparent in his work. He preferred direct representation of nature, and often painted his landscapes outdoors in an attempt to capture the rapidly changing light of Connemara. It has been said of Lamb that 'his work could never be criticised on the grounds of having excess of means over content'. His fine paintings of the west of Ireland are a testament to and an historically accurate record of a bygone age.

Charles Lamb *1969; McConkey 1990; Kennedy (S B) 1991 (2)*.

PAUL HENRY
(1876–1958)　　　　(SEE P 121)

Paul Henry was born in Belfast, the son of the Revd Robert Mitchell Henry, a Baptist minister who later converted to the Plymouth Brethren, and his wife Kate Ann Berry. His upbringing was strict, and after leaving school he served as an apprentice with a Belfast linen firm. He left after a short time to pursue his wish to become an artist, and he enrolled at the Belfast School of Art. In 1898 he went to Paris where he attended the Académie Julian and James McNeill Whistler's Académie Carmen. From Whistler he acquired an appreciation of the importance of tone over colour. He also admired the work of Jean François Millet, the Barbizon painter of French peasant life. Henry was especially competent in the use of charcoal, which became his favourite medium. In about 1901 he moved to London, and for the next decade he made a modest living as an illustrator of books and magazines. While in Paris he had met Grace Mitchell, a Scottish-born painter whose father, like Henry's, was a minister, and they were married in 1903.

Henry's work as a graphic artist did not challenge his talents, and he began to make pictures, exhibiting for the first time in 1906 at a group exhibition in London. On the advice of friends who had enjoyed a visit to Achill Island, off County Mayo on the west coast of Ireland, Paul and Grace Henry went there in the summer of 1910. They stayed for nearly one year, and in 1912 they settled on the island, living there until 1919 when they moved to Dublin. On Achill, Henry found a poor peasantry which reminded him of those noble people painted by Millet. He began to paint their daily activities; harvesting seaweed, gathering turf and fishing. He was captivated by the 'other worldliness' of the rugged landscape, particularly in the early hours of the morning, and he was attracted by the effects of the rapidly changing light which he observed while on painting trips in the west of Ireland.

After moving to Dublin Henry became active in the local art scene, and in 1920 he and Grace, together with a number of other painters including Jack B Yeats, James Sleator and Mary Swanzy, founded the Society of Dublin Painters. The society became a sort of 'Salon des Indépendants', and through its regular exhibitions, modernist trends in painting were introduced. Until the foundation of the Irish Exhibition of Living Art in 1943, the society's members were the main proponents of avant-garde painting in Ireland. By the mid 1920s Henry had developed a style of painting that changed little for the rest of his career. During his early years on Achill he had painted pictures of people, but he then moved to landscape, with a few elements, a mountain, a lake and some cottages, placed in a bold composition, and a cloud-filled sky accounting for more than half of the picture space. *Lakeside Cottages*, painted about 1930, is a quintessential work by Paul Henry, redolent of a simple, disciplined, rural way of life free from the advance of technology.

During the 1920s a number of Henry's works were reproduced as posters and distributed in Ireland and abroad. The popularity of these images as the standard view of the west of Ireland in tourist literature and in government publications created such a demand for similar pictures that Henry became a victim of his own imagery. His pictures brought him success, however, and in 1926 he was elected an associate of the Royal Hibernian Academy, and he became a member two years later. Marital difficulties and financial problems also contributed to a decline in his capacity for creating original compositions. In 1930 his marriage broke up and he moved to Carrigoona Cottage, near Enniskerry, County Wicklow. There he settled with Mabel Young, whom he had first met in 1924, and after Grace's death in 1953 they were married. In his last years Henry became almost totally blind and he could no longer paint, but his disability did not prevent him from writing short stories and two volumes of an autobiography. He died at Enniskerry in 1958.

Paul Henry, like Jack B Yeats, was a great individualist, who influenced many other painters. He created a new type of Irish landscape painting that was unromantic and sympathetic to the lifestyle and environment of the poorest people of the west of Ireland. In his use of mass and colour he was the first artist working in Ireland who painted in the post-Impressionist style. He never became an academic painter and his canvases are devoid of literary references. Although Henry's later output is repetitive, works like *Lakeside Cottages* are pure landscapes which guarantee him an important place in the history of Irish painting.

Pyle 1975; Kennedy (S B) 1989–90, 1990, 1991 (1), 1991 (2); McConkey 1990; Croke et al 1991; Murphy 1991; Kennedy (B P) 1993.

MAURICE MACGONIGAL
(1900–79) (SEE P 122)

Maurice MacGonigal was born in Dublin, the son of Frank MacGonigal, a Sligo-born master painter and decorator, and his wife Caroline Lane. He was sent to the Christian Brothers' School at Synge Street, Dublin, and at the age of fifteen he became an indentured apprentice in the stained glass studio owned by his uncle, Joshua Clarke. The type of glass design produced by the studio was determined largely by MacGonigal's cousin, the brilliant stained glass artist Harry Clarke. In 1916 MacGonigal joined the republican organisation Na Fianna Éireann, and from there he progressed to membership of the Irish Republican Army. He was actively involved in the struggle for Irish independence and was arrested and interned in 1920. While in prison, he studied the Irish language and the cultural history of Ireland. On his release in 1922 he resigned from the IRA and rejected active politics. He continued to work in the Clarke Studios, and in the evenings he studied at the Metropolitan School of Art. In 1923 he won the Taylor Art Scholarship, along with an award enabling him to become a day student. He decided to abandon stained glass, which he found restrictive, and to pursue instead an academic training as a painter. His teachers included William Orpen's protégés, Seán Keating, Patrick Tuohy and James Sleator. He first exhibited at the Royal Hibernian Academy, Dublin,

in 1924, and he continued to participate in its annual show for the next fifty-four years.

In 1927 MacGonigal visited Holland, where he was impressed by seventeenth-century Dutch art and by the works of the nineteenth-century painters, in particular Van Gogh, whose works pulsated with life: 'He was more valuable than all those old masters, and I have not seen a modern that could come near him in intensity.' The trip to Holland convinced MacGonigal that the painting of well-observed landscapes could assist the establishment of a national identity, and he determined to concentrate on landscape painting, although he also painted genre scenes and some portraits. His visits to the west of Ireland confirmed his view that an identification with the Irish landscape was a basic requirement for an understanding of Gaelic culture. He held his first one-man show in 1929, was elected an associate of the RHA in 1931 and a member two years later. He became keeper of the RHA School and was soon one of the most successful artists in Dublin. In 1947 he was appointed professor of painting at the RHA, and he was elected president of the academy in 1962, in succession to Seán Keating. He designed posters, stage sets, and worked as a book illustrator, besides producing many oil paintings and watercolours.

MacGonigal's death in 1979 marked the close of a splendid generation of painters who had been influenced by William Orpen and had helped to forge a visual identity for independent Ireland. The large studio palette that was placed in his grave at Roundstone, County Galway, had been bequeathed to MacGonigal by James Sleator, who had, in his turn, received it from Orpen.

The Dockers is a forceful subject painting which shows three dockers standing before a crowd, with the hull of a large red ship in the background. These workers were called 'button' men, casual labourers who were hired on a daily basis, and the expressions on the faces of those shown here display a resigned acceptance of their insecurity. They were recruited for MacGonigal by his friend, the union leader 'Big Jim Larkin'. MacGonigal makes a sympathetic case for the plight of dockers in Dublin port by using a strong coloration and a confrontational composition. The painting provides a serious political comment on the economic difficulties in Ireland during the 1930s.

Turpin 1988; McConkey 1990; Croke et al 1991; Crouan 1991; Kennedy (S B) 1991 (2).

MAINIE JELLETT
(1897–1944) (SEE P 123)

Mary Harriet (Mainie) Jellett was a key figure in the history of twentieth-century Irish art. She was born into a distinguished Dublin family; her father was a leading barrister and her mother a talented musician. The four Jellett girls were given pet names, Mainie, Bay, Betty and Babbin. Mainie was a highly proficient pianist and she could have become a professional musician, but she chose instead to be a painter. Her early teachers were the Yeats sisters (Lily and Lollie), May Manning and Norman Garstin. She was influenced by William Orpen at the Dublin Metropolitan School of Art, before travelling to London to enrol under Walter Sickert at the Westminster School of Art. Sickert encouraged her to open her imagination, while also instilling in her the principles of good technique.

Jellett met Evie Hone in London and they became lifelong friends. Together they travelled to Paris to study at André Lhote's academy. Lhote emphasised the need to appreciate the permanent truths to be found in the works of the old masters. He was a renowned teacher and theorist who practised a modified version of Cubism, in which he approached his subject from one angle only, thereby failing to appreciate the real radicalism of the Cubist method. In 1922 Jellett and Hone became students of Albert Gleizes, one of the original Cubist group, and then collaborated with him for almost ten years in his development of principles for abstract painting. The modernism that emerged, controversial even in Paris, was treated harshly in Dublin. When Jellett exhibited two abstract paintings in her native city in 1923 the writer George Russell attacked them as 'artistic malaria'. Jellett worked with Gleizes in the evolution of his theories of 'translation and rotation', which encouraged the spectator to see the logical progression of colours and forms within a painting. Volume was negated in favour of a series of planes, each one level with the canvas surface. During the 1920s Jellett's work was abstract, and in the 1930s she moved towards semi-abstraction and a more realistic style of painting. Up until her final solo exhibitions of 1939 and 1941 she rarely used titles for her paintings.

Jellett returned to Ireland to teach and to promote the modernist movement in art. Because she chose to reside there, her international reputation suffered, expecially when compared with that earned by expatriates like Roderic O'Conor, John Lavery and William Orpen. Jellett was a good publicist, a manifesto-maker, and an excellent lecturer and broadcaster. She travelled widely during the 1930s and was commissioned by the Irish government to decorate the Irish pavilion at the Glasgow Fair in 1937. She was a founder member and the first chairperson of the Irish Exhibition of Living Art, but she became ill before its first showing, and died in Dublin in 1944, aged forty-six.

Achill Horses, a visual poem, was painted in 1941. Jellett's research for the Glasgow murals had focused her mind on the landscape of the west of Ireland, and of Achill Island, County Mayo, in particular. In *Achill Horses* the animals prance and dance in the sea-waves. The painting is an elaborate composition of subtle colour harmonies and surface patterning, in which Jellett ably adheres to her own dictum: 'The surface is my starting point, my aim is to make it live.'

Irish Art Handbook 1943; Frost 1957; McCarvill 1958; Hartigan 1987; Croke et al 1991; Kennedy (S B) 1991 (2); O'Connell 1991; Arnold 1992.

HARRY KERNOFF
(1900–74) (SEE P 124)

Aaron 'Harry' Kernoff was born in London, the son of a Russian Jewish father and a Spanish mother. When he was fourteen his family moved to Dublin, where his father established a business as a cabinet maker. He was apprenticed to his father's trade but attended evening classes at the Metropolitan School of Art. In 1923 he became the first night student to win the Taylor Art Scholarship in both watercolour and oil painting. He lived in Dublin for the rest of his life, making only a few trips abroad: to the Soviet Union about 1930 and to Nova Scotia in the summer of 1958. He travelled widely in Ireland and painted many of the colourful characters of Dún Chaoin, County Kerry, and of the Blasket Islands off the Kerry coast. He was much involved with the literary and theatrical personalities of Dublin and he painted portraits of most of them during his long career. He was a noted 'character' and was easily recognised, being a small man with thick glasses and a large black hat. He exhibited at the Royal Hibernian Academy, Dublin, for the first time in 1926, and then every year until 1974, when he died on Christmas Day. He was elected an associate of the RHA in 1935 and a member the following year.

Kernoff's loyalty to the academic tradition is evident in his figurative and landscape studies. He joined the Society of Dublin Painters in 1927, but after a brief dalliance with modernist tendencies he rejected abstraction and opted for a realistic approach to painting his surroundings. His subject matter was confined largely to portraits and landscapes. The portraits are distinguished by an excellent standard of characterisation and careful observation of dress and mannerisms. The landscapes are concerned with presenting the details of a scene, the buildings and people, rather than mood and atmosphere. It is this trait that links Kernoff with German realism, a concern for working people and a disdain for pomposity and pseudo-sophistication. He was a competent graphic artist who produced innumerable woodcuts and illustrations for books, periodicals and ballad sheets. His drawings for theatre sets and costumes are often delightful and witty, and occasionally satirical. The work of the Russian designers of the 1920s, which Kernoff witnessed at first hand, influenced him greatly and gave his drawings a cosmopolitan air, allowing him to reveal the Bohemian society that existed in Dublin during the years of the Irish Free State (1922–48).

Kernoff has been described as the Irish urban artist *par excellence* and the quintessential painter of the country's capital city, recording its citizens and its architectural and cultural heritage. *Sunny Day, Dublin* is a typical example of his robust, linear approach to painting, in which he depicts a mundane city alley with its old gas lamp, drain pipes, chimneys, a derelict plot and a stepped walkway where a woman scurries along and a pony-tailed young girl stares through a railing. The ordinariness of Kernoff's subjects is perhaps their most attractive feature. His pictures are full of charm, guaranteeing the artist a permanent place in the affections of those who appreciate Irish art.

MacGonigal 1976; Ruane 1986, 1988; McConkey 1990; O'Brien 1990; Croke et al 1991; Kennedy (S B) 1991 (2).

NORAH McGUINNESS
(1903–80) (SEE P 123)

Norah McGuinness was born in Derry in 1903 to a prominent family of merchants and farmers. She was educated at Victoria High School, Derry, and while still a pupil there she attended classes at the Derry Technical School. McGuinness was determined to become an artist, and in 1921 she went to Dublin and enrolled at the Metropolitan School of Art. Her teachers included the painter Patrick Tuohy, the designer Oswald Reeves, and the stained glass artist Harry Clarke. While Clarke was the strongest influence on her work during her student days, it was an exhibition of Impressionist and post-Impressionist paintings which she saw in London in 1923 or 1924 that had the greatest impact on her artistic development. In 1925 she married the poet Geoffrey Phibbs (better known as Geoffrey Taylor) and became involved in the theatrical world of Dublin. She began to produce costumes and set designs for plays at the Abbey Theatre and at the Peacock Theatre where, in November 1927, she designed the sets for its first production. She was also in demand as a book illustrator, and her illustrations for William Butler Yeats's *Stories of Red Hanrahan and The Secret Rose* (1927) were much praised.

In 1929 McGuinness's marriage broke up, and on the advice of her friend Mainie Jellet she went to Paris to study with André Lhote. Perhaps because she had already been working as a designer for a few years, Lhote's Cubism made little impression on her. Instead she absorbed influences from a range of artists, including Lhote, Jean Lurçat, Maurice Vlaminck, Raoul Dufy and especially Georges Braque. She developed a bold style with strong coloration and moved away from the linear quality of her design work. She began to use watercolour and gouache (also called poster paint), which allowed her to experiment with tonal values. McGuinness travelled to India for five months in 1931, then lived in Paris for about a year, and in 1932 she moved to London where she stayed until 1937. Late in 1937 she went to the United States of America, remaining there until 1939 when she returned to live permanently in Dublin. The New York fashion for well-designed shop window displays had impressed McGuinness and she persuaded Edward McGuire of Brown Thomas's department store in Dublin to employ her as a window designer, a position she held for the next thirty years or so. She resumed her work as a stage designer, although she lamented that after working at length to create good designs, her work was then only on view to the public for a few weeks before it was dismantled. Nonetheless, she had the comfort of knowing that her designs were well received, and among her most dramatic sets were those designed for the first Abbey Theatre production of Samuel Beckett's *Waiting for Godot*.

By the 1930s McGuinness's painting was restricted to landscape and still-life subjects, and she showed no interest in pure abstraction. She continued to work in watercolour or gouache or, as in *The Swan, Kilkenny*, in oil on paper (1943). This attractive picture is typical of McGuinness's brisk, loose brushwork at this time, an unacademic approach to oil painting which is fresh and spontaneous. In 1943 she was a founder member of the Irish Exhibition of Living Art, and after Mainie Jellett's death the following year, she was selected as president. In this role McGuinness was an active proponent of modernism, offering support and encouragement to young artists. In 1950 she was selected with the artist Nano Reid to represent Ireland at the Venice Biennale, and in 1957 she was elected an honorary member of the Royal Hibernian Academy, Dublin. A retrospective of her work was held in Dublin and Cork in 1968, and she was awarded an honorary doctorate by Dublin University in 1973. She died in 1980.

Crookshank 1968; Pyle 1975; Barrett 1980; Hartigan 1986, 1987; Irish Women Artists 1987; McConkey 1990; Kennedy (S B) 1991 (2).

SEÁN O'SULLIVAN
(1906–64) (SEE P 125)

Seán O'Sullivan was arguably Ireland's most naturally gifted portrait draughtsman. He was born in Dublin, where his father had a woodworking business, and was educated at the Christian Brothers' School in Synge Street. A scholarship from the Dublin Metropolitan School of Art enabled him to travel to London, where he is reputed to have studied with Henri Morriset, Angel Zarrago (a Mexican artist) and at the Central School of Art. From there he travelled to Paris, where he enrolled at a number of private establishments, among them La Grande Chaumière and Colarossi's. After his return to Dublin he began teaching at the Metropolitan School of Art. A superb technician and draughtsman, he quickly received many commissions for pencil and oil portraits.

In 1928, aged twenty-one, O'Sullivan became an associate of the Royal Hibernian Academy in Dublin, and in 1931 he was elected a member. His oil portraits, landscapes, graphic work and postage stamp designs have been underrated, but it was his speed and sureness of hand as a portrait draughtsman that won him special admiration. His small portrait drawings in pencil, chalk or pastel provide a veritable 'Who's Who' of Irish society from the late 1920s to the early 1960s. A big, burly man with a kind heart, O'Sullivan had a sensitive feel for each of his sitters, and his best portraits include those of distinguished individuals such as Douglas Hyde,

William Butler Yeats, Sir Alfred Chester Beatty and Éamon de Valera. A fluent French speaker, he revisited Paris many times and became acquainted with talented writers and artists living there, including James Joyce, Thomas MacGreevy, Georges Rouault and Raoul Dufy. In 1958 he visited America, where he was inundated with requests for portrait drawings, for each of which he received a $100 fee. The constant demand for what came easy to him drained O'Sullivan of his vitality. There were few public commissions to challenge his imagination and there was only so much variety of pose possible in his portraiture. The commissions he received for paintings of religious subjects, for example from Fr Senan, editor of *The Capuchin Annual*, led to competent but uninspired work of modest importance. In many respects O'Sullivan was a victim of his times because although he had natural talent and openness to new ideas, Ireland offered him little opportunity to explore them. He died in Nenagh, County Tipperary, in 1964, aged fifty-eight.

O'Sullivan's large portrait, *Éamon de Valera*, was completed in 1943 when the great Irish statesman was sixty-one. De Valera was then Taoiseach (Prime Minister) of Ireland, at the height of his influence and steering a careful course for his country during the Second World War. O'Sullivan argued that a portrait should reveal how an artist feels about his sitters, each of whom must be portrayed 'as dispassionately as a piece of still life'. It is obvious that O'Sullivan was sympathetic to de Valera, whose resolute but compassionate gaze and assertive pose inspire confidence and trust. The low-key palette of blue, black and brown serves to direct attention towards the flesh areas of the face and hands, which have been painted with the assured confidence of the master portraitist.

Denson 1968–9; Pyle 1975; Kennedy (S B) 1991 (2).

JAMES SINTON SLEATOR
(1885–1950) (SEE P 125)

The power of William Orpen's personality and his teaching legacy extended over academic painting in Ireland for several decades after his death in 1931. Dermod O'Brien, president of the Royal Hibernian Academy, Dublin, from 1910 to 1945, was older than Orpen, but his successors James Sleator (president 1945–50) and Seán Keating (president 1950–62) had been Orpen's studio assistants, and they in turn taught Maurice MacGonigal (president 1962–77). In some respects Orpen's influence stunted the potential of his pupils, but it is equally true that he taught them an approach to anatomy, characterisation and painting technique that they might not otherwise have appreciated.

James Sinton Sleator was born in 1885 near Portadown, County Armagh, to a Presbyterian family with origins in Scotland. In about 1903 he went to the Belfast College of Art, where he trained as an art teacher. He enrolled as a mature student in the Dublin Metropolitan School of Art in 1909 and remained there until 1914. Orpen, who considered Sleator to be a good student, invited him to London as his studio assistant. The following year Sleator returned to Dublin where he began exhibiting at the Royal Hibernian Academy. He was elected an associate of the RHA in January 1917 and a member the following October. His reputation was based on his academic approach to portrait painting, but he also expressed some interest in modernist

developments in art. In 1920 he was one of the initial group of members of the Society of Dublin Painters, which had been instigated by Paul Henry to promote public interest in modern painting. He took part in the first exhibition only, and presumably dropped out because he felt himself at variance with the non-academic approach of his colleagues. In about 1922 he went to Italy, where he stayed for five years, making occasional visits to Ireland and England. It is not known if he received any major commissions in Italy, but while he was based there he had a one-man exhibition in Belfast, *Portraits and Still Life Works*, the only solo show of his career, and he continued to exhibit regularly at the RHA.

In 1927 he returned to London as Orpen's studio assistant and worked on private portrait commissions. When Orpen died Sleator was asked to complete a number of his former master's unfinished portraits, although during the 1930s he sent mostly still lifes to the annual RHA exhibitions. The wartime blitz in London prompted his return to Dublin in 1941, where he was soon in demand for official portrait commissions. He became closely involved with the RHA, for which he was elected as secretary and professor of painting in 1942, and president in 1945. His modesty and agreeable disposition helped the academy through the difficult period of adjustment that followed the rejection of academic art by the supporters of modernism, who had founded the Irish Exhibition of Living Art in 1943. Sleator never married, and he died in his home, Academy House, in 1950.

Sleator's portrait *Jack Butler Yeats RHA* is a fine example of his easy, disciplined style. Yeats, an introspective man, is presented in relaxed pose, wearing his overcoat, with his hat propped on his head and a gentle, slightly quizzical gaze on his face. Sleator never sets out to flatter his sitters, but his sympathetic approach to character and personality is always in evidence.

Arnold 1981; Kennedy (S B) 1989, 1991 (2); McConkey 1990; Murray 1992.

FRANCIS BACON
(1909–92) (SEE P 126–127)

Francis Bacon was born in 1909 at 63 Lower Baggot Street, Dublin, one of five children of English parents. His father, Edward Anthony Mortimer Bacon, a retired British Army major, was a horse trainer at the Curragh, County Kildare, and his strict, moralising character brought him into conflict with his artistic son. Bacon's mother, Christine Winifrid Firth, had an easy-going and gregarious nature, but like her husband she found her son difficult to understand. Bacon suffered from asthma during his childhood, as a consequence of which he had no regular schooling except for some tutoring by an Irish clergyman. He became unsettled when his father joined the War Office in London in 1914 and the family moved to London. Thereafter, Bacon's family transferred regularly between England and Ireland. Bacon remained in Ireland, at the family home, Straffan Lodge, County Kildare, where he was under the supervision of a nanny who abused him by locking him in a cupboard for hours at a time. He also spent considerable time with his agreeably eccentric maternal grandmother, a wealthy lady, thrice married, who was fond of entertaining at her large house in Abbeyleix, County Laois. When Bacon's father sent him to Dean's Close School, Cheltenham, to receive a proper English boarding school education, Bacon absconded and returned to Ireland to his grandmother's house in Laois. Bacon always retained memories of cavalry manoeuvres at the Curragh during the First World War and of the violent atmosphere of the Irish War of Independence (1919–21) and the Civil War (1922–3). Finally, in 1926, when Bacon's homosexuality was

revealed after his father discovered him wearing his mother's underwear, he was banished from the family home. Bacon left Ireland and never visited it again, although he acknowledged, on the rare occasions he spoke about his childhood there, that his Anglo-Irish inheritance had given him an open-minded outlook, a love of gambling and extravagance, and a rigorous work discipline which he maintained throughout his life.

After he left Ireland Bacon stayed in London for a year, and in 1926 he spent two months in Berlin, where he revelled in the city's mood of freedom and pleasure. He visited Munich briefly and then moved to France, where he worked for two years as an interior decorator and designer in Paris. Visits to that city's great museums and galleries impressed him, but it was an exhibition of drawings by Picasso, which he saw at a commercial gallery in 1927, that inspired him to make some watercolours and drawings. He returned to London in 1929 and began to study the technique of oil painting by a process of self-discovery, because he had received no formal artistic training. He had only minor successes throughout the 1930s, with one of his paintings included in a book about contemporary art, his first one-man exhibition in 1934, which he organised himself, and some works included in group exhibitions. In 1943 he was declared unfit for military service, due to his asthmatic condition. He worked briefly as an air-raid warden but was again discharged because of ill-health. Later in 1943 he destroyed most of his earlier pictures, and the following year he resumed painting with an obsession that never left him. He settled in

London and resided there for the rest of his life, although he made regular trips abroad.

Bacon painted *Figure in a Landscape* in 1945, the year the Second World War ended. It was inspired by a photograph of his friend Eric Hall dozing in a canvas chair in Hyde Park, London. Bacon's painting, however, shows a truncated male figure seated on a chair, as if the machine-gun-like contraption, shown to the right, has blown off its head. The image is one of violence and barbaric savagery amid a harsh, desert landscape. It is highly complex, capable of numerous interpretations, but is undoubtedly a comment on the futility of war.

From the late 1940s Bacon received increasing international recognition for his paintings. Their monumentality, sheer artistic presence, and the manner in which they were perceived to address the austerity and the anxiety of war-torn Europe, made them difficult but accurate icons of their time. After 1951 Bacon began to paint portraits of identifiable persons, including a number of men with whom he had lengthy relationships. The first major retrospective exhibition of his paintings was held at the Tate Gallery, London, in 1962. During the next three decades several large exhibitions of his work were held in various cities throughout the world, including one at Dublin's Municipal Gallery of Modern Art in 1965, which made a significant impact in his native city. Bacon died in 1992 at the age of eighty-two, while on holiday in Madrid.

Russell 1971; Leiris 1983; Sylvester 1987; Gowing and Hunter 1989; Alphen 1992; Farson 1993.

JOHN LUKE
(1906–75) (SEE P 128–129)

John Luke was born in 1906, one of eight children of a Belfast Methodist working-class family. After primary school he began work as a 'heater boy', bringing hot rivets to the steelworkers in Workman and Clarke's Shipyard. Encouraged by his workmates and by his father, who recognised his artistic talent, he enrolled as a student in the Belfast School of Art. In 1927 he was awarded the Dunville Scholarship of one hundred pounds, and this took him to the Slade School of Art in London, where he trained under Henry Tonks. He attended the Westminster School of Art for a time, and in late 1931 he returned to Belfast. He was a founder member of the modernist group of painters called the Ulster Unit, which was formed in 1934 and modelled on Unit One, the group founded by Paul Nash in London the same year. During the Second World War Luke lived at Knappagh Farm, Killylea, County Armagh, where he experimented with a highly individual approach to landscape painting — romantic and almost mystical in concept. He had a particular interest in aesthetics and in painting techniques, and his visionary capacity was given ample scope in his series of fantasy pictures begun in the early 1940s. He gave up easel painting in about 1948, and during the 1950s he received a number of public commissions to paint murals, including those at Belfast City Hall and at the Masonic Hall in Rosemary Street, Belfast. Luke was a brilliant

draughtsman and was employed as an art teacher at the Belfast College of Art, but he found it difficult to communicate his approach to drawing to his students. An intensely shy man, he lived a solitary existence and had only a few friends who knew him well. He began work on his last major commission in 1961, for the College of Technology at Millfield, and it was still unfinished when he died in 1975.

The extraordinary painting technique developed by Luke was laborious and craftsmanlike, and he usually produced no more than one or two pictures each year. One critic wrote that his technique had reached 'a pitch of perfection rarely heard of since the Renaissance' and warned that 'any painter of such ability is in danger of becoming a slave to his own technical virtuosity'. Luke became so fascinated by technique that he prepared detailed notes, which were typed and pasted to the back of his pictures for posterity. The notes for the lovely dreamland painting *The Old Callan Bridge, Armagh*, completed at Knappagh Farm in 1945, detail his process. He used a masonite board as the support, to which he glued a cotton cloth and then applied a gesso (plaster) ground, resulting in a smooth, brilliant white surface. The underpainting of the design was then elaborated by heightening with tempera. The modelling and drawing were developed fully in light tones, and the overpainting consisted of up to five separate glazes of oil paints, to which linseed oil and varnish were

added, but no turpentine. Finally, the bridge, road and human figures were heightened with pale tempera colour.

Luke's paintings are sometimes described as provincial or eccentric, but in truth he was a brilliant naïve or primitive artist, and it has been remarked perceptively of *The Old Callan Bridge, Armagh* that it has echoes of the French artist Henri 'Le Douanier' Rousseau. In the history of Irish art John Luke is quite simply unique.

Hewitt 1977, 1978; McConkey 1990; Kennedy (S B) 1991 (2).

WILLIAM SCOTT
(1913–89) (SEE P 130)

William Scott was born in Greenock on the Firth of Clyde in Scotland in 1913, one of eleven children of a Scottish mother and an Irish father. The family lived in poor circumstances in Scotland, and in 1924 Scott's father, a house and sign painter, brought them to live in Ireland, in his native town of Enniskillen, County Fermanagh. His father taught him basic skills like mixing colours and cleaning brushes, and, recognising William's talent, sent him to a local art teacher, Kathleen Bridle, for lessons in drawing and painting. She introduced her teenage pupil to the work of great artists, including Cézanne, Derain, Modigliani and Picasso. In 1927 Scott's father was killed in a tragic accident and, because he was held in high regard, the local Protestant community created a fund for his family. In addition, Kathleen Bridle arranged for William to receive a scholarship to attend the Belfast College of Art. He enrolled at the college in 1928, aged fifteen, and stayed for three years.

In 1931 Scott went to London in the hope of entering the Royal Academy Schools. He applied for the course in sculpture because he thought the entrance qualifications would be easier, and for two-and-a-half years he trained as a sculptor. He transferred to the school of painting in January 1934, and received a highly academic training under the direction of Sir Walter Russell. In July 1935 he was

awarded a Leverhulme Travelling Scholarship. He did not take up the scholarship immediately, but continued to live in London, where he made regular visits to the major art galleries. He spent six months in Cornwall in 1936 and began to focus his artistic energies on what he called 'primitive realism', which he found in the work of artists such as Modigliani and 'Le Douanier' Rousseau. In 1937 he married Mary Lucas, a fellow student at the Royal Academy Schools, and they spent the following two years abroad, in Italy and France. They settled at Pont Aven in Brittany, where Gauguin and his followers had worked in the 1880s and 1890s. When the Second World War began late in 1939, the Scotts moved to Dublin for a short time before returning to London. From summer 1942 until spring 1946 Scott served as a private soldier with the Royal Engineers. He was not appointed as an official war artist and, consequently, had little time for painting.

After the war Scott resumed painting and accepted a position as senior painting master at Bath Academy. He was fascinated by the work of the French masters of still-life painting, Chardin, Cézanne and Braque, and following their example he began to restrict his subject matter to common kitchen objects, pots, saucepans, fruits, eggs, fishes and bottles. The content of Scott's still-life compositions was deliberately uninteresting so that it allowed him to concentrate on contrasting forms and on defining spatial

arrangements. Scott developed an individual style, of which *Still Life* (1949) is a typical example. It was exhibited in 1951 as 'Plums, knife and window'. The objects are arranged in a carefully worked composition, creating a matrix of horizontal, vertical and diagonal lines in which curvilinear forms appear to float on the flat picture plane. The colours used are rich, even sensuous, although the paint is applied thinly. The picture is testimony to Scott's belief that 'the poetry of the subject will be in the painting of it'.

From the 1950s to the 1980s Scott dedicated himself to the study of forms in space, moving intermittently from periods of pictorial abstraction to recognisable imagery. His meeting in 1953 with the American abstract expressionists, Jackson Pollock, de Kooning, Rothko, Kline and others, convinced him that he should not imitate them but continue to follow European traditions. This was reaffirmed by his visit to the Lascaux caves in France, where the prehistoric paintings renewed his interest in primitivism. Scott was elected an associate of the Royal Academy, London, in 1977, and a member in 1984. His paintings gained him an international reputation and examples were acquired for many important public and private collections. He died at his home near Bath in 1989.

Bowness 1972; Alley and Flanagan 1986; McConkey 1990; Kennedy (S B) 1991 (2).

EVIE HONE
(1894–1955) (SEE P 131)

Evie Hone was the daughter of Joseph Hone, a well-to-do maltster and a director of the Bank of Ireland, whose family lineage included the artists Nathaniel Hone the Elder (1718–84) and Nathaniel Hone the Younger (1831–1917). Her mother was the daughter of Sir Henry Robinson, a prominent lawyer. From the age of eleven Hone was partially crippled by infantile paralysis, and throughout her life she showed an indomitable spirit in the face of her constant struggle with her disability. Her childhood was one of prolonged medical treatment and of visits to England, France and Italy with her governess. In 1911 she was deeply impressed by a visit to Assisi, which fostered her profound interest in the Christian faith. She was determined to become an artist, and she trained with Byam Shaw, Walter Sickert and Bernard Meninsky in London. In 1920 she took Meninsky's advice to travel to Paris, where she joined her friend Mainie Jellett as a pupil of André Lhote. In 1922 Hone and Jellett became students of Albert Gleizes, one of the original Cubist group, and for part of each year until 1931 they travelled to France to assist him in developing his principles of abstract painting.

In 1924 Hone and Jellett held a joint exhibition at the Dublin Painters' Gallery. Their paintings were almost indistinguishable from each other. The works were described by critics as 'Cubist' and 'in the modern manner', and there can be no doubt that Hone and Jellett were the pioneers of abstract

painting in Ireland. Hone lost enthusiasm for the theory of abstraction, however, and in 1925 she ceased painting and entered a community of Anglican nuns in Truro, Cornwall. She remained there for about a year, and then decided to leave to resume painting. Her work became more figurative and brighter in colour. The stained glass windows of Chartres Cathedral and the work of Georges Rouault stimulated her interest in religious art. She was encouraged by the stained glass artist Wilhelmina Geddes to experiment with glass, and in 1933 she joined 'An Túr Gloine', the studio run by Sarah Purser. Hone's colleague at the studio, Michael Healy, taught her the finer points of the craft of stained glass, and soon she had established a reputation for exciting design and excellent technique. In 1937 Hone converted to Catholicism and her work became ever more religious in character. It was a secular window, however, that consolidated her reputation. In 1938 she was commissioned by the Department of Industry and Commerce in Dublin to design a window for the Irish Pavilion at the New York World's Fair of 1939. The result was a large upright rectangular window on the theme of the four provinces of Ireland, *My Four Green Fields*, which was a great success. During the 1940s Hone received commissions to design windows for churches in Ireland and England. In 1943, following the closure of 'An Túr Gloine', she opened her own studio at the Dower House, Marlay Park,

Rathfarnham, Dublin. In that year also she was a founder member of the Irish Exhibition of Living Art. She died at Rathfarnham in 1955.

It was Hone's design for the east window of Eton College Chapel that brought her international recognition and ranked her among the best stained glass artists of her time. The huge window was commissioned to replace one that was destroyed in a German bombing raid in 1941. Hone began the task in 1949 and the window was erected in 1952. It is divided into two large areas, the Crucifixion in the upper space with symbols of the Resurrection and Christ's miracles, and below it, the Last Supper flanked by Melchizedek and the sacrifice of Isaac. Hone's design process was lengthy and arduous. Before making cartoons she drew a preliminary sketch and several scale studies. She insisted on executing a number of the sections several times until she felt the window reached her own high standards. Hone's art belongs to the medieval tradition of stained glass, with its strong coloration, heavy symbolism and brilliant technique. Her remarkable achievement, especially considering her disability, was the production and promotion of religious art, which raised Ireland's profile internationally.

Frost 1957; White 1958; Pyle 1975; Bowe, Caron and Wynne 1988; Kennedy (S B) 1991 (2); Croke et al 1991.

JACK BUTLER YEATS
(1871–1957) (SEE P 132–133)

Horses and donkeys were always Jack Butler Yeats's favourite animals. His earliest sketches are of horses; in Yeats's mind they symbolised loyalty, intelligence and freedom. The most impressive horse created by Yeats is the noble animal in *My Beautiful, My Beautiful*, painted when he was in his eighties. It is one of his finest images, demonstrating his romantic lyricism, his imagination and his masterly use of colour. The little oasis in the desert in the bottom left corner is captured with a few lines and dabs of paint. The viewer's attention, however, is focused on the man and the horse. The head of the horse is characterised with ease; the rich strokes of paint appear casual but are the inspired results of long experience. The title of the painting is taken from the first line of a poem by Caroline Norton, which tells of an Arab who has to sell his horse in order to get money to buy bread. The poem begins:

My beautiful, my beautiful! that standest meekly by,
With thy proudly-arched and glossy neck, and dark and
* fiery eye!*
Fret not to roam the desert now with all thy winged speed;
I may not mount on thee again! — thou'rt sold my Arab
* steed.*

Yeats emphasises the emotional parting between the man and his horse, and ignores the fact that the poem ends with the Arab's final decision not to sell the animal.

Jack Butler Yeats is among the best-loved Irish painters of the twentieth century. He was born in London in 1871, the son of the portrait painter John Butler Yeats and brother of the poet William Butler Yeats. He spent his boyhood years in County Sligo with his maternal grandparents, and loved the romance and vitality of the locality. In 1887 he returned to London where he studied at a number of art schools and established himself as an illustrator for various magazines and journals. Yeats decided early in his career that he would seek to be the painter of the Irish Revival, to represent visually what his brother and others were revealing through poetry and drama. He certainly immersed himself in the Irish experience. In 1905 he toured the poorest districts of the west of Ireland, providing illustrations for John Millington Synge's articles for the *Manchester Guardian*. In 1910 Yeats moved to Ireland with his wife 'Cottie', settling first in County Wicklow and then in Dublin city. He was elected an associate of the Royal Hibernian Academy, Dublin, in 1915 and a member the following year. He liked the vibrant atmosphere of Dublin in the years of the struggle for independence and, although he was not politically active, he was a life-long republican. This was in sharp contrast to his brother, W B, who became a member of the Irish Free State senate.

A beguiling draughtsman and a sensitive watercolourist, Yeats was liberated by his imaginative use of oil paints. His first known oil painting dates from 1902, but after settling in Ireland he began to use oils consistently. His early oils are composed carefully and the colours are muted. In the 1920s Yeats began to give serious consideration to the artistic power of colours. His late works like *My Beautiful, My Beautiful* are among his best. Yeats dared to leave areas of the canvas blank, while using thick paint (impasto) in other parts. He continued to paint with extraordinary energy and vigour until shortly before his death in 1957. Yeats was an artist of European stature, an author of avant-garde novels and plays, a brilliant colourist and a classic individualist, who pursued his painterly occupation in determined and contented isolation.

MacGreevy 1945; Pyle 1970, 1990, 1992, 1993; White and Pyle 1971; Kennedy (B P) 1991, 1992–3; Potterton 1993.

Máire Rua O'Brien (SEE PAGE 9)

Artist unknown
Oil on canvas, 81.25 x 66 cm (32 x 26 in)
c. 1640

Private collection

Artist unknown

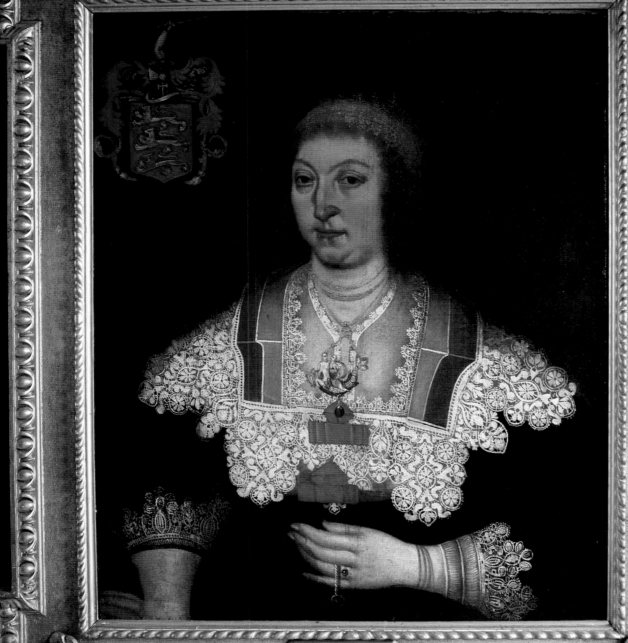

MÁIRE RUADH (NÉE MAC MAHON)
M. CONOR O'BRIEN, 1639

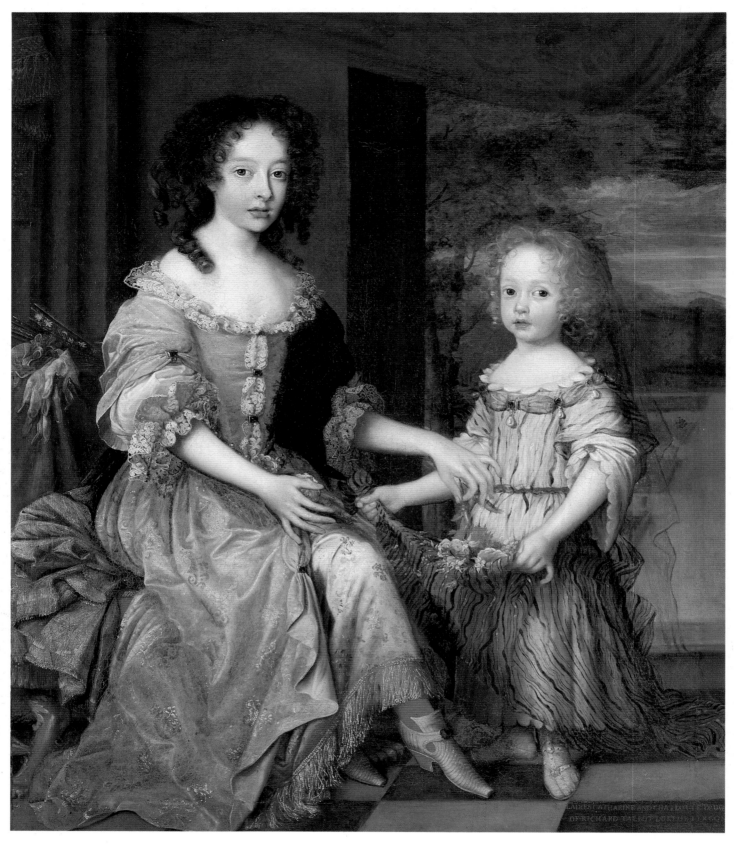

The Ladies Catherine and Charlotte Talbot
(SEE PAGE 9)

John Michael Wright (1617–94)
Oil on canvas, 130 x 110 cm (51¼ x 43¼ in)
1679

National Gallery of Ireland, Dublin (Inv. no 4184)

John Michael Wright

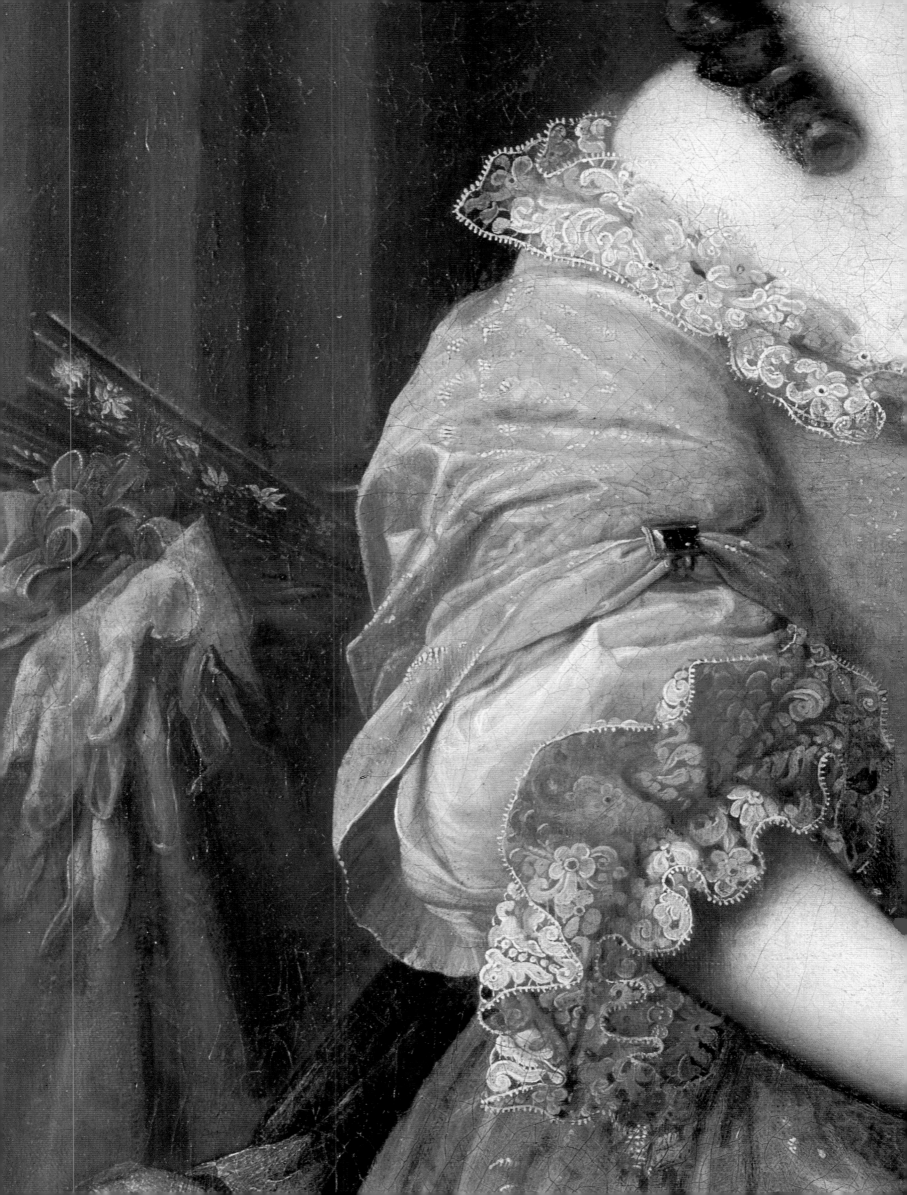

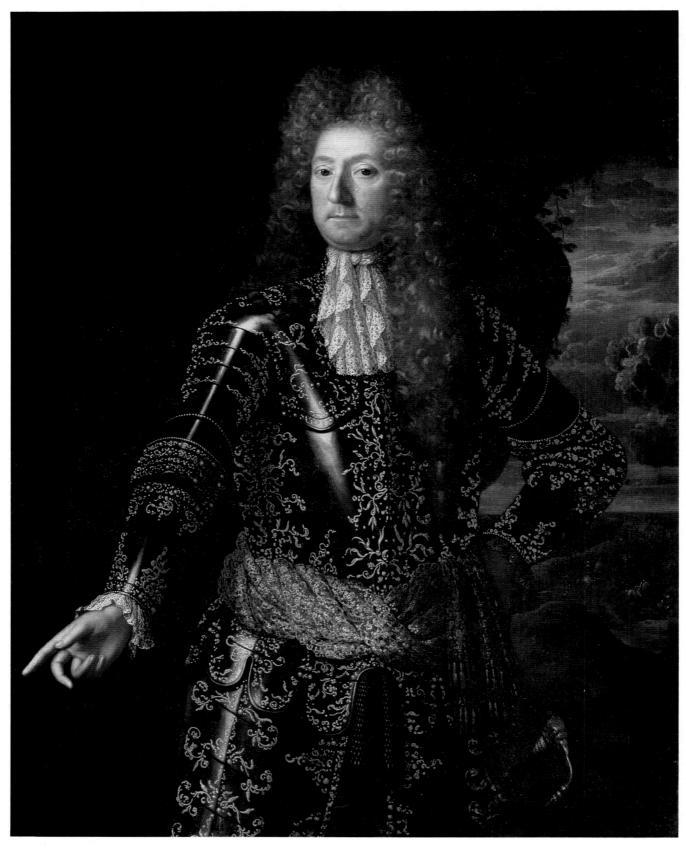

Brigadier General William Wolseley
(SEE PAGE 10)

Garret Morphy (*c.* 1655–1715)
Oil on canvas, 129 x 101.5 cm (50³/₄ x 40 in)
1692

Private collection

Garret Morphy

Portrait of a Lady (possibly Lady Mary Wortley Montagu)
(SEE PAGE 10)

Charles Jervas (*c.* 1675–1739)
Oil on canvas, 214.5 x 126 cm (84¹/₂ x 49¹/₂ in)
1720s

National Gallery of Ireland, Dublin (Inv. no 4342)

Charles Jervas

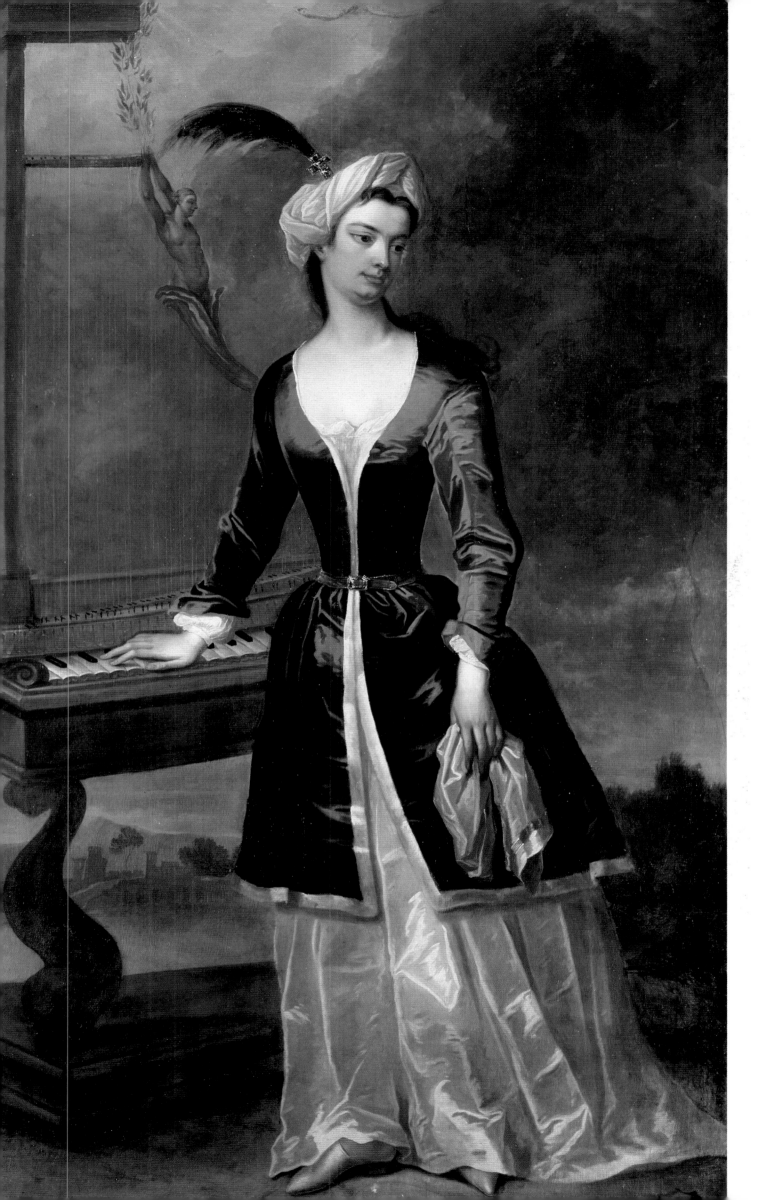

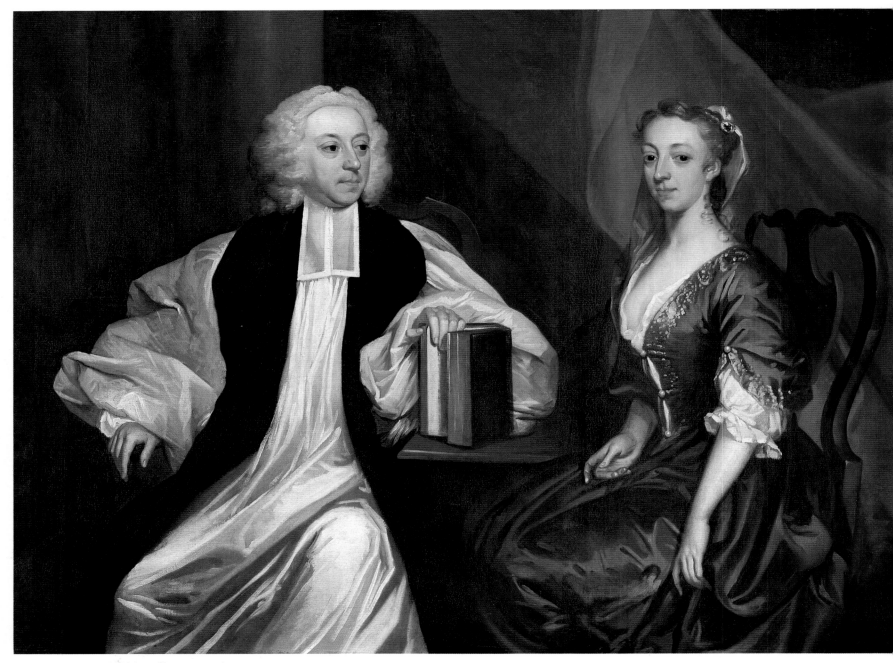

Bishop Robert Clayton and his Wife
(SEE PAGE 11)

James Latham (1696–1747)
Oil on canvas, 128 x 175 cm (50 ½ x 69 in)
1730s

National Gallery of Ireland, Dublin (Inv. no 4370)

James Latham

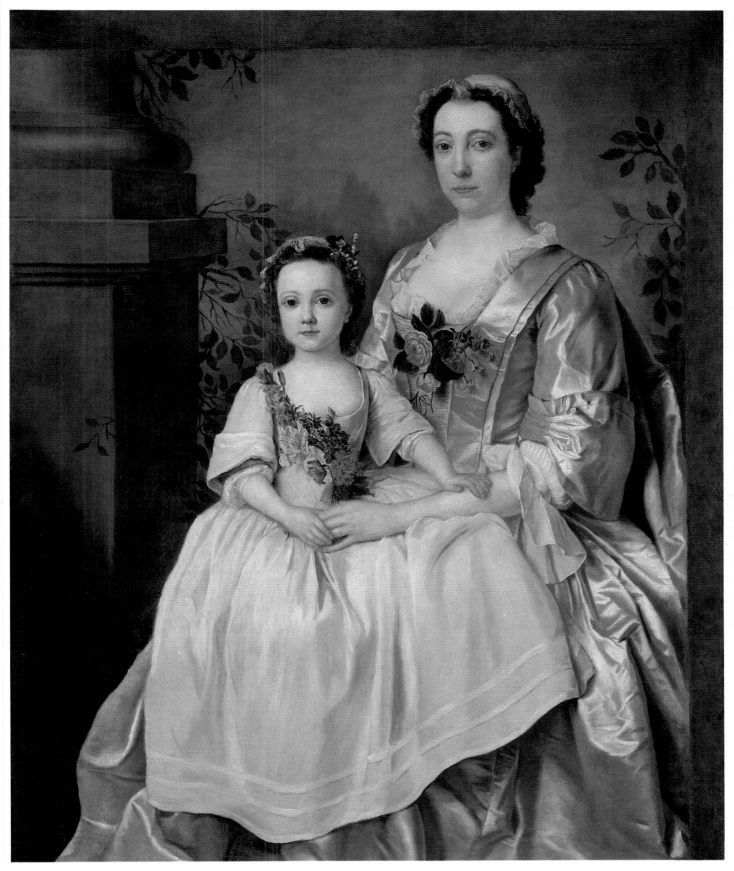

A Lady and Child (SEE PAGE 11)

Stephen Slaughter (1697–1765)
Oil on canvas, 130 x 104 cm (51 ¼ x 41 in)
1745

National Gallery of Ireland, Dublin (Inv. no 797)

Stephen Slaughter

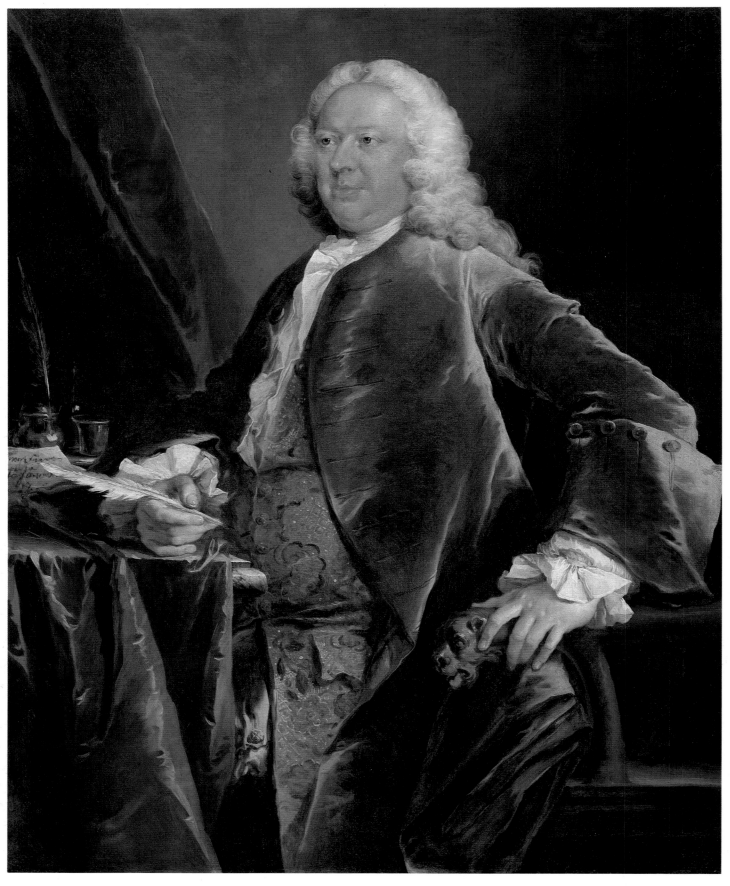

Henry Crispe of the Custom House
(SEE PAGE 12)

Thomas Frye (1710–62)
Oil on canvas, 124.5 x 101.6 cm (49 x 40 in)
1746

Tate Gallery, London

Thomas Frye

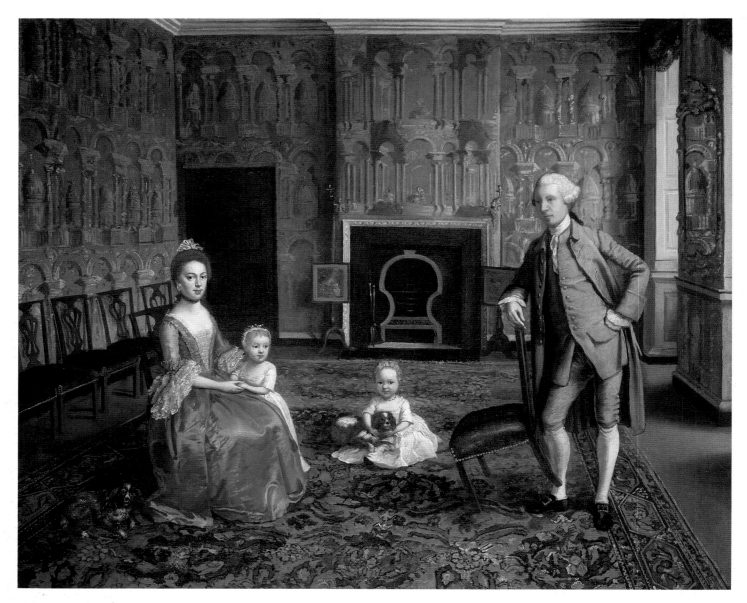

An Interior with Members of a Family
(SEE PAGE 12)

Philip Hussey (1713–83)
Oil on canvas, 62 x 76 cm (24 1/2 x 30 in)
1750s

National Gallery of Ireland, Dublin (Inv. no 4304)

Philip Hussey

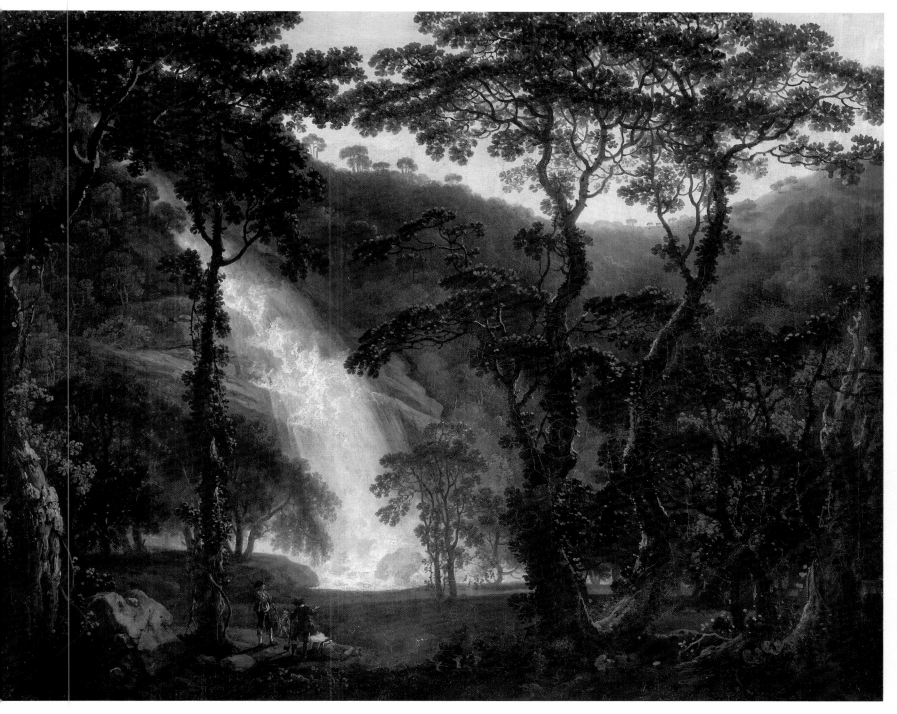

A View of Powerscourt Waterfall
(SEE PAGE 13)

George Barret (1728/32–84)
Oil on canvas, 100 x 127 cm (39 1/2 x 50 in)
c. 1760

National Gallery of Ireland, Dublin (Inv. no 174)

George Barret

53

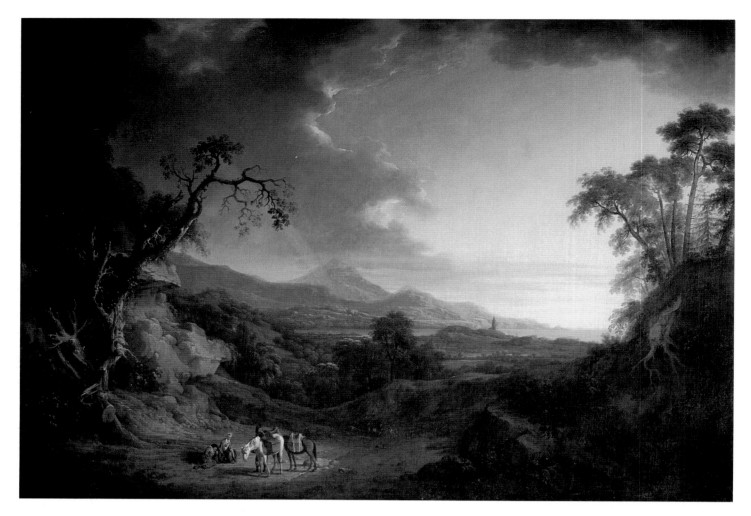

An Ideal Landscape (SEE PAGE 13)

Thomas Roberts (1748–78)
Oil on canvas, 109 x 150 cm (43 x 59 in)
1770s

Private collection

Thomas Roberts

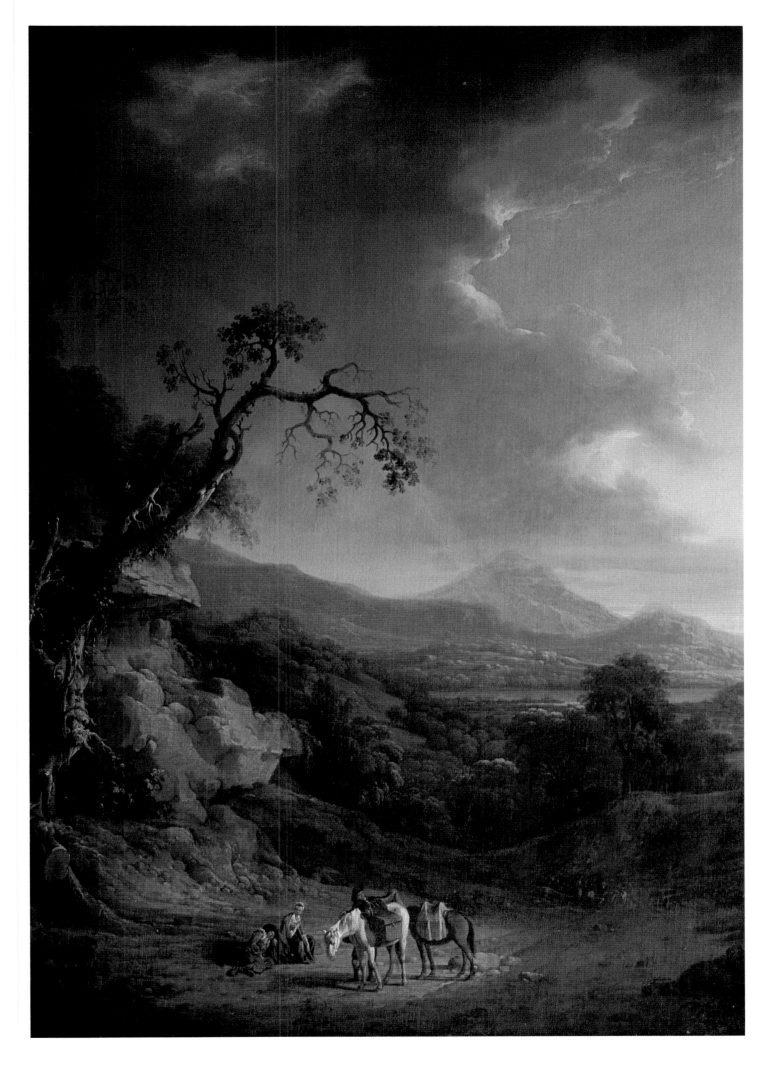

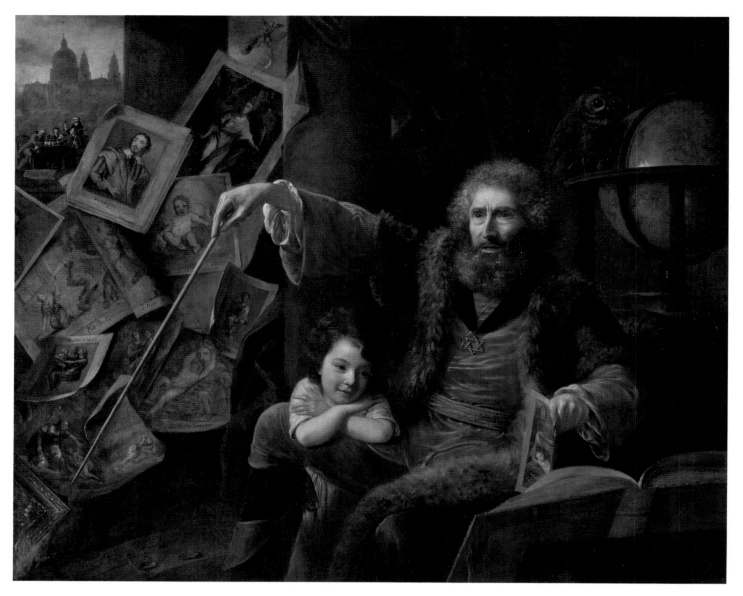

The Conjuror (SEE PAGE 14)

Nathaniel Hone the Elder (1718–84)
Oil on canvas, 145 x 173 cm (57 x 68 in)
1775

National Gallery of Ireland, Dublin (Inv. no 1790)

Nathaniel Hone the Elder

The Irish House of Commons (SEE PAGE 14)

Francis Wheatley (1747–1801)
Oil on canvas, 162.5 x 215.9 cm (64 x 85 in)
1780

Leeds City Art Galleries, Yorkshire

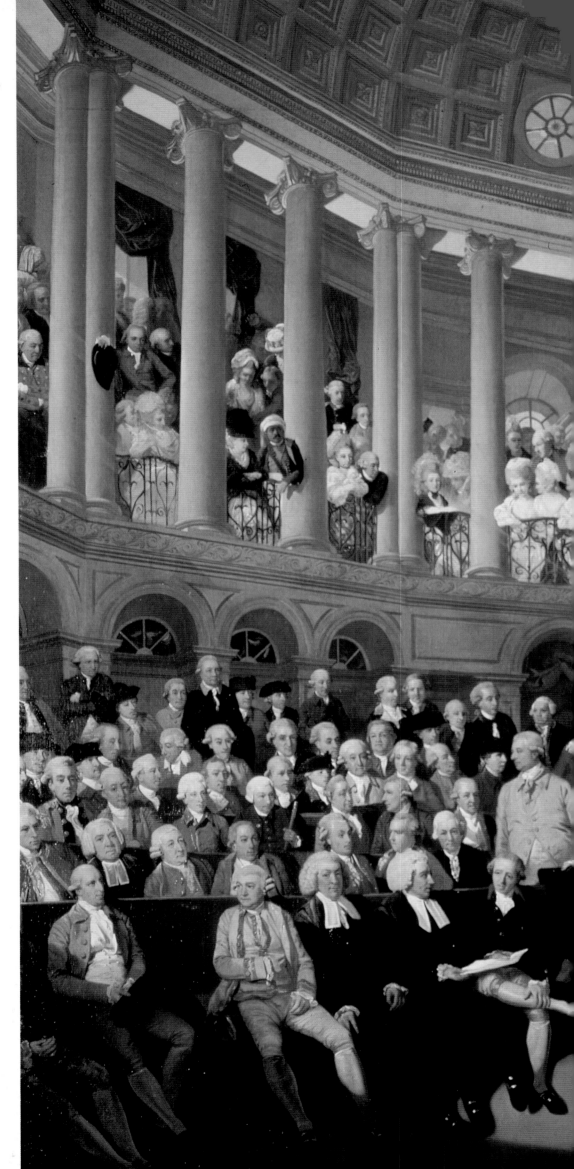

Francis Wheatley

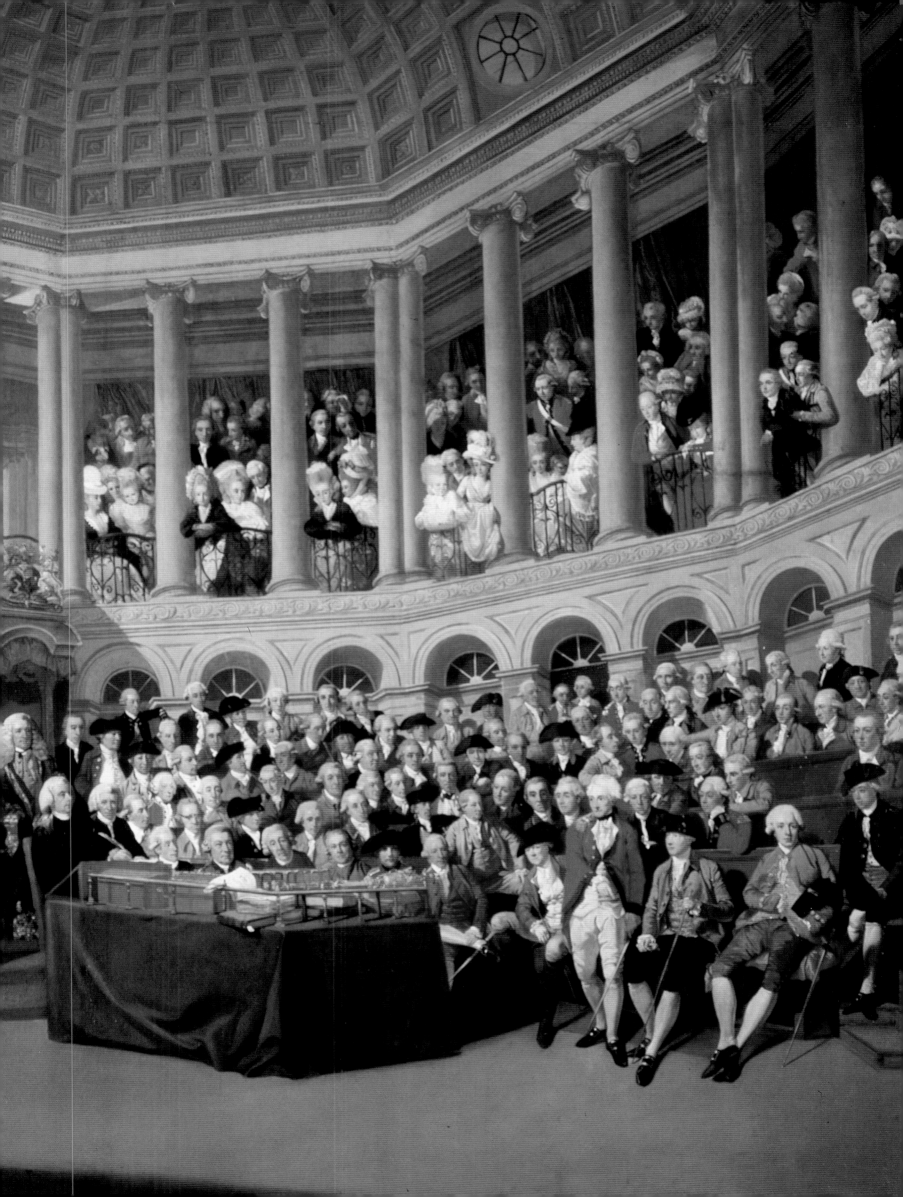

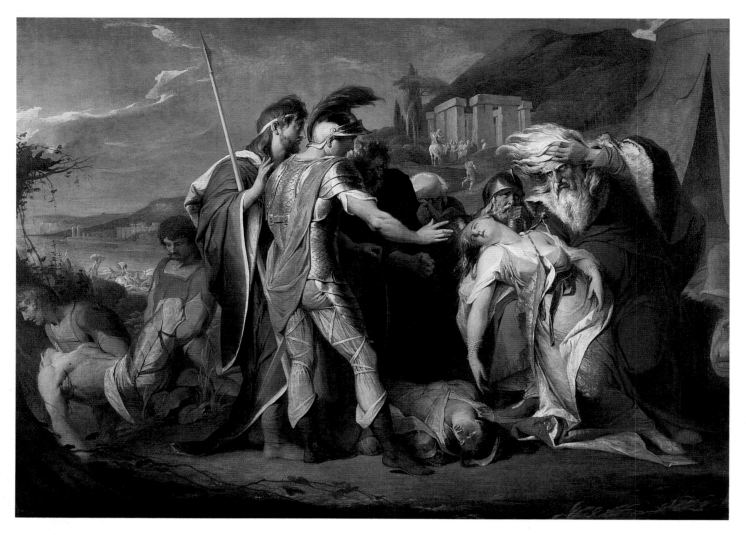

King Lear Weeping over the Body of
Cordelia (SEE PAGE 15)

James Barry (1741–1806)
Oil on canvas, 269 x 367 cm (106 x 144 ½ in)
1786–7

Tate Gallery, London

James Barry

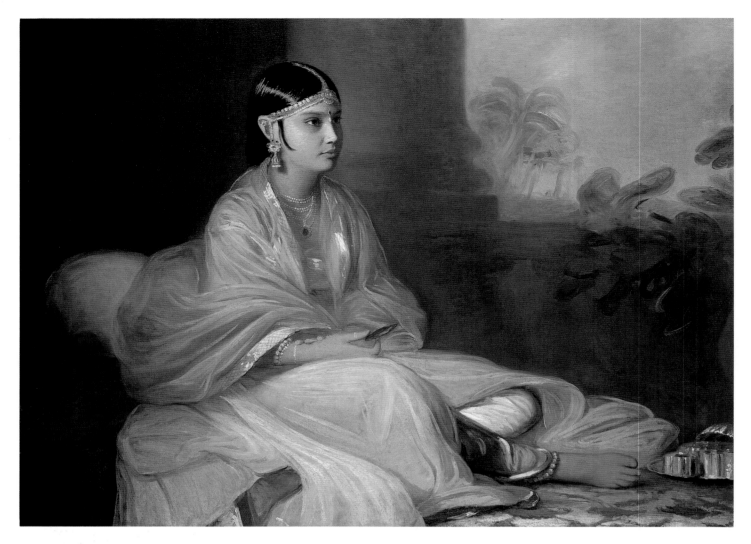

An Indian Lady (SEE PAGE 15)

Thomas Hickey (1741–1824)
Oil on canvas, 102 x 127 cm (40 x 50 in)
1787

National Gallery of Ireland, Dublin (Inv. no 1390)

Thomas Hickey

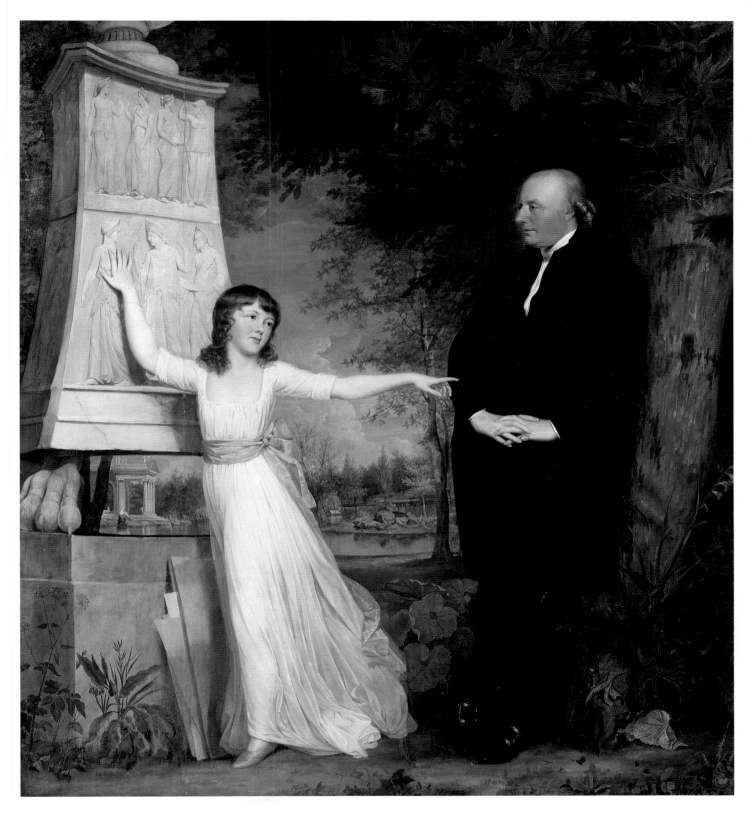

Frederick Hervey, Bishop of Derry and fourth Earl of Bristol, 1730–1803, with his granddaughter, Lady Caroline Crichton
(SEE PAGE 16)

Hugh Douglas Hamilton (*c.* 1739–1808)
Oil on canvas, 230 x 199 cm (90 1/2 x 78 1/4 in)
c. 1789

National Gallery of Ireland, Dublin (Inv. no 4350)

Hugh Douglas Hamilton

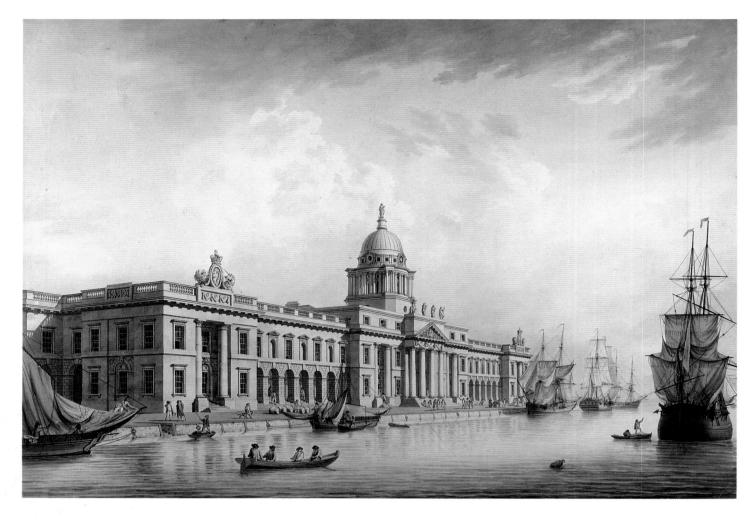

The Custom House, Dublin (SEE PAGE 16)

James Malton (*c.* 1760–1803)
Watercolour over ink on paper, 53.6 x 77 cm
(21 x 30 1/4 in)
1793

National Gallery of Ireland, Dublin (Inv. no 2705)

James Malton

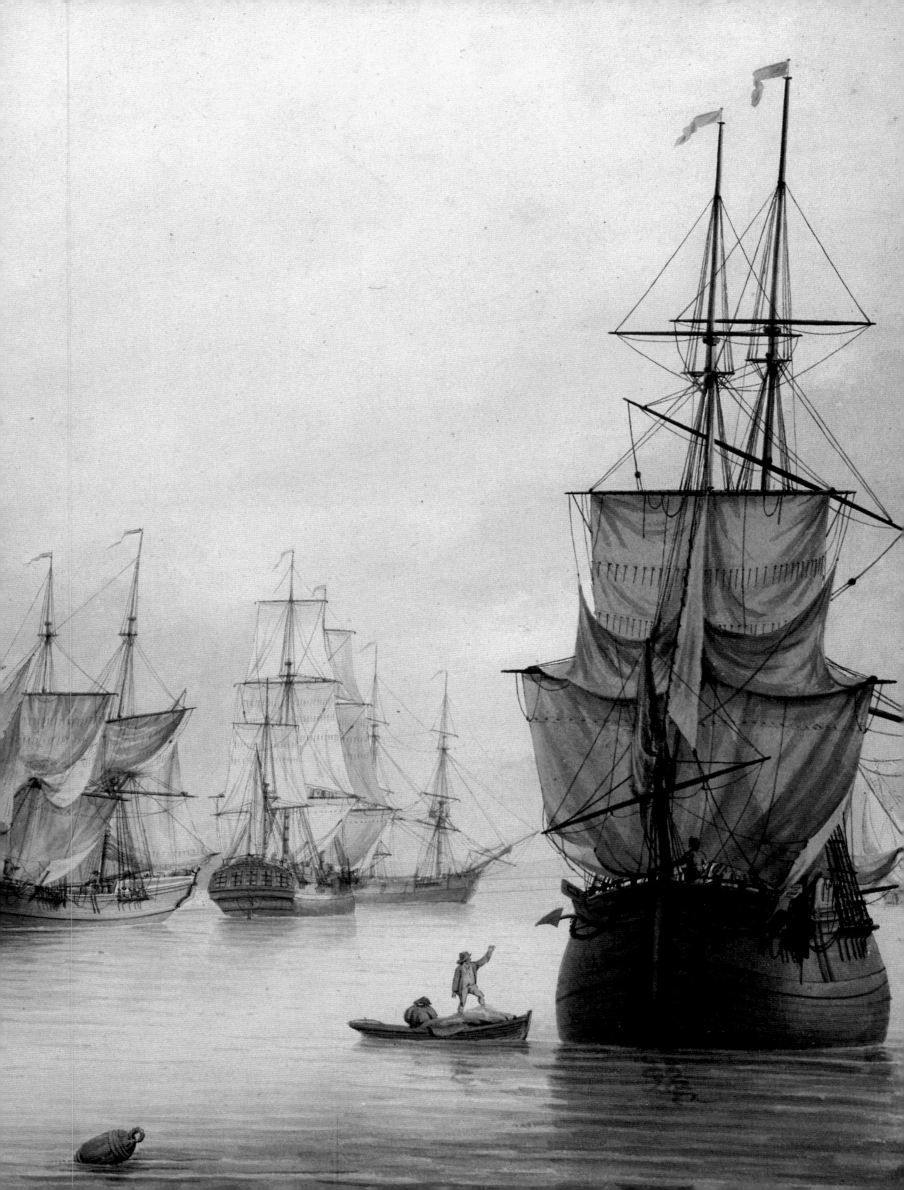

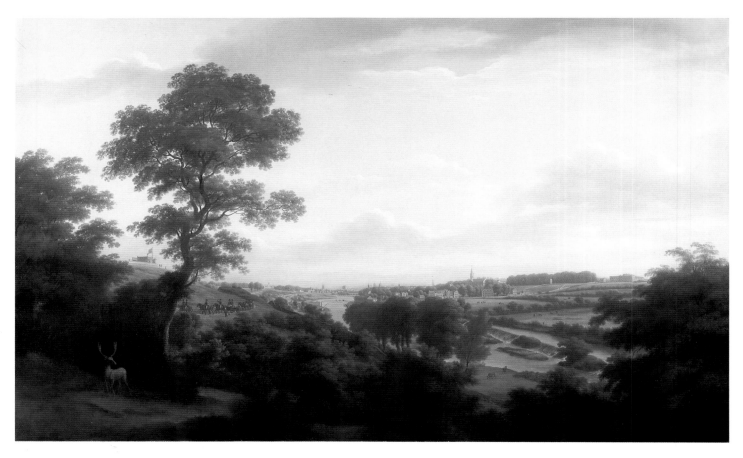

A View of Dublin from Chapelizod
(SEE PAGE 17)

William Ashford (*c.* 1746–1824)
Oil on canvas, 114 x 183 cm (45 x 72 in)
c. 1797

National Gallery of Ireland, Dublin (Inv. no 4138)

William Ashford

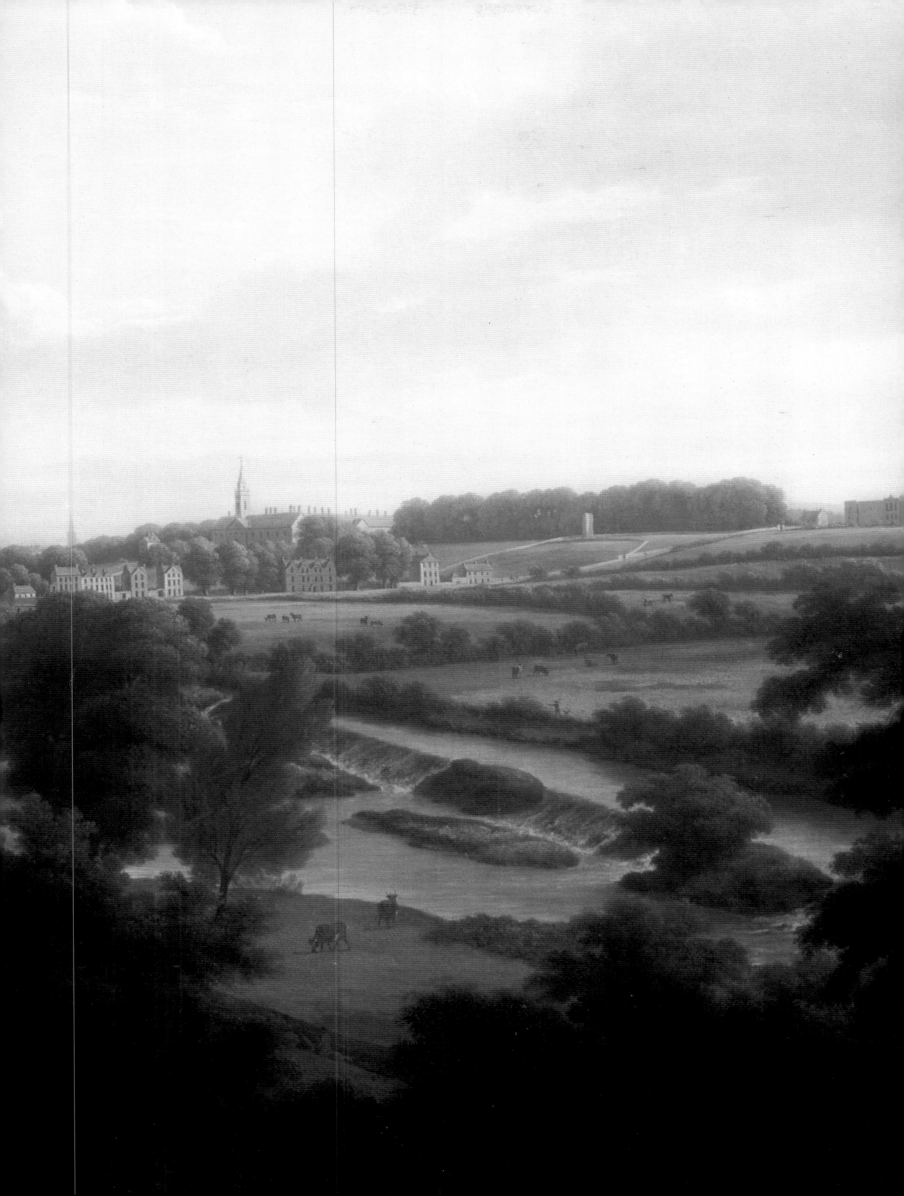

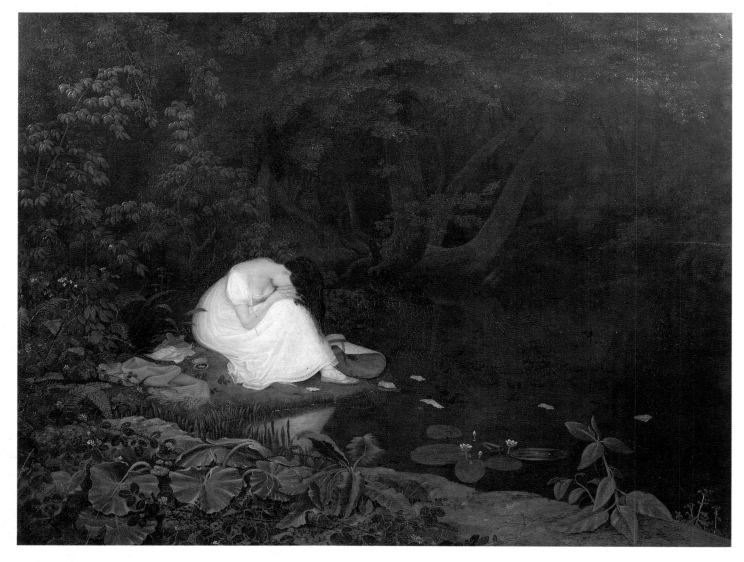

Disappointed Love (SEE PAGE 17)

Francis Danby (1793–1861)
Oil on panel, 62 x 80 cm (24 $\frac{1}{2}$ x 31 $\frac{1}{2}$ in)
1821

By courtesy of the Board of Trustees of the
Victoria and Albert Museum, London

Francis Danby

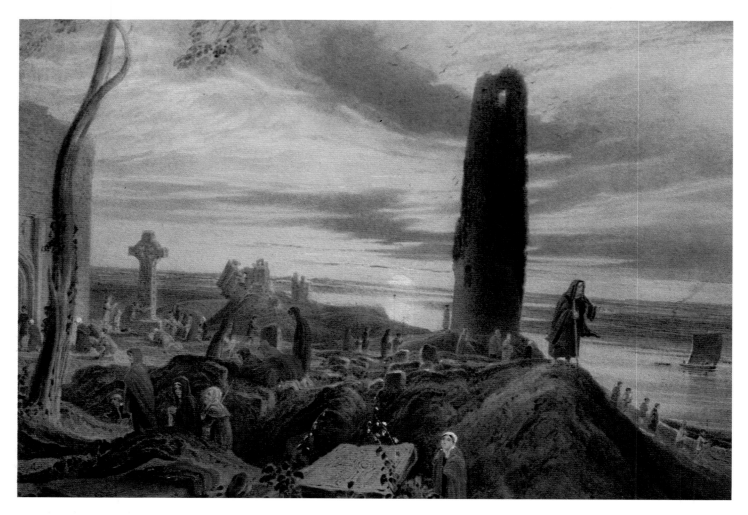

The Last Circuit of Pilgrims at
Clonmacnoise, Co. Offaly (SEE PAGE 18)

George Petrie (1789–1866)
Pencil and watercolour on paper, 18.5 x 25.6
cm (7 ¼ x 10 in)
1828

Private collection

George Petrie

A Bank of Flowers, with a View of Bray,
Co. Wicklow (SEE PAGE 18)

Andrew Nicholl (1804–86)
Watercolour on paper, 35.1 x 52.1 cm
(13 ³/₄ x 20 ¹/₂ in)
1830s

Ulster Museum, Belfast

Andrew Nicholl

71

A Thunderstorm: the Frightened Wagoner
(SEE PAGE 19)

James Arthur O'Connor (*c.* 1792–1841)
Oil on canvas, 65 x 76 cm (25 1/2 x 30 in)
1832

National Gallery of Ireland, Dublin (Inv. no 4041)

James Arthur O'Connor

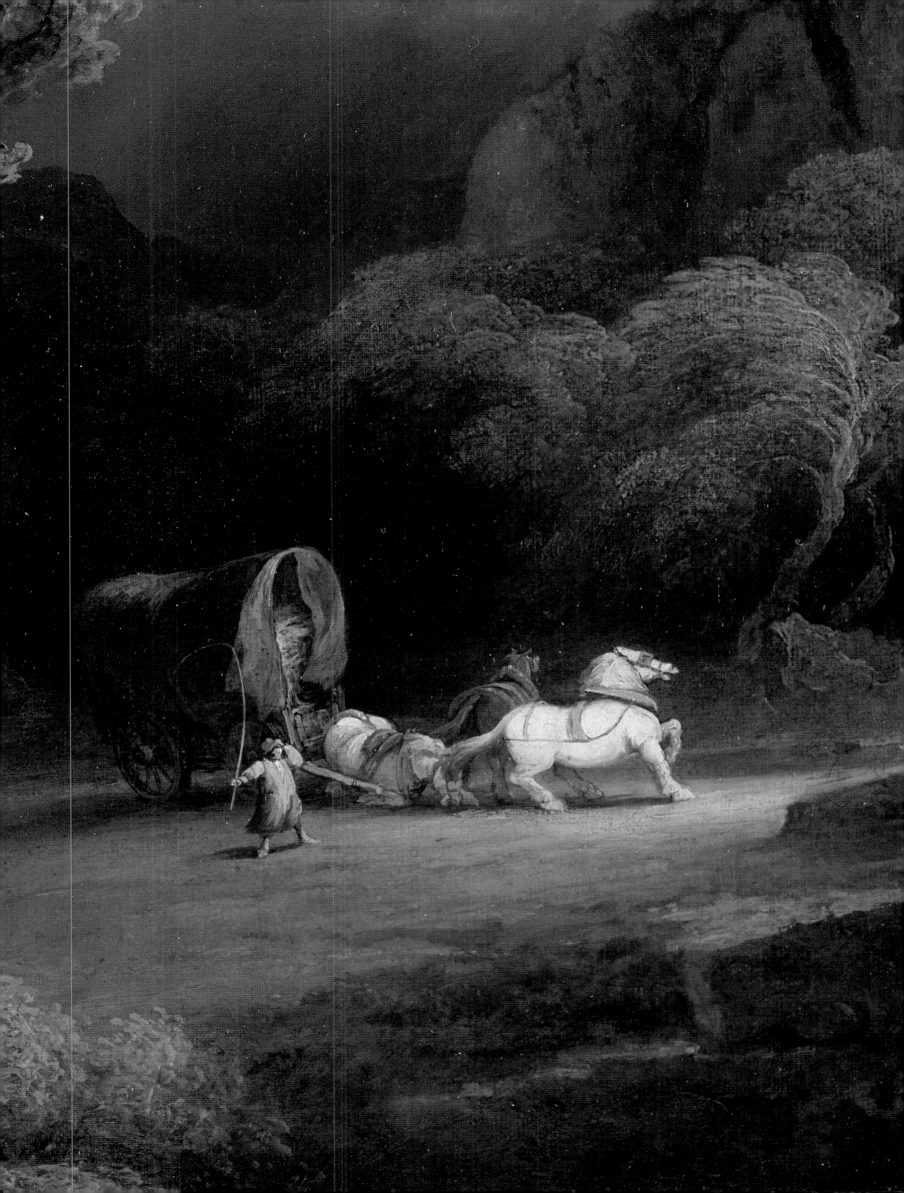

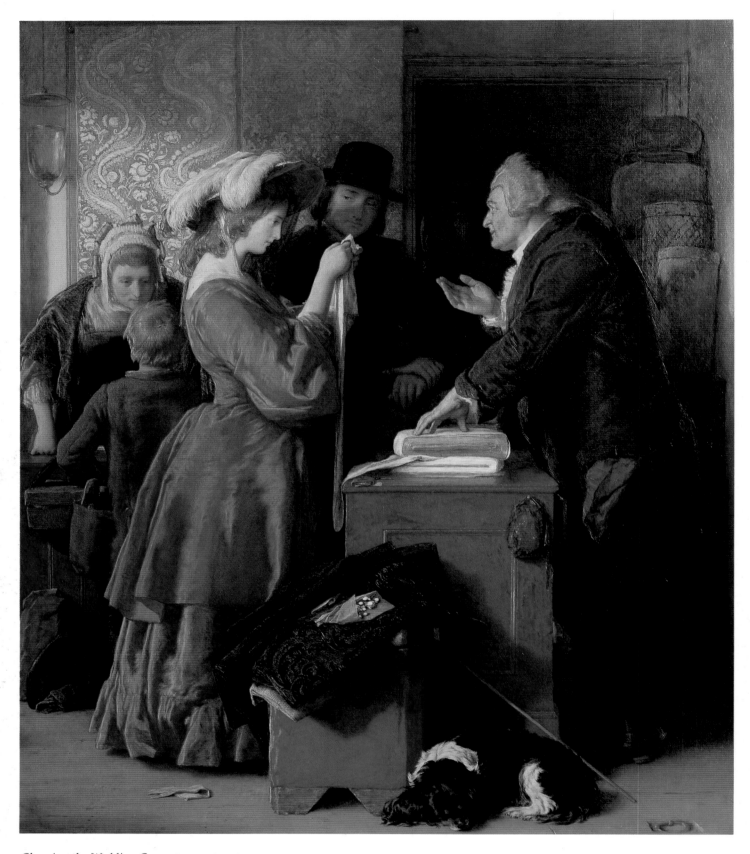

Choosing the Wedding Gown (SEE PAGE 19)

William Mulready (1786–1863)
Oil on panel, 53 x 44 cm (21 x 17 1/4 in)
1845

By courtesy of the Board of Trustees of the
Victoria and Albert Museum, London

William Mulready

The Visit by Queen Victoria and Prince Albert to the Fine Art Hall of the Irish Industrial Exhibition, Dublin 1853

(SEE PAGE 20)

James Mahony (1810–79)
Watercolour on paper, 62.8 x 81 cm
(24 3/4 x 32 in)
c. 1853

National Gallery of Ireland, Dublin (Inv. no 7009)

James Mahony

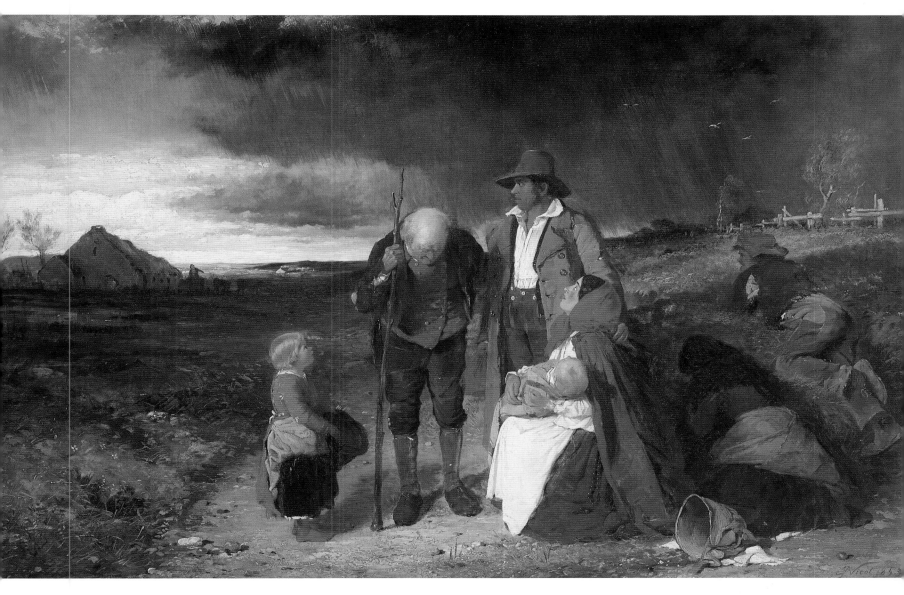

An Ejected Family (SEE PAGE 20)

Erskine Nicol (1825–1904)
Oil on canvas, 50 x 82 cm (19 3/4 x 32 1/4 in)
1853

National Gallery of Ireland, Dublin (Inv. no 4577)

Erskine Nicol

Sackville Street, Dublin (SEE PAGE 21)

Michael Angelo Hayes (1820–77)
Watercolour with gum arabic and white
highlights on paper, 54.5 x 77.6 cm
(21 ¹/₂ x 30 ¹/₂ in)
c. 1853

National Gallery of Ireland, Dublin (Inv. no 2980)

Michael Angelo Hayes

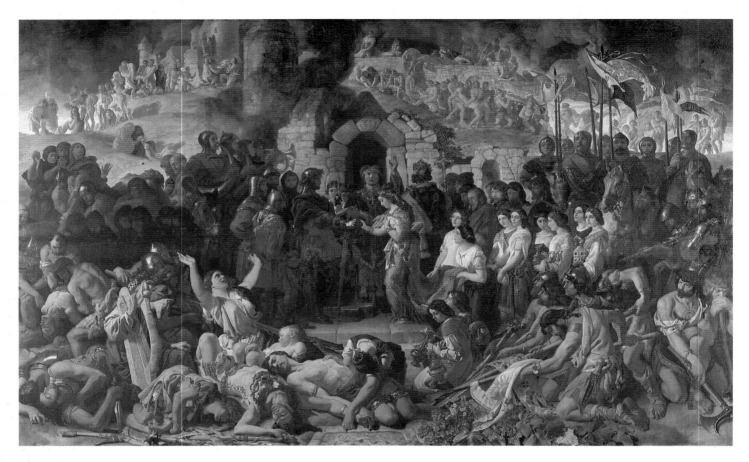

The Marriage of Strongbow and Aoife
(SEE PAGE 21)

Daniel Maclise (1806–1870)
Oil on canvas, 309 x 505 cm
(121 ½ x 198 ¾ in)
c. 1854

National Gallery of Ireland, Dublin (Inv. no 205)

Daniel Maclise

Man Overboard (SEE PAGE 22)

Edwin Hayes (1820–1904)
Oil on canvas, 101.6 x 177.8 cm (40 x 70 in)
1862

Private collection

Edwin Hayes

The Sick Call (SEE PAGE 22)

Matthew James Lawless (1837–64)
Oil on canvas, 63 x 103 cm (24 $^{3}/_{4}$ x 40 $^{1}/_{2}$ in)
1863

National Gallery of Ireland, Dublin (Inv. no 864)

Matthew James Lawless

Hellelil and Hildebrand or *The Meeting on
the Turret Stairs* (SEE PAGE 23)

Frederic William Burton (1816–1900)
Watercolour on paper, 95.5 x 60.8 cm
(37 1/2 x 24 in)
1864

National Gallery of Ireland, Dublin (Inv. no 2358)

Frederic William Burton

*The Boundary Fence, Forest of
Fontainebleau* (SEE PAGE 23)

Nathaniel Hone the Younger (1831–1917)
Oil on canvas, 39 x 60 cm (15 1/4 x 23 1/2 in)
c. 1868

Private collection

Nathaniel Hone the Younger

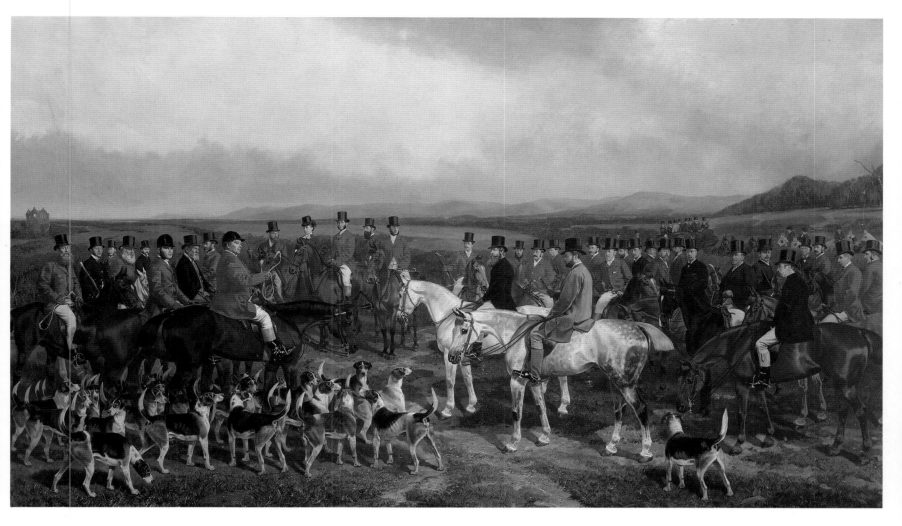

The Ward Hunt (SEE PAGE 24)

William Osborne (1823–1901)
Oil on canvas, 109 x 184 cm (43 x 72 ½ in)
1873

National Gallery of Ireland, Dublin (Inv. no 891)

William Osborne

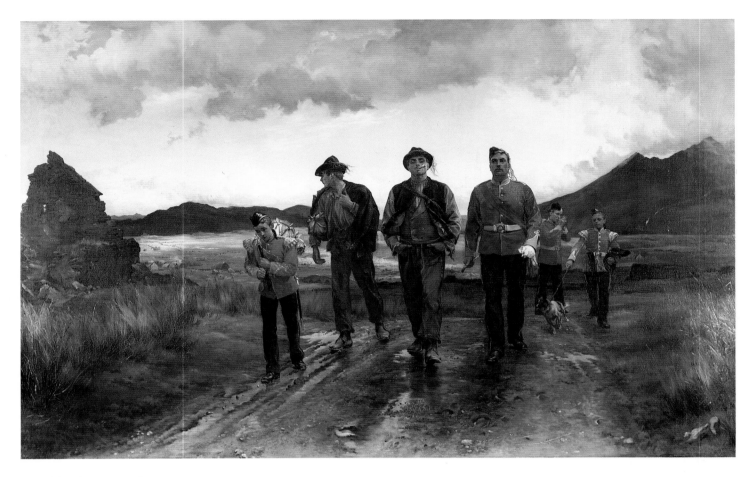

Listed for the Connaught Rangers
(SEE PAGE 24)

Lady Butler (Elizabeth Thompson)
(1846–1933)
Oil on canvas, 105 x 166 cm (41 1/4 x 65 1/4 in)
1878

Bury Art Gallery and Museum, Lancashire

Lady Butler (Elizabeth Thompson)

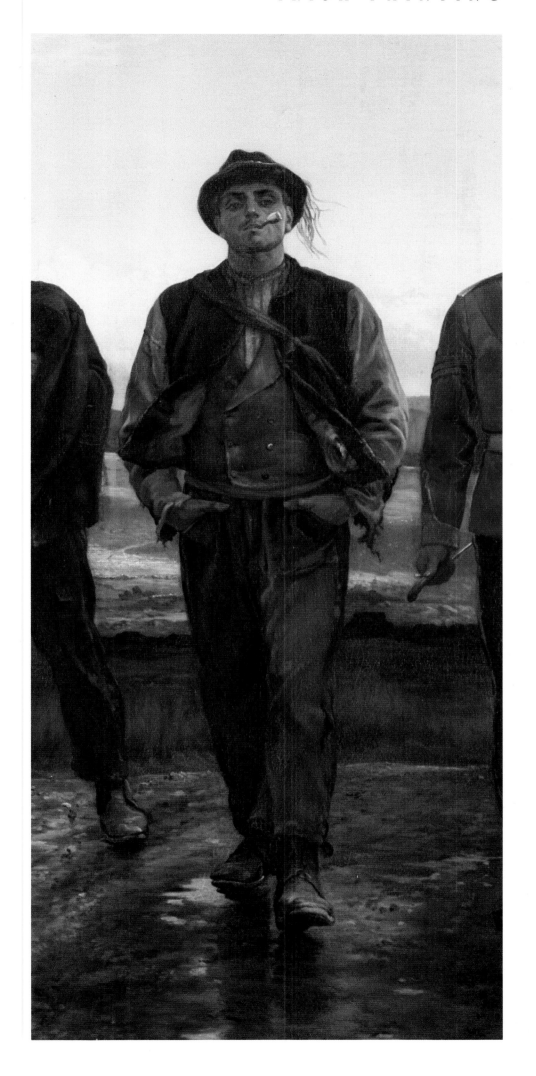

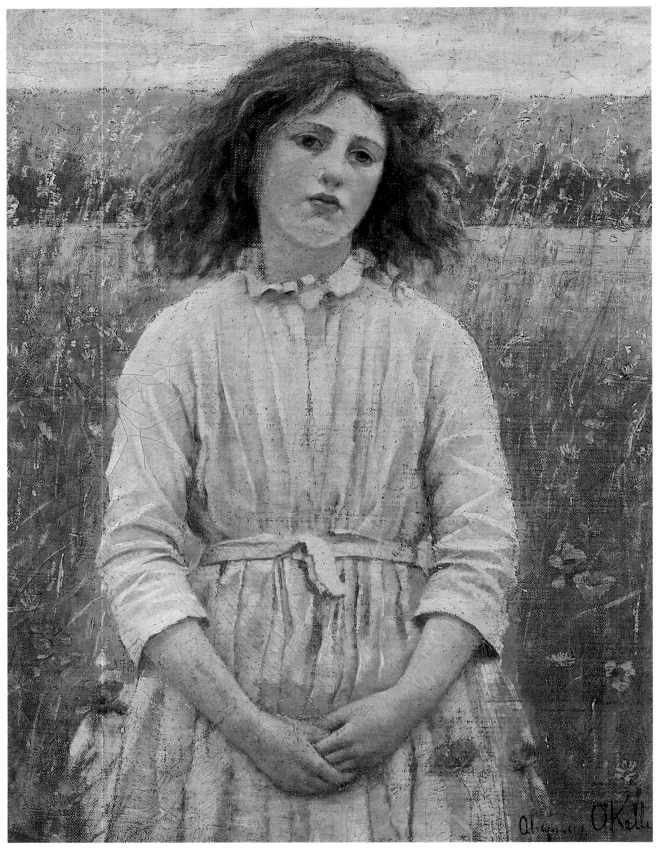

Girl in a Meadow (SEE PAGE 25)

Aloysius O'Kelly (1851–1926)
Oil on canvas, 45.7 x 35.5 cm (18 x 14 in)
1880s

Private collection

Facing page
The Connemara Girl (SEE PAGE 25)

Augustus Burke (1838–91)
Oil on canvas, 63 x 48 cm (24 3/4 x 19 in)
1880s

National Gallery of Ireland, Dublin (Inv. no 1212)

Aloysius O'Kelly

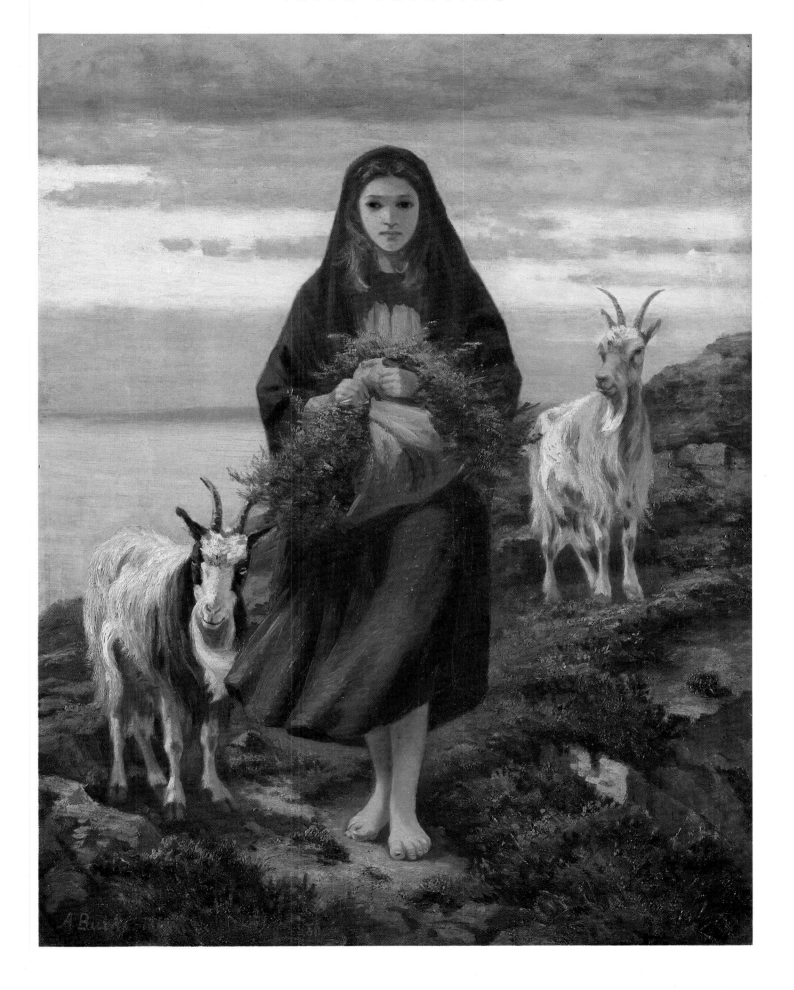

Augustus Burke

The Wounded Poacher (SEE PAGE 26)

Henry Jones Thaddeus (1859–1929)
Oil on canvas, 120 x 85 cm (47 1/4 x 33 1/2 in)
1881

National Gallery of Ireland, Dublin (Inv. no 4487)

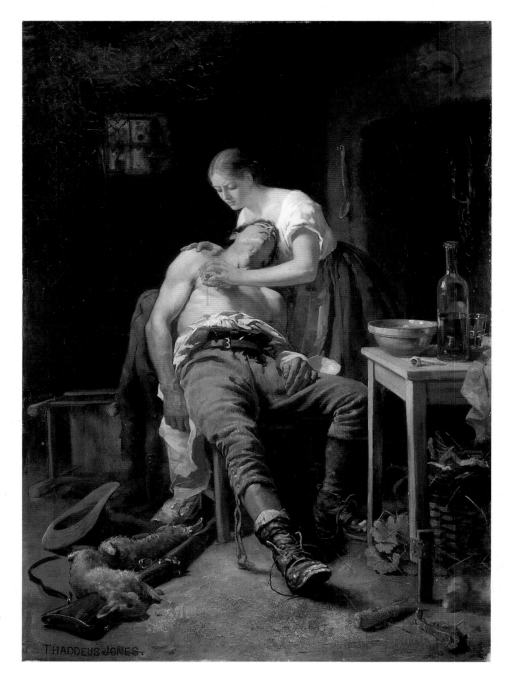

Henry Jones Thaddeus

Le Petit Déjeuner (SEE PAGE 26)

Sarah Purser (1848–1943)
Oil on canvas, 35 x 27 cm (13 ¾ x 10 ½ in)
c. 1882

National Gallery of Ireland, Dublin (Inv. no 1424)

Sarah Purser

96

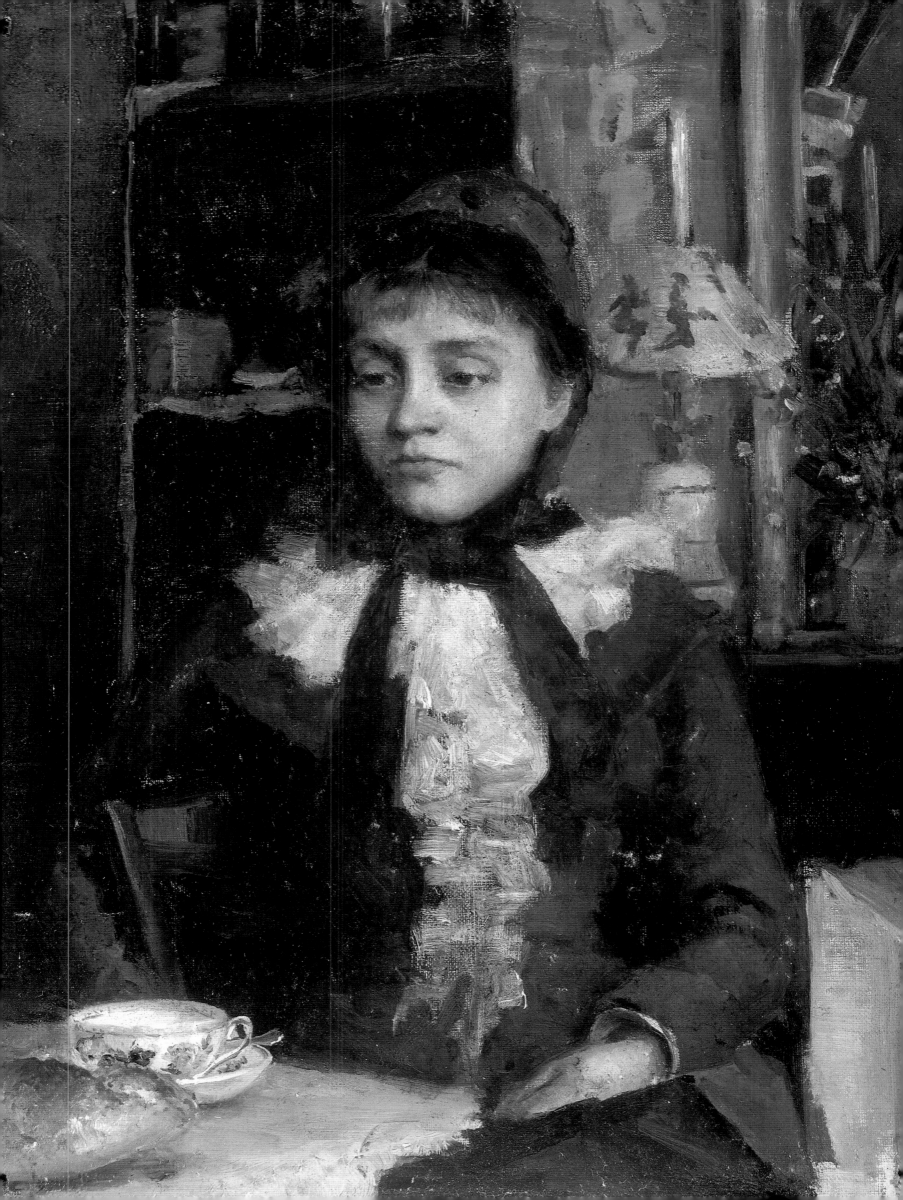

Apple Gathering, Quimperlé (SEE PAGE 27)

Walter Osborne (1859–1903)
Oil on canvas, 58 x 46 cm (22 ¾ x 18 in)
1883

National Gallery of Ireland, Dublin (Inv. no 1052)

Walter Osborne

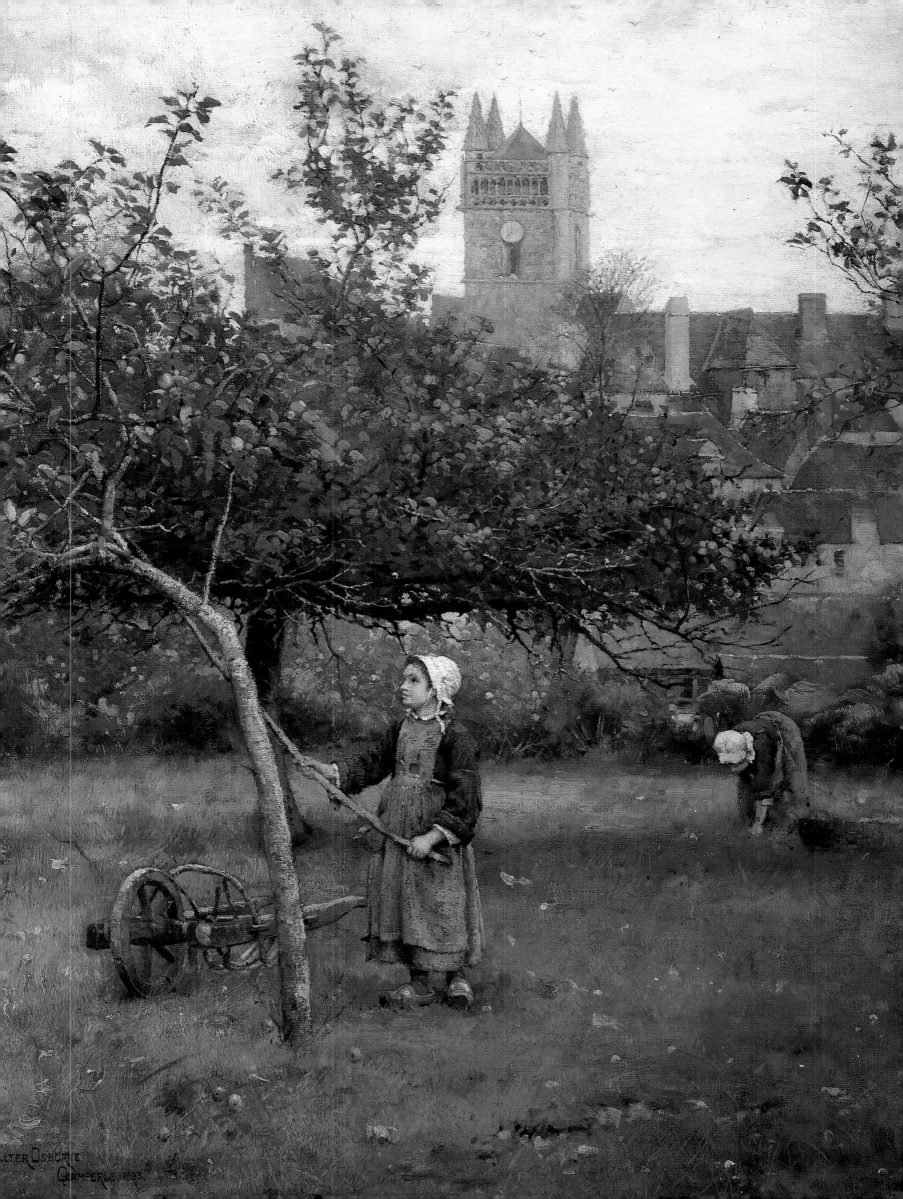

Towards Night and Winter (SEE PAGE 27)

Frank O'Meara (1853–88)
Oil on canvas, 150 x 127 cm (59 x 50 in)
1885

Hugh Lane Municipal Gallery of Modern Art,
Dublin

Frank O'Meara

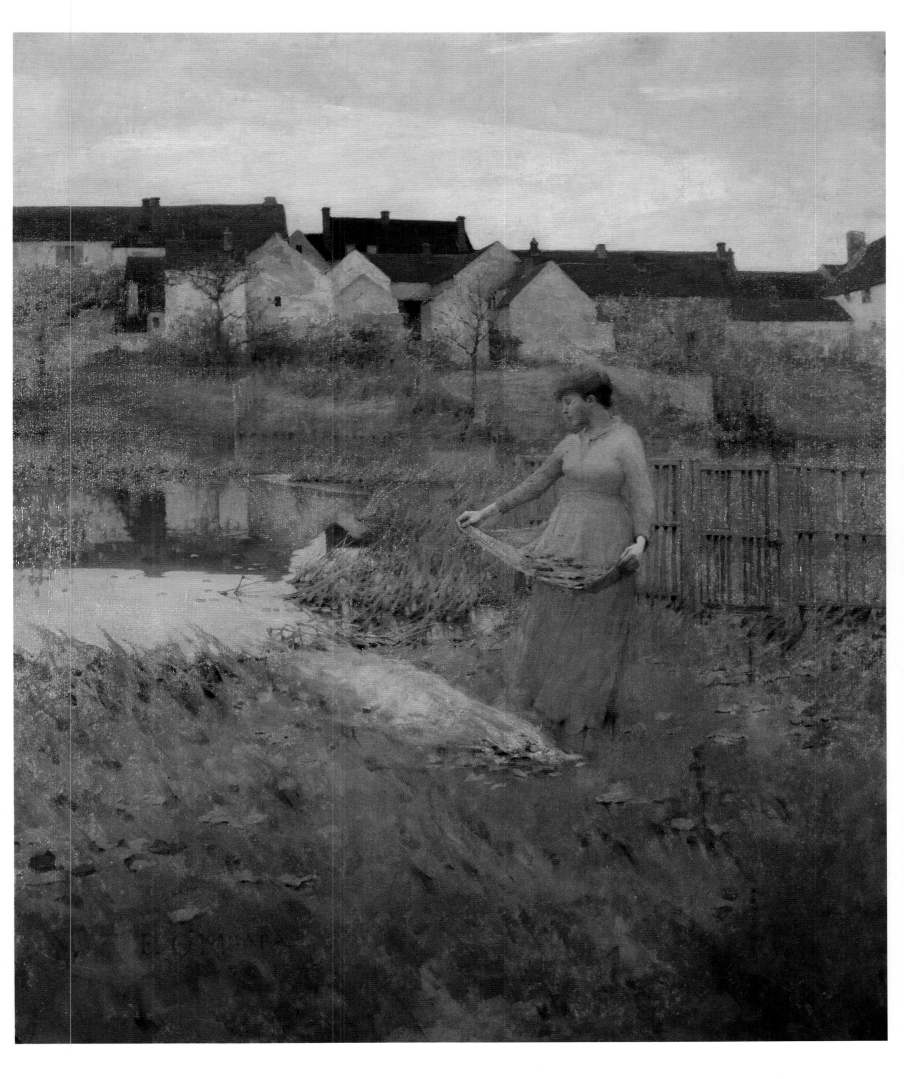

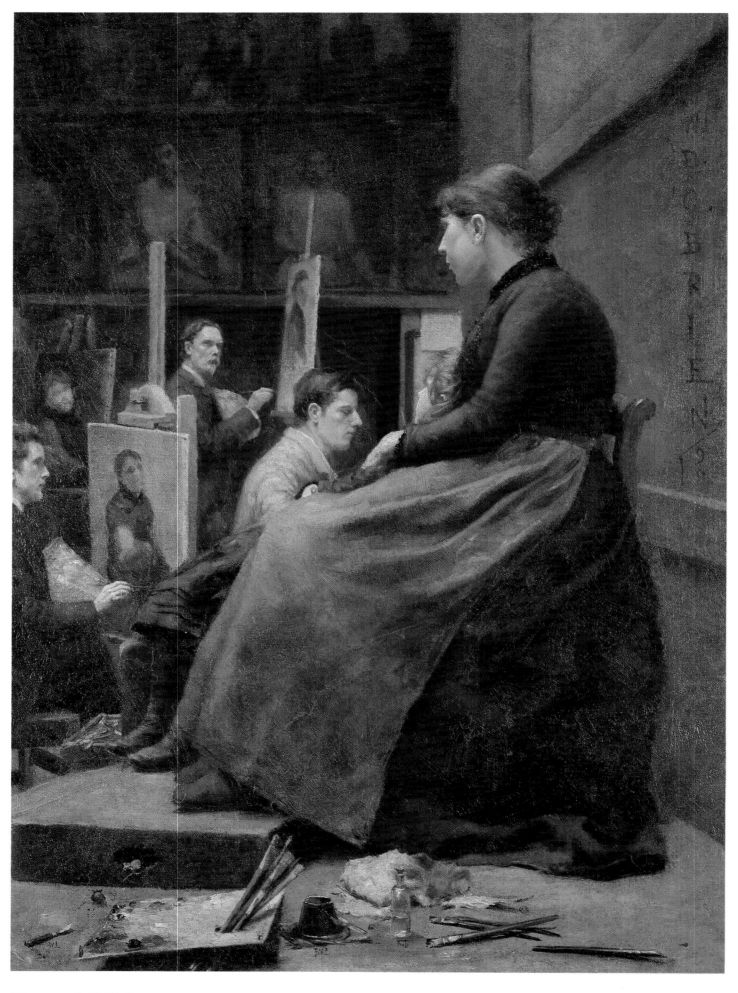

Dermod O'Brien

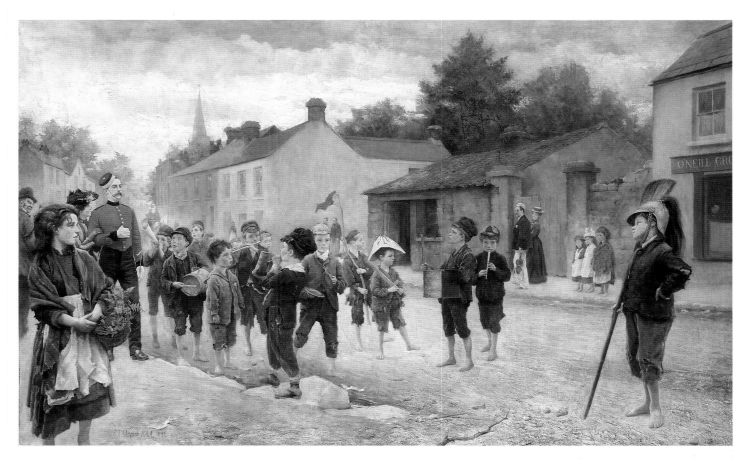

Military Manoeuvres (SEE PAGE 28)

Richard Thomas Moynan (1856–1906)
Oil on canvas, 148 x 240 cm (58 1/4 x 94 1/2 in)
1891

National Gallery of Ireland, Dublin (Inv. no 4364)

Facing page
The Fine Art Academy, Antwerp
 (SEE PAGE 28)
Dermod O'Brien (1865–1945)
1890
Oil on canvas, 80 x 58.5 cm (31 1/2 x 23 in)

Ulster Museum, Belfast

Richard Thomas Moynan

La Ferme de Lezaven, Finistère
(SEE PAGE 29)

Roderic O'Conor (1860–1940)
Oil on canvas, 72 x 93 cm (28 $\frac{1}{4}$ x 36 $\frac{1}{2}$ in)
1894

National Gallery of Ireland, Dublin (Inv. no 1642)

Roderic O'Conor

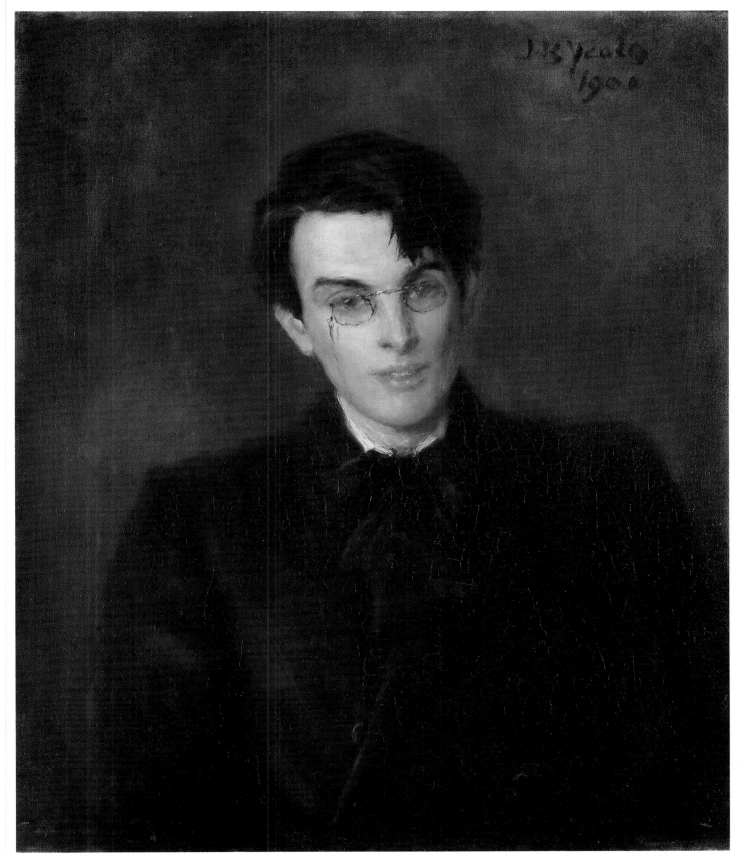

William Butler Yeats (SEE PAGE 29)

John Butler Yeats (1839–1922)
Oil on canvas, 77 x 64 cm (30 1/4 x 25 1/4 in)
1900

National Gallery of Ireland, Dublin (Inv. no 872)

John Butler Yeats

The Mirror (SEE PAGE 30)

William Orpen (1878–1931)
Oil on canvas, 50.8 x 40.6 cm (20 x 16 in)
1900

Tate Gallery, London

William Orpen

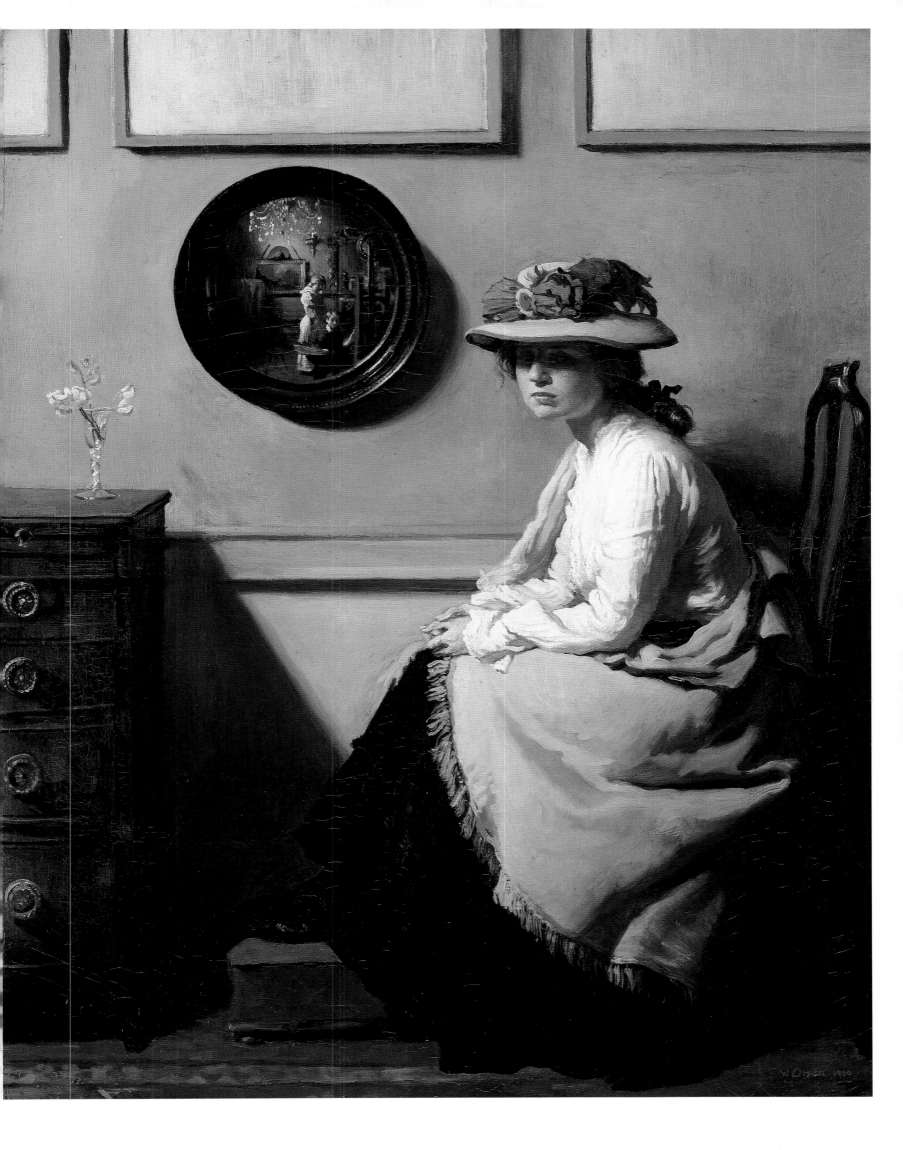

Mrs Lavery Sketching (SEE PAGE 30)

John Lavery (1856–1941)
Oil on canvas, 203 x 99 cm (80 x 39 in)
1910

Hugh Lane Municipal Gallery of Modern Art,
Dublin

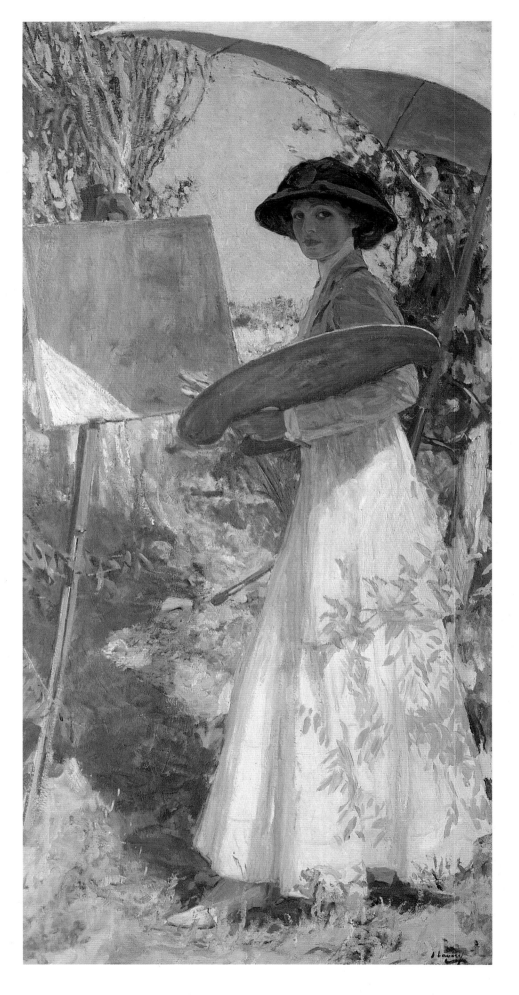

John Lavery

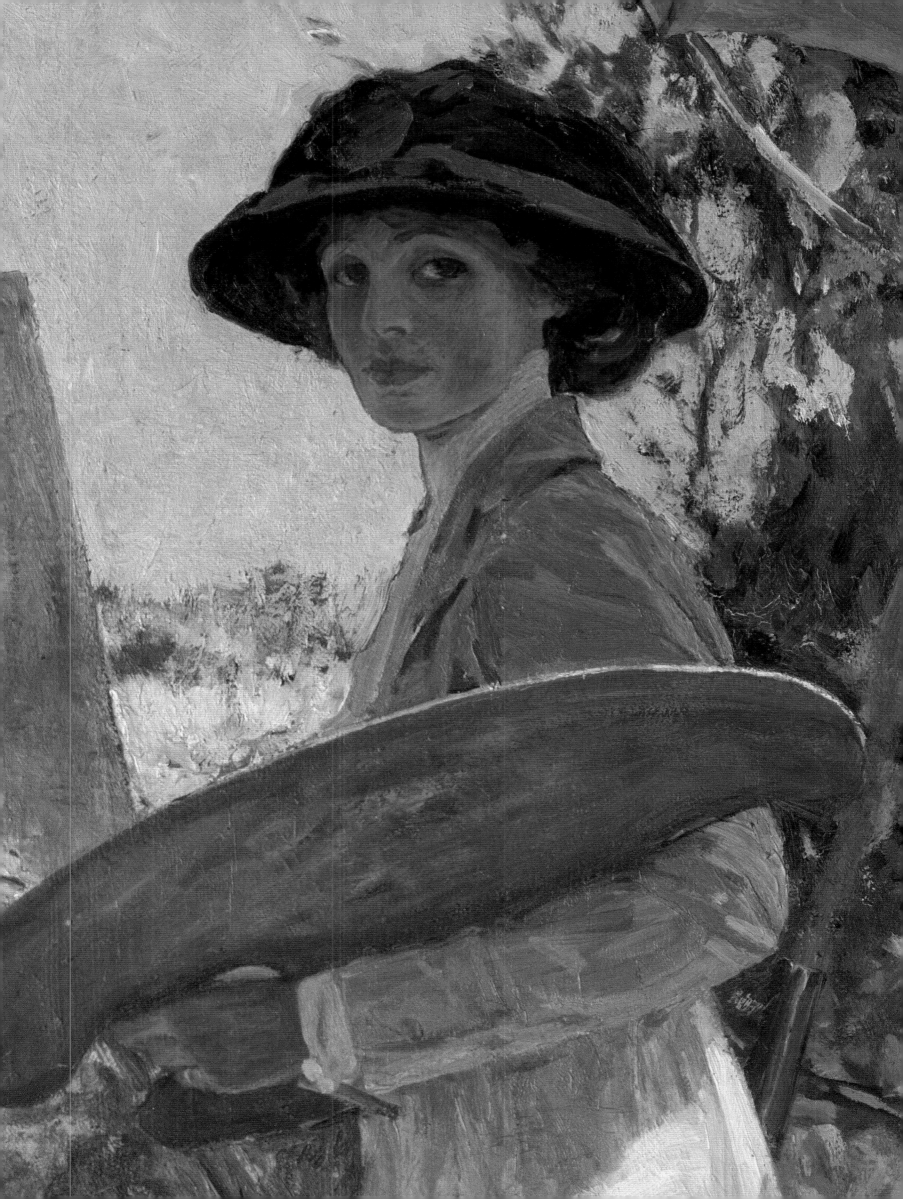

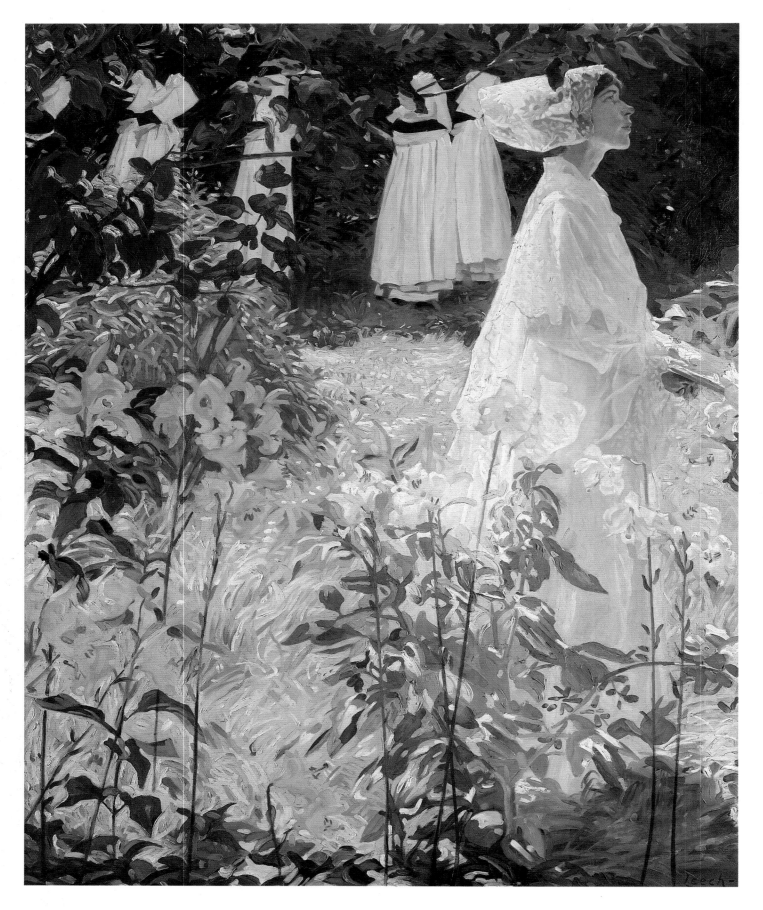

A Convent Garden, Brittany (SEE PAGE 31)

William John Leech (1881–1968)
Oil on canvas, 132 x 106 cm (52 x 41 ³/₄ in)
c. 1911

William John Leech National Gallery of Ireland, Dublin (Inv. no 1245)

Sir Hugh Lane (SEE PAGE 31)

Sarah Cecilia Harrison (1863–1941)
Oil on panel, 41 x 31 cm (16 1/4 x 12 1/4 in)
c. 1914

National Gallery of Ireland, Dublin (Inv. no 1280)

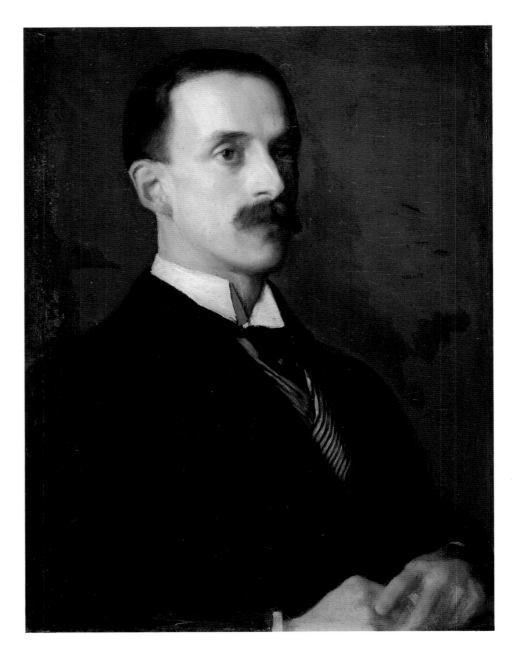

Facing page
The Little Seamstress (SEE PAGE 32)

Patrick Tuohy (1894–1930)
Watercolour on paper, 72 x 52 cm
(28 1/4 x 20 1/2 in)
1914

Hugh Lane Municipal Gallery of Modern Art,
Dublin

Sarah Cecilia Harrison

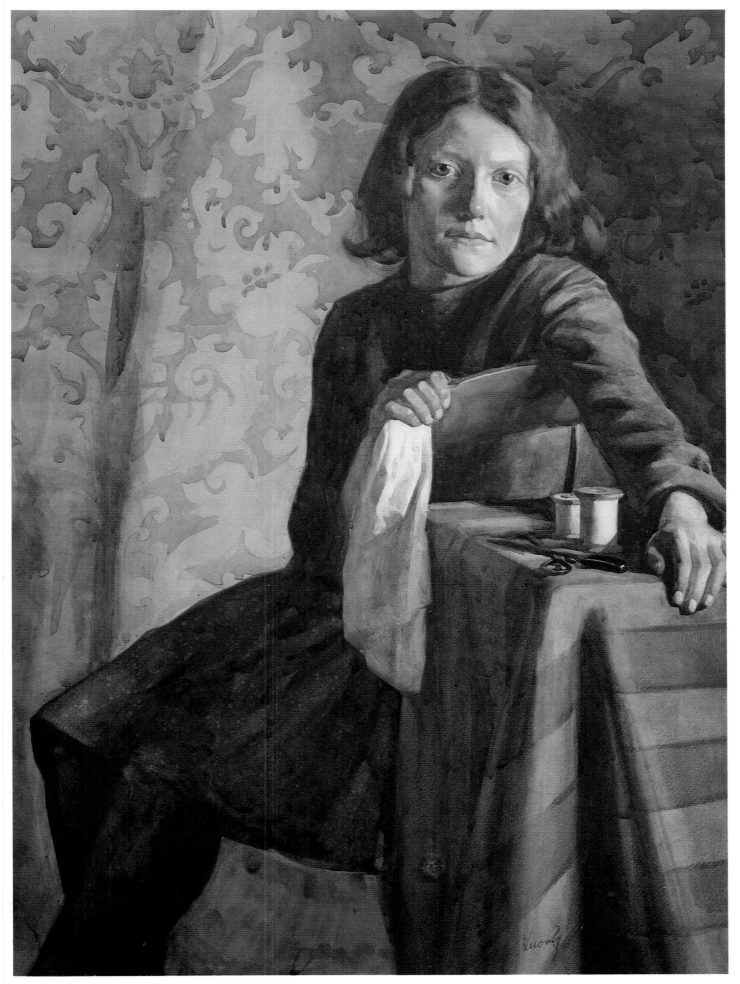

Patrick Tuohy

The Song of the Mad Prince (SEE PAGE 32)

Harry Clarke (1889–1931)
Stained glass, 34.3 x 17.7 cm (13 1/2 x 7 in)
1917

National Gallery of Ireland, Dublin (Inv. no 12074)

Harry Clarke

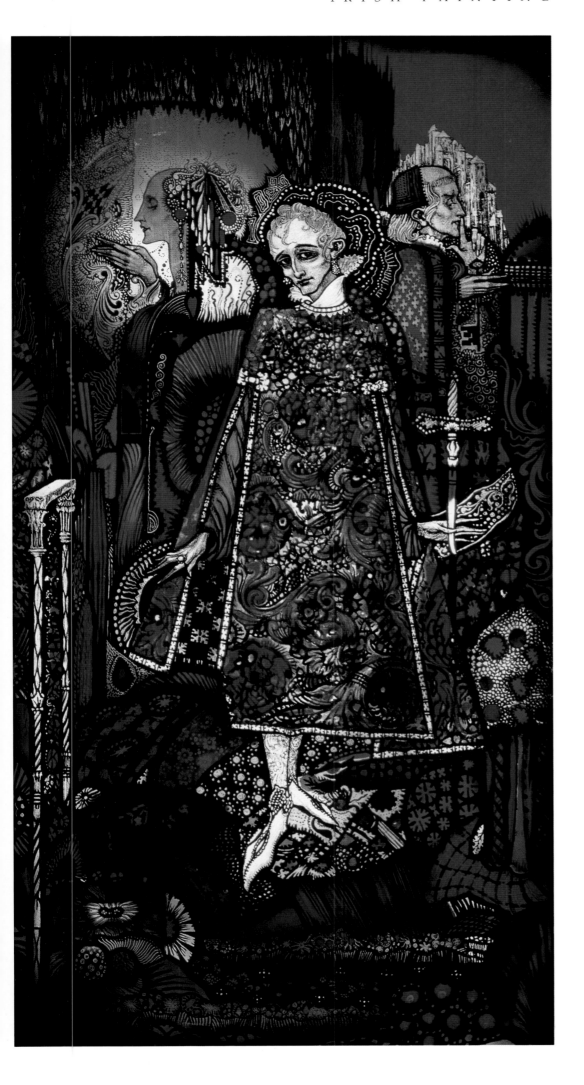

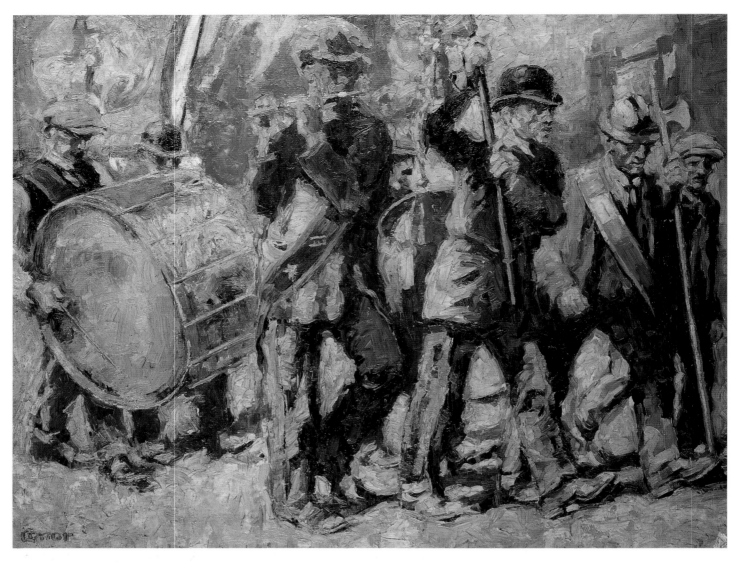

The Twelfth (SEE PAGE 33)

William Conor (1881–1968)
Oil on canvas, 71.1 x 91.4 cm (28 x 36 in)
1918

Ulster Folk and Transport Museum, County Down

William Conor

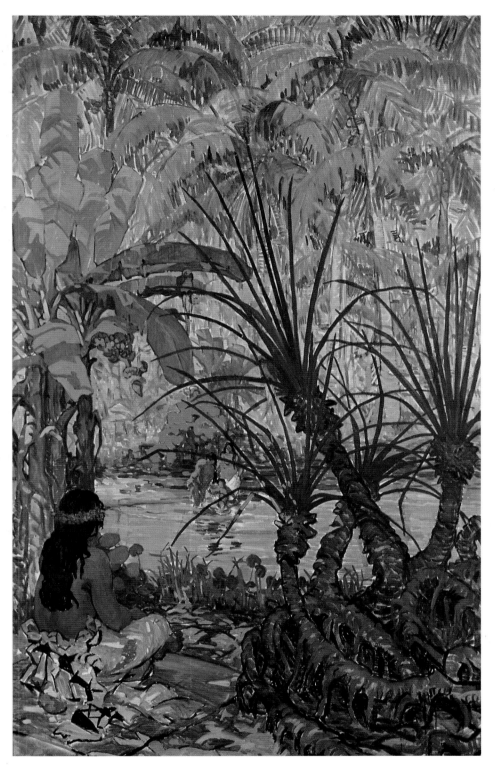

Samoan Scene (SEE PAGE 33)

Mary Swanzy (1882–1978)
Oil on canvas, 152 x 92 cm (59 3/4 x 36 1/4 in)
c. 1923

Allied Irish Bank Collection, Dublin

Mary Swanzy

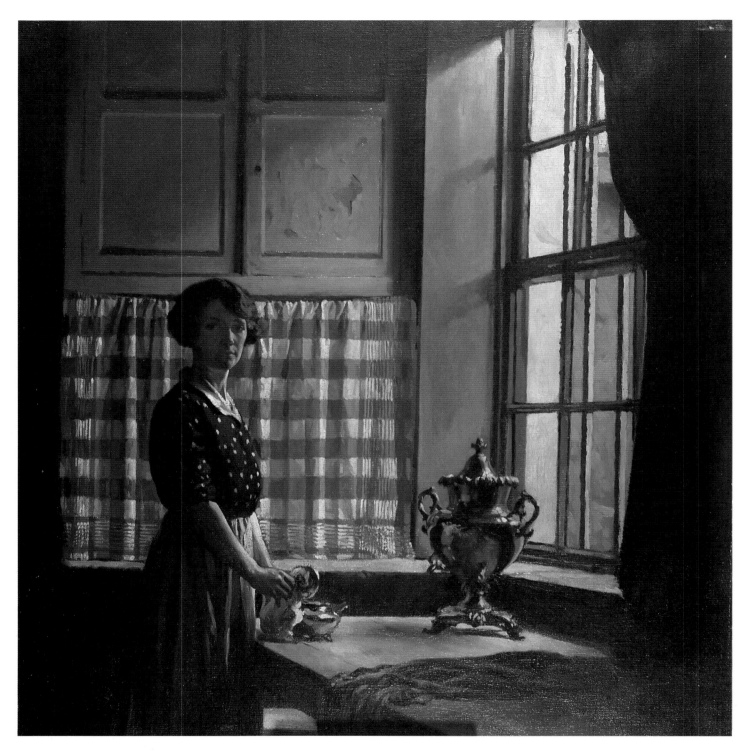

The Kitchen Window (SEE PAGE 34)

Leo Whelan (1892–1956)
Oil on canvas, 50.1 x 40.7 cm (19 ³/₄ x 16 in)
c. 1926

Crawford Municipal Art Gallery, Cork

Leo Whelan

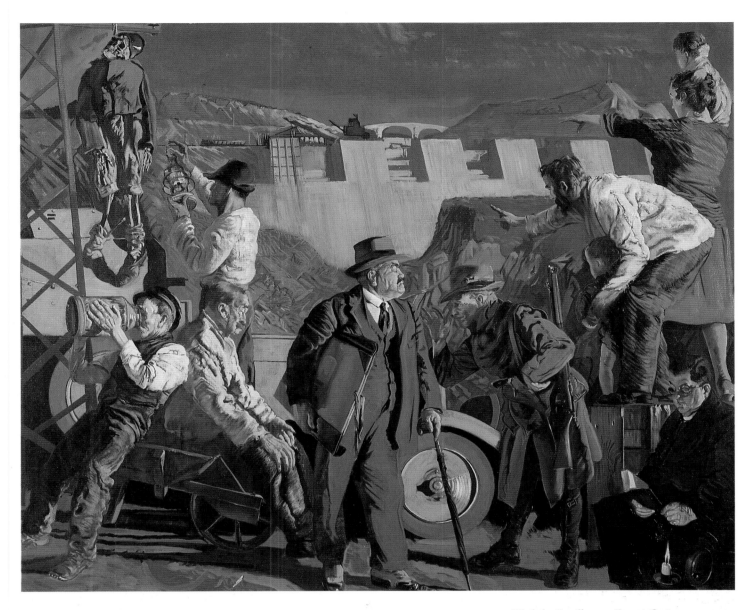

Night's Candles are Burnt Out

(SEE PAGE 34)

Seán Keating (1889–1977)
Oil on canvas, 99.1 x 104.1 cm (39 x 41 in)
1928–9

Oldham Art Gallery, Lancashire.
Reproduced by arrangement with the Electricity
Supply Board, Dublin

Seán Keating

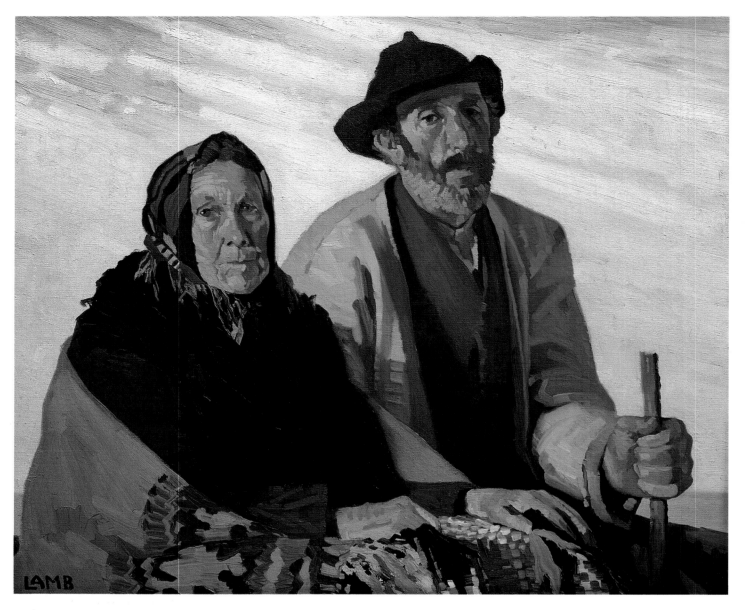

A Quaint Couple (SEE PAGE 35)

Charles Lamb (1893–1964)
Oil on canvas, 61 x 73 cm (24 x 28 3/4 in)
1930

Crawford Municipal Art Gallery, Cork

Charles Lamb

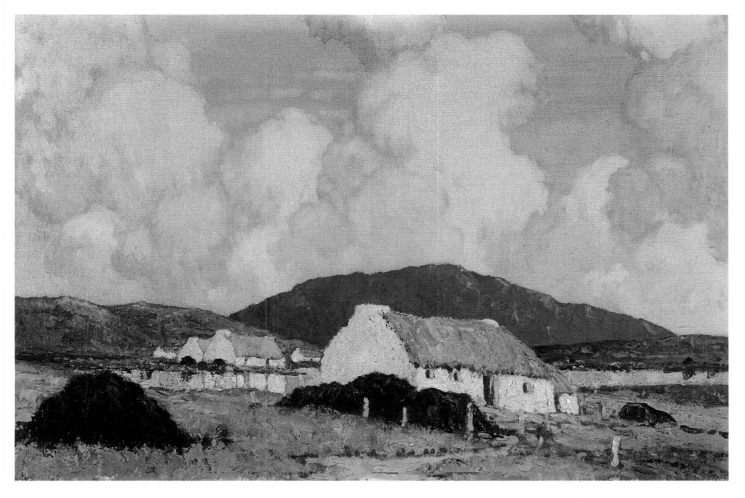

Lakeside Cottages (SEE PAGE 35)

Paul Henry (1876–1958)
Oil on canvas, 40 x 60 cm (15 3/4 x 23 1/2 in)
c. 1930

Hugh Lane Municipal Gallery of Modern Art,
Dublin

Paul Henry

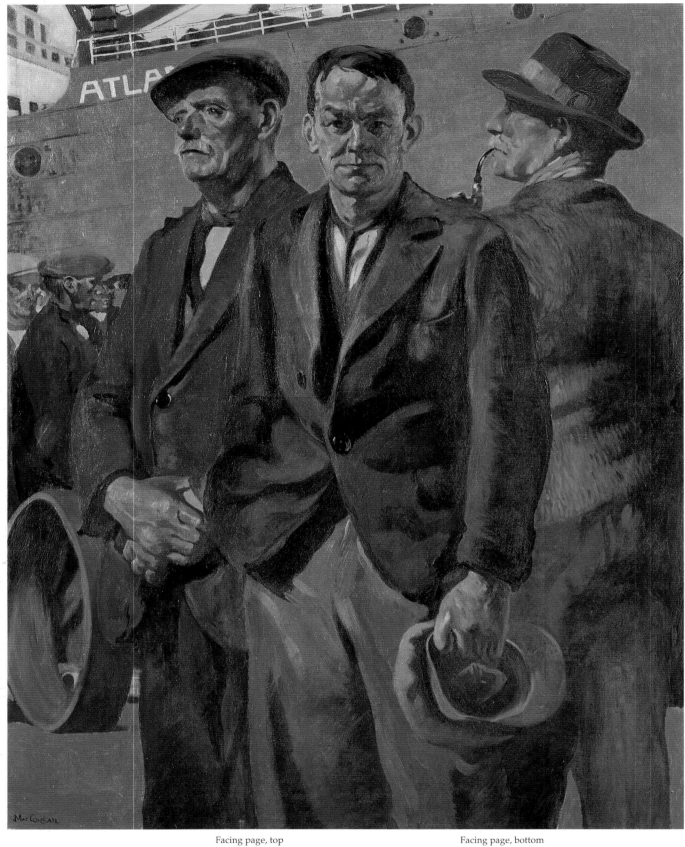

	Facing page, top	Facing page, bottom
The Dockers (SEE PAGE 36)	*Achill Horses* (SEE PAGE 36)	*The Swan, Kilkenny* (SEE PAGE 37)
Maurice MacGonigal (1900–79)	Mainie Jellett (1897–1944)	Norah McGuinness (1903–80)
Oil on canvas, 125.4 x 100 cm (49 1/2 x 39 1/2 in)	Oil on canvas, 61 x 91 cm (24 x 36 in)	Oil on paper, 35.5 x 48.5 cm (14 x 19 in)
1933–4	1941	1943
Hugh Lane Municipal Gallery of Modern Art, Dublin	National Gallery of Ireland, Dublin (Inv. no 4320)	With the kind permission of the Commissioners for Public Works, Dublin

Maurice MacGonigal

Mainie Jellett

Norah McGuinness

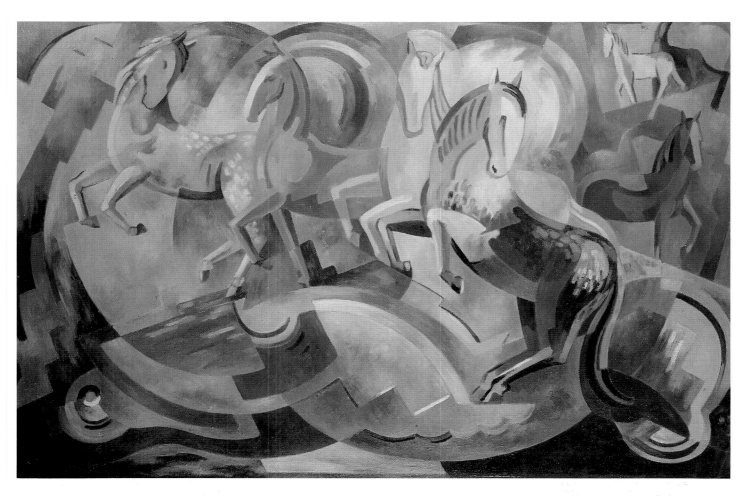

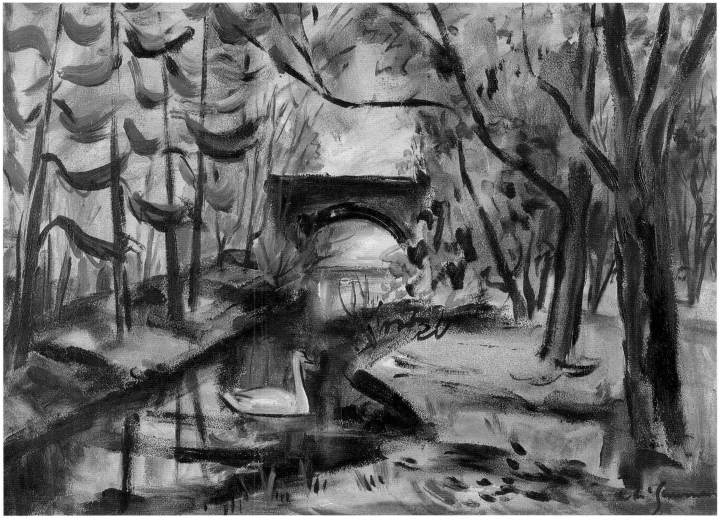

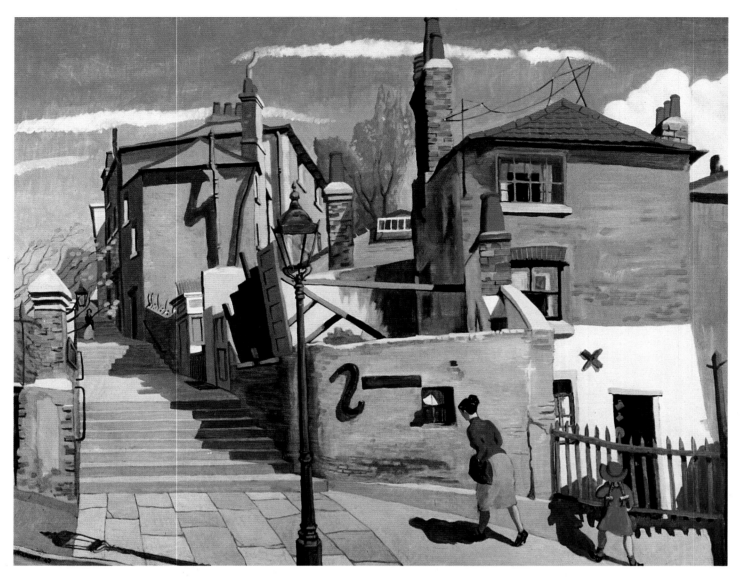

Sunny Day, Dublin (SEE PAGE 37)

Harry Kernoff (1900–74)
Oil on canvas, 60 x 75.5 cm (23 1/2 x 29 3/4 in)
1943

Allied Irish Bank Collection, Dublin

Facing page, top
Éamon de Valera (SEE PAGE 38)

Seán O'Sullivan (1906–64)
Oil on board, 163 x 120 cm (64 1/4 x 47 1/4 in)
1943

Aras an Uachtaráin, Dublin

Facing page, bottom
Jack Butler Yeats RHA (SEE PAGE 38)

James Sinton Sleator (1885–1950)
Oil on canvas, 76.3 x 63.5 cm (30 x 25 in)
1943

Crawford Municipal Art Gallery, Cork

Harry Kernoff **Seán O'Sullivan** **James Sinton Sleator**

Figure in a Landscape (SEE PAGE 39)

Francis Bacon (1909–92)
Oil on canvas, 144.8 x 128.3 cm (57 x 50 ½ in)
1945

Tate Gallery, London

Francis Bacon

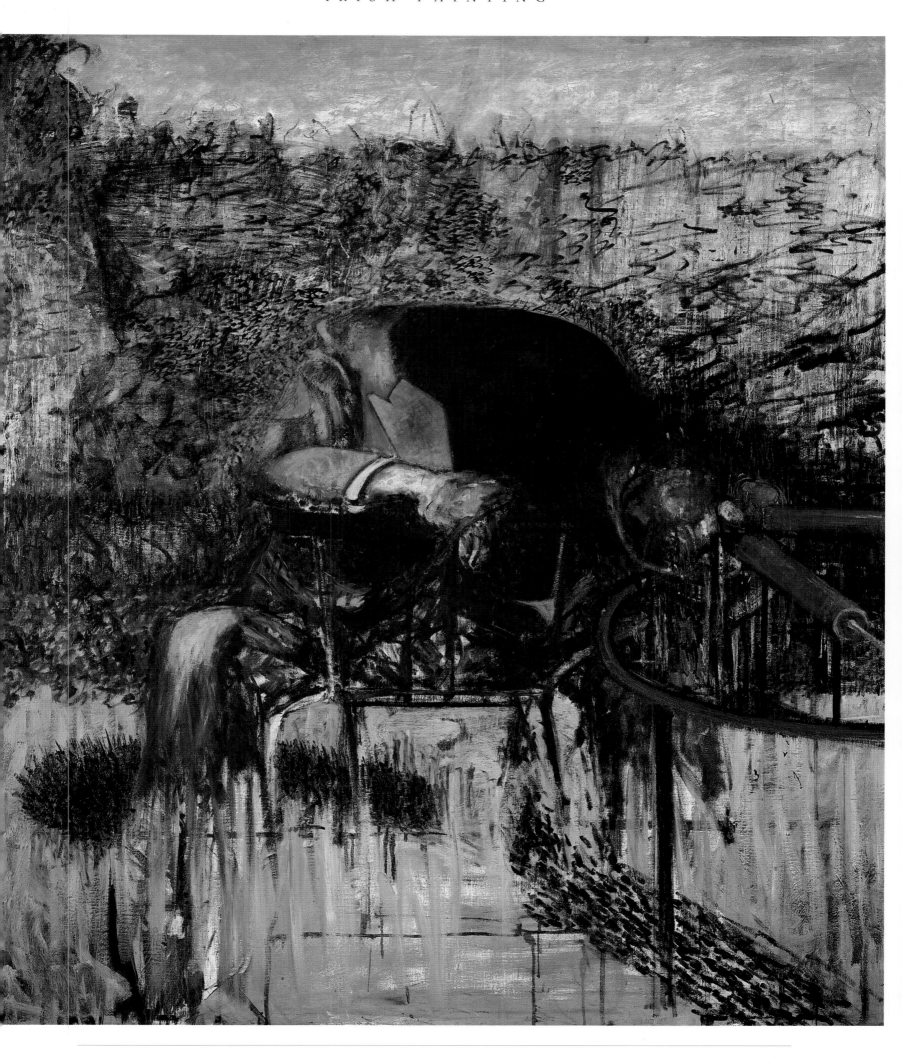

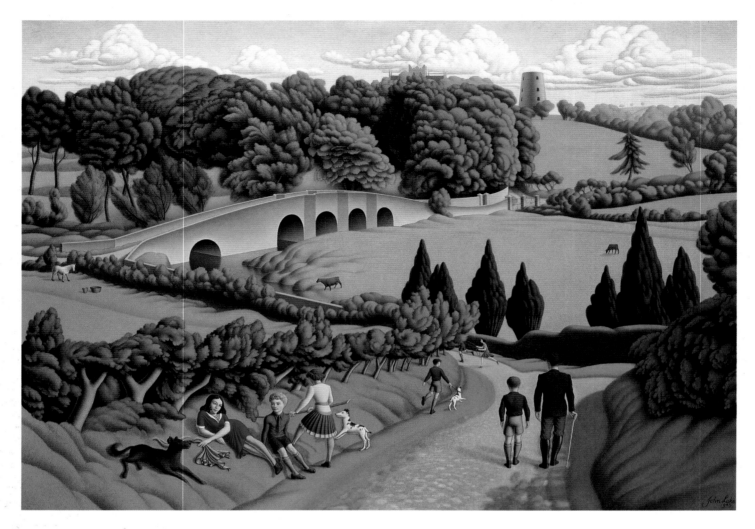

The Old Callan Bridge, Armagh
(SEE PAGE 39)

John Luke (1906–75)
Oil and tempera on board, 57 x 79 cm
(22 ¹/₂ x 31 in)
1945

Armagh County Museum, Armagh

John Luke

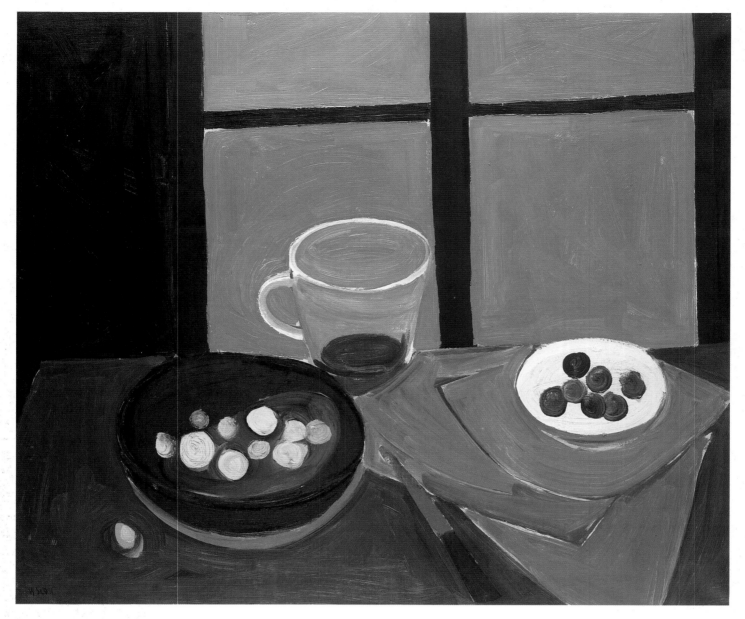

Still Life (SEE PAGE 40)

William Scott (1913–89)
Oil on canvas, 57 x 66 cm (22 ¹/₂ x 26 in)
1949

Ulster Museum, Belfast. By kind permission of
Gimpel Fils Gallery, London

Facing page
The Crucifixion and the Last Supper
(SEE PAGE 40)

Evie Hone (1894–1955)
Stained glass, 504 x 360 cm (198 ¹/₂ x 141 ³/₄ in)
1949–52

By kind permission of the Provost and Fellows
of Eton College, Berkshire

William Scott

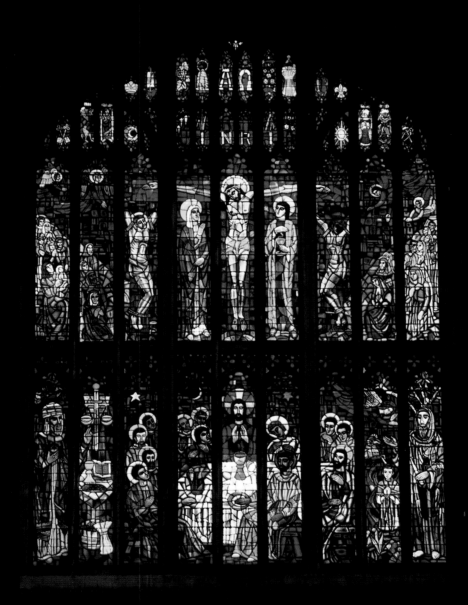

Evie Hone

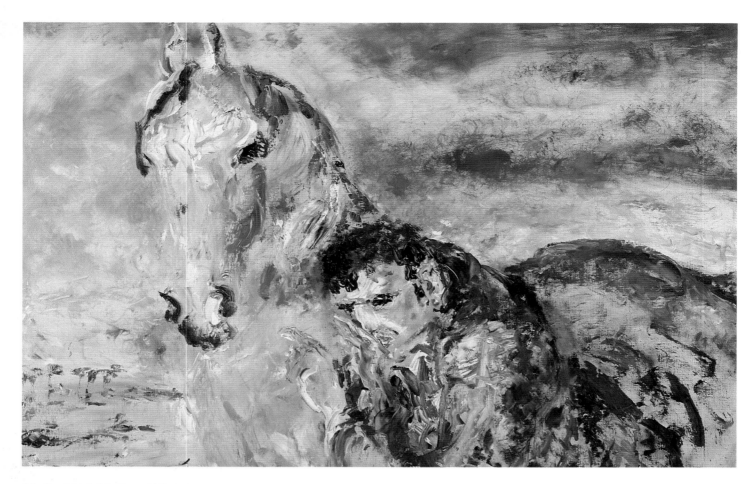

My Beautiful, My Beautiful (SEE PAGE 41)

Jack Butler Yeats (1871–1957)
Oil on canvas, 102 x 153 cm (40 x 60 in)
1953

Private collection

Jack Butler Yeats

BIBLIOGRAPHY

ADAMS 1973. Eric Adams, *Francis Danby: Varieties of Poetic Landscape*, Yale Univ. Press, New Haven, Conn. 1973.

ADAMS 1984. Ronald Adams, 'Andrew Nicholl', *Irish Arts Review*, Vol 1, No 4, pp 29–34.

ALLEY and FLANAGAN 1986. Ronald Alley and T P Flanagan, *William Scott*, Exh. Cat., The Arts Council of Northern Ireland, Belfast 1986.

ALPHEN 1992. Ernst Van Alphen, *Francis Bacon and the Loss of Self*, London 1992.

ANDREW 1986. Patricia R Andrew, 'Jacob More and the Earl-Bishop of Derry', *Apollo*, Vol 124, No 294, August 1986, pp 88–94.

ANDREW NICHOLL 1973. *Andrew Nicholl 1804–1886*, Exh. Cat., Ulster Museum, Belfast 1973.

ANGLESEA 1989. Martyn Anglesea, *Portraits and Prospects: British and Irish Drawings and Watercolours from the Collection of the Ulster Museum, Belfast*, Belfast 1989.

ARCHER 1975. Mildred Archer, 'Wellington and South India: Portraits by Thomas Hickey', *Apollo*, Vol 102, No 161, July 1975, pp 30–35.

ARCHER 1979. Mildred Archer, *India and British Portraiture 1770–1825*, London 1979.

ARNOLD 1969. Bruce Arnold, *A Concise History of Irish Art*, London 1969.

ARNOLD 1981. Bruce Arnold, *Orpen, Mirror to an Age*, London 1981.

ARNOLD 1991. Bruce Arnold, *William Orpen*, Lives of Irish Artists, Dublin 1991.

ARNOLD 1992. Bruce Arnold, *Mainie Jellett and the Modern Movement in Ireland*, Yale Univ. Press, New Haven, Conn., and London 1992.

ASPECTS OF IRISH ART 1974. *Aspects of Irish Art*, Exh. Cat., Columbus Gallery of Fine Arts, Toledo Museum of Arts, St Louis Art Museum; National Gallery of Ireland, Dublin 1974.

BAILEY 1987. Christopher Bailey, 'Matthew James Lawless', *Irish Arts Review*, Vol 4 No 2, Summer 1987, pp 20–24.

BARRELL 1992. John Barrell, *The Birth of Pandora and the Division of Knowledge*, London 1992.

BARRETT 1971. Cyril Barrett, *Irish Art in the 19th Century*, Exh. Cat., Cork 1971.

BARRETT 1975. Cyril Barrett, 'Irish Art and Nationalism', *Studies*, Vol LXIV, Winter 1975.

BARRETT 1980. Cyril Barrett, *Irish Art 1943–1973*, Exh. Cat., Cork 1980.

BENCE-JONES 1973. Mark Bence-Jones, 'Ireland's Great Exhibition', *Country Life*, 15 March 1973, pp 666–8.

BENEZIT 1976. Emmanuel-Charles Benezit, *Dictionnaire Critique et Documentaire des Peintres, Sculpteurs, Dessinateurs et Graveurs*, Nouvelle Edition, 10 vols, Paris 1976.

BENINGTON 1992. Jonathan Benington, *Roderic O'Conor*, Dublin 1992.

BODKIN 1920. Thomas Bodkin, *Four Irish Landscape Painters*, Dublin 1920.

BODKIN 1932. Thomas Bodkin, *Hugh Lane and His Pictures*, Dublin 1932.

BOURKE 1987. Máire Bourke, *The Aran Fisherman's Drowned Child by Frederic William Burton RHA*, Exh. Cat., Dublin 1987.

BOWE 1979. Nicola Gordon Bowe, *Harry Clarke*, Exh. Cat., Douglas Hyde Gallery, Trinity College, Dublin 1979.

BOWE 1983. Nicola Gordon Bowe, 'The miniature stained glass panels of Harry Clarke', *Apollo*, Feb 1982, pp 111–13.

BOWE 1985. Nicola Gordon Bowe, *The Dublin Arts and Crafts Movement 1885–1930*, Exh. Cat., Edinburgh College of Art and Design, 1985.

BOWE 1989. Nicola Gordon Bowe, *The Life and Work of Harry Clarke*, Dublin 1989.

BOWE 1989–90. Nicola Gordon Bowe, 'Symbolism in turn-of-the-century Irish Art', *The GPA Irish Arts Review Yearbook 1989–90*, pp 133–44.

BOWE 1990–91. Nicola Gordon Bowe, 'Irish Arts and Crafts Movement 1886–1925', *The GPA Irish Arts Review Yearbook 1990–91*, pp 172–85.

BOWE, CARON and WYNNE 1988. Nicola Gordon Bowe, David Caron and Michael Wynne, *Gazetteer of Irish Stained Glass: the Works of Harry Clarke and the Artists of An Túr Gloine, 1903–63*, Dublin 1988.

BOWNESS 1972. Alan Bowness, *William Scott: Paintings, Drawings and Gouaches 1938–71*, Exh. Cat., Tate Gallery, London 1972.

BREEZE 1985. George Breeze, *Society of Artists in Ireland: Index of Exhibits 1765–80*, Dublin 1985.

BRENNAN 1983. Fionnuala Brennan, 'Mary Swanzy 1882–1978, BA thesis, Trinity College, Dublin 1983.

BRINDLEY 1923. Jim Brindley, *Reminiscences of the Ward Union Hunt*, Dublin 1923.

BRYAN 1918. *Bryan's Dictionary of Painters and Engravers*, New edn, revised and enlarged under the supervision of George C Williamson, 5 vols, 1918.

BUTLER 1984. Patricia Butler, 'The ingenious Mr Francis Place', *Irish Arts Review*, Vol 1, No 4, pp 38–40.

BUTLER 1990. Patricia Butler, *Three Hundred Years of Irish Watercolours and Drawings*, London 1990.

BUTLIN 1970. Martin Butlin, 'An eighteenth-century art scandal: Nathaniel Hone's *The Conjuror*', *The Connoisseur*, Vol 174, No 699, May 1970, pp 1–9.

CAMPBELL 1980 (1). Julian Campbell, 'The French peasant in nineteenth century Irish Art', in James Thompson, *The Peasant in French 19th Century Art*, Exh. Cat., Douglas Hyde Gallery, Trinity College, Dublin 1980, pp 181–91.

CAMPBELL 1980 (2). Julian Campbell, 'Irish Artists in France and Belgium 1850–1914, PhD thesis, Trinity College, Dublin 1980.

CAMPBELL 1984. Julian Campbell, *The Irish Impressionists: Irish Artists in France and Belgium, 1850–1914*, Exh. Cat., National Gallery of Ireland, Dublin 1984.

CAMPBELL 1986. Julian Campbell, *Mary Swanzy*, Exh. Cat., Pyms Gallery, London 1986.

CAMPBELL 1989. Julian Campbell, *Frank O'Meara*, Exh. Cat., Hugh Lane Municipal Gallery of Modern Art, Dublin 1989.

CAMPBELL 1991 (1). Julian Campbell, *Nathaniel Hone the Younger*, Exh. Cat., National Gallery of Ireland, Dublin 1991.

CAMPBELL 1991 (2). Julian Campbell, 'W J Leech and the convent garden', in Brian P Kennedy (Ed), *Art Is My Life: a Tribute to James White*, National Gallery of Ireland, Dublin 1991, pp 36–45.

CAW 1908. Sir James L Caw, *Scottish Painting Past and Present 1620–1908*, Edinburgh and London 1908.

CHARLES LAMB 1969. *Charles Lamb RHA 1893–1964: a memorial exhibition*, Exh. Cat., Hugh Lane Municipal Gallery of Modern Art, Dublin 1969.

CHRISTIAN 1992. John Christian, *Shakespeare in Western Art*, Exh. Cat., Tokyo 1992.

COXHEAD 1965. Elizabeth Coxhead, *Daughters of Erin*, London 1965.

CRAIG 1981. Maurice Craig, *James Malton's Dublin Views in Colour*, Port Laoise 1981.

CROKE et al 1991. Fionnuala Croke; Raymond Keaveney; Brian P Kennedy; Adrian Le Harivel; Michael Wynne, *Irish Watercolours and Drawings*, Exh. Cat., National Gallery of Ireland, Dublin 1991.

CROOKSHANK 1968. Anne Crookshank, *Norah McGuinness*, Exh. Cat., Trinity College, Dublin 1968.

CROOKSHANK 1979. Anne Crookshank, *Irish Art from 1600*, Dublin 1979.

CROOKSHANK 1988. Anne Crookshank, 'James Latham 1696–1747', *The GPA Irish Arts Review Yearbook 1988*, pp 56–72.

CROOKSHANK 1989–90. Anne Crookshank, 'Robert Hunter', *The GPA Irish Arts Review Yearbook 1989–90*, pp 169–85.

CROOKSHANK and GLIN 1969. Anne Crookshank and the Knight of Glin (Desmond FitzGerald), *Irish Portraits 1660–1860*, Exh. Cat., Paul Mellon Foundation for British Art 1969.

CROOKSHANK and GLIN 1978. Anne Crookshank and the Knight of Glin, *The Painters of Ireland c. 1660–1920*, London 1978.

CROOKSHANK and WEBB 1990. Anne Crookshank and David Webb, *Paintings and Sculptures in Trinity College Dublin*, Dublin 1990.

CROUAN 1991. Catherine Crouan, *Maurice MacGonigal, RHA 1900–1979*, Exh. Cat., Hugh Lane Municipal Gallery of Modern Art, Dublin 1991.

CULLEN 1978. Fintan Cullen, *The Drawings of John Butler Yeats 1839–1922*, Exh. Cat., Albany Institute of History and Art, New York 1978.

CULLEN 1982. Fintan Cullen, 'Hugh Douglas Hamilton in Rome 1779–1792', *Apollo*, Vol 115, Feb 1982, pp 86–91.

CULLEN 1984. (1) Fintan Cullen, 'Hugh Douglas Hamilton's Letters to Canova', *Irish Arts Review*, Vol 1, No 2, Summer 1984, pp 31–5.

CULLEN 1984 (2) Fintan Cullen, 'Oil Paintings of Hugh Douglas Hamilton', *Walpole Society Journal*, Vol 50, 1984.

CUNNINGHAM 1929–32. Alan Cunningham, *The Lives of the Most Eminent British Painters*, 6 vols, 1929–32.

De COURCY 1985. Catherine De Courcy, *The Foundation of the National Gallery of Ireland*, National Gallery of Ireland, Dublin 1985.

De COURCY and MAHER 1985. Catherine De Courcy and Ann Maher, *Fifty Views of Ireland*, National Gallery of Ireland, Dublin 1985.

DENSON 1968–9. Alan Denson, *An Irish Artist, W J Leech, RHA (1881–1968)*, 2 vols, Kendal 1968–9.

DNB 1908. *Dictionary of National Biography*, ed Leslie Stephen, 63 vols and supplements, index and epitome, Smith Elder 1908, and 20th-century supplements, Oxford Univ. Press.

DUNLEVY 1989. Mairéad Dunlevy, *Dress in Ireland*, London 1989.

FARR 1978. Denis Farr, *English Art 1870–1940*, Oxford 1978.

FARSON 1993. Daniel Farson, *The Gilded Gutter Life of Francis Bacon*, London 1993.

FENLON 1987. Jane Fenlon, 'The Painters Stainers Companies of Dublin and London, Craftsmen and Artists 1670–1740', in Jane Fenlon, Nicola Figgis and Catherine Marshall, *New Perspectives: Studies in Art History in Honour of Anne Crookshank*, Dublin 1987, pp 101–8.

FENLON 1989–90. Jane Fenlon, 'French influence in late seventeenth century portraits', *The GPA Irish Arts Review Yearbook 1989–90*, pp 156–68.

FENLON 1991–2. Jane Fenlon, 'Garret Morphy and his circle', *Irish Arts Review Yearbook 1991–92*, pp 135–48.

FERRAN 1992. Denise Ferran, *William Leech*, Lives of Irish Artists, Dublin 1992.

FERRAN 1993. Denise Ferran, 'W J Leech's Brittany', *Irish Arts Review Yearbook 1993*, pp 224–32.

FFOLLIOTT 1989–90. Rosemary ffolliott, 'Fashion as a guide to dating Irish portraits 1660–1880'. *The GPA Irish Arts Review Yearbook 1989–90*, pp 214–32.

FIGGIS 1986. Nicola Figgis, 'Irish artists and society in eighteenth century Rome', *Irish Arts Review*, Vol 3, No 3, Autumn 1986, pp 28–36.

FIGGIS 1987. Nicola Figgis, 'Irish Landscapists in Rome 1750–1780', *Irish Arts Review*, Vol 4, No 4, Winter 1987, pp 60–65.

FIGGIS 1988. Nicola Figgis, 'Irish portrait and subject painters in Rome 1750–1800', *The GPA Irish Arts Review Yearbook 1988*, pp 125–136.

FITZGERALD 1978. Desmond FitzGerald (the Knight of Glin), *Irish Furniture*, Dublin 1978.

FORD 1974. Brinsley Ford, 'The earl-bishop: an eccentric and capricious patron of the arts', *Apollo*, Vol 99, No 148, June 1974.

FRANCIS 1991. Richard Francis, *Francis Bacon*, Exh. Cat., Tate Gallery, London 1991.

FRANCIS BACON 1965. *Francis Bacon*, Exh. Cat., The Municipal Gallery of Modern Art, Dublin 1965.

FROST 1957. Stella Frost (Ed), *A Tribute to Evie Hone and Mainie Jellett*, Dublin 1957.

GALLAGHER 1992. William Gallagher, *Art of the State*, Exh. Cat., Office of Public Works, Dublin 1992.

GIBBONS 1991. Luke Gibbons, 'A shadowy narrator: history, art and romantic nationalism in Ireland 1750–1780', in Ciarán Brady (Ed), *Ideology and the Historians*, Dublin 1991, pp 99–127.

GILLESPIE 1993. Raymond Gillespie, 'Describing Dublin: Francis Place's visit 1698–9', in Adele Dalsimer (Ed), *Visualizing Ireland: Images and Identity*, Boston 1993.

GILLESPIE, MOONEY and RYAN 1986. Frances Gillespie, Kim-Mai Mooney, Wanda Ryan, *Fifty Irish Watercolours and Drawings*, National Gallery of Ireland, Dublin 1986.

GOWING and HUNTER 1989. Lawrence Gowing and Sam Hunter, *Francis Bacon*, New York and London 1989.

GRAVES 1969 (1). Algernon Graves, *A Dictionary of Artists who have exhibited works in Principal London Exhibitions from 1760 to 1893*, 1895, enlarged edn 1901, Kingsmead Reprints, Bath 1969.

GRAVES 1969 (2). Algernon Graves, *The Society of Artists of Great Britain 1760–1791 and the Free Society of Artists 1761–1783*, 1907, Kingsmead Reprints, Bath 1969.

GRAVES 1970 (1). Algernon Graves, *The Royal Academy of Arts: a Complete Dictionary of Contributors and their Work, from its foundation in 1769 to 1904*, 4 vols, 1905, Kingsmead Reprints, Bath 1970.

GRAVES 1970 (2). Algernon Graves, *A Century of Loan Exhibitions 1813–1912*, 5 vols, 1913–15, reprinted in 3 vols, Kingsmead Reprints, Bath 1970.

GREAVES 1950. Ralph Greaves, *A Short History of the Ward Union Hounds*, Dublin 1950.

GREENACRE 1973. Francis Greenacre, *The Bristol School of Artists: Francis Danby and Painting in Bristol 1810–1840*, Exh. Cat., City Art Gallery, Bristol 1973.

GREENACRE 1988. Francis Greenacre, *Francis Danby*, Tate Gallery, London 1988.

HALSBAND 1956. R Halsband, *The Life of Lady Mary Wortley Montagu*, Oxford 1956.

HALSBAND 1966. R Halsband (Ed), *The Complete Letters of Lady Mary Wortley Montagu*, Oxford 1966.

HARBISON, POTTERTON and SHEEHY 1978. Peter Harbison; Homan Potterton; Jeanne Sheehy, *Irish Art and Architecture*, London 1978.

HARTIGAN 1986. Marianne Hartigan, 'The commercial design career of Norah McGuinness', *Irish Arts Review*, Vol 3, Autumn 1986, pp 23–5.

HARTIGAN 1987. Marianne Hartigan, 'The Irish Exhibition of Living Art', *Irish Arts Review*, Vol 4, No 4, Winter 1987, pp 58–9.

HELENIAK 1980. Kathryn Moore Heleniak, *William Mulready*, New Haven and London 1980.

HENRY 1951. Paul Henry, *An Irish Portrait*, London 1951.

HEWITT 1977. John Hewitt, *Art in Ulster*, Belfast 1977.

HEWITT 1978. John Hewitt, *John Luke (1906–77)*, Exh. Cat., Arts Councils of Ireland, Dublin and Belfast 1973.

HOBART 1982. Mary Hobart, *The Irish Revival*, Exh. Cat., Pym's Gallery, London 1982.

HUGH LANE 1961. *A Tribute to Sir Hugh Lane*, Cork 1961.

HUTCHINSON 1985. John Hutchinson, *James Arthur O'Connor*, Exh. Cat., National Gallery of Ireland, Dublin 1985.

HUTCHINSON 1989–90. John Hutchinson, 'Intrusions and representations: the landscape of Wicklow', *The GPA Irish Arts Review Yearbook 1989–90*, pp 91–9.

HUTCHINSON, RYAN and WHITE 1978. John Hutchinson, Vera Ryan, James White, *William Orpen, 1878–1931, A Centenary Exhibition*, Exh. Cat., National Gallery of Ireland, Dublin 1978.

IRISH ART HANDBOOK 1943. *Irish Art Handbook*, Dublin 1943.

IRISH WOMEN ARTISTS 1987. *Irish Women Artists*, Exh. Cat., National Gallery of Ireland, Dublin 1987.

IRWIN 1975. David and Francina Irwin, *Scottish Painters at Home and Abroad 1700–1900*, London 1975.

JOHNSTON 1984. Roy Johnston, 'Roderic O'Conor in Brittany', *Irish Arts Review*, Vol 1, No 1, Spring 1984, pp 16–17.

JOHNSTON 1985 (1). Roy Johnston, *Roderic O'Conor*, Exh. Cat., Barbican Art Gallery, London and Ulster Museum, Belfast; London 1985.

JOHNSTON 1985 (2). Roy Johnston, 'Roderic O'Conor — the elusive personality', *Irish Arts Review*, Vol 2, No 4, Winter 1985, pp 31–40.

KELLY 1993. James Kelly, 'Francis Wheatley: his Irish paintings 1779–83', in Adele Dalsimer (Ed), *Visualizing Ireland: Images and Identity*, Boston 1993.

KENNEDY (B P) 1990. Brian P Kennedy, *Dreams and Responsibilities: the State and the Arts in Independent Ireland*, Dublin 1990.

KENNEDY (B P) 1991. Brian P Kennedy, *Jack B Yeats*, Lives of Irish Artists, Dublin 1991.

KENNEDY (B P) 1992. Brian P Kennedy, 'The failure of the cultural republic: Ireland 1922–39', *Studies*, Vol 31, No 321, Spring 1992, pp 14–22.

KENNEDY (B P) 1992–3. Brian P Kennedy, 'The oil painting technique of Jack B Yeats', *Irish Arts Review Yearbook 1993*, pp 115–23.

KENNEDY (B P) 1993. Brian P Kennedy, 'The traditional Irish thatched house: image and reality 1793–1993', in Adele Dalsimer (Ed), *Visualizing Ireland: Images and Identity*, Boston 1993.

KENNEDY (S B) 1989. S B Kennedy, *James Sinton Sleator PRHA, 1885–1950*, Exh. Cat., Armagh County Museum 1989.

KENNEDY (S B) 1989–90. S B Kennedy, 'Paul Henry: an Irish portrait', *The GPA Irish Arts Review Yearbook 1989–90*, pp 43–54.

KENNEDY (S B) 1990. S B Kennedy, 'Irish landscape painting in a political setting 1922–48', in Myrtle Hill and Sarah Barber (Eds), *Aspects of Irish Studies*, Belfast 1990, pp 47–54.

KENNEDY (S B) 1991 (1). S B Kennedy, *Paul Henry*, Lives of Irish Artists, Dublin 1991.

KENNEDY (S B) 1991 (2). S B Kennedy, *Irish Art and Modernism*, Exh. Cat., Hugh Lane Municipal Gallery of Modern Art, Dublin 1991.

LAVERY 1940. Sir John Lavery, *The Life of a Painter*, London 1940.

LEEDS 1989. Corinne Miller, Lynda Nead, Griselda Pollock, *Images of Women*, Exh. Cat., Leeds City Art Galleries 1989.

LE HARIVEL 1983. Adrian Le Harivel, *National Gallery of Ireland: Illustrated Summary Catalogue of Drawings, Watercolours and Miniatures*, Dublin 1983.

LE HARIVEL 1992. Adrian Le Harivel, *Nathaniel Hone the Elder*, Lives of Irish Artists, Dublin 1992.

LEIRIS 1983. Michael Leiris, *Francis Bacon: Full Face and in Profile*, New York 1983.

LYNCH 1988. Brendan Lynch, 'Irish patrons and collectors of Indian art', *The GPA Irish Arts Review Yearbook 1988*, pp 169–84.

McCARVILL 1958. Eileen McCarvill (Ed), *Mainie Jellett: the Artist's Vision*, Dundalk 1958.

McCONKEY 1979. Kenneth McConkey, *Artists and the Great War*, Exh. Cat., Newcastle-upon-Tyne Polytechnic Art Gallery 1979.

McCONKEY 1982. Kenneth McConkey, 'From Grez to Glasgow, French naturalistic influence in Scottish painting', *Scottish Art Review*, Vol XV, No 4, 1982, pp 23–9.

McCONKEY 1984 (1). Kenneth McConkey, 'Hazel in Black and Gold', *Irish Arts Review*, Vol 1, No 3, Autumn 1984, pp 12–17.

McCONKEY 1984 (2). Kenneth McConkey, *Sir John Lavery RA 1856–1941*, Exh. Cat., Ulster Museum, Belfast and Fine Art Society, London 1984.

McCONKEY 1986. Kenneth McConkey, 'Cultural identity and Irish art', in *Irish Renaissance*, Exh. Cat., Pyms Gallery, London 1986.

McCONKEY 1987 (1). Kenneth McConkey, *Orpen and the Edwardian Era*, Exh. Cat., Pyms Gallery, London 1987.

McCONKEY 1987 (2). Kenneth McConkey, *Edwardian Portraits: Images of an Age of Opulence*, London 1987.

McCONKEY 1990. Kenneth McConkey, *A Free Spirit: Irish Art 1860–1960*, London 1990.

MacFARLANE 1976. Jane MacFarlane, 'Sir Frederic William Burton RHA', BA dissertation, Trinity College, Dublin 1976.

MacGONIGAL 1976. Ciarán MacGonigal, *Harry Kernoff*, Exh. Cat., Hugh Lane Municipal Gallery of Modern Art, Dublin 1976.

MacGREEVY 1945. Thomas MacGreevy, *Jack B Yeats*, Dublin 1945.

MacGREEVY 1949. Thomas MacGreevy, 'Fifty years of Irish painting', *Capuchin Annual*, 1949, pp 497–512.

MACMILLAN 1990. Duncan Macmillan, *Scottish Art 1460–1990*, Edinburgh 1990.

MacNEILL 1990. Máire MacNeill, *Máire Rua: Lady of Leamaneh*, Ballinakella Press, Whitegate, County Clare, 1990.

MULCAHY 1989–90. Rosemary Mulcahy, 'Patrick J Tuohy 1894–1930', *The GPA Irish Arts Review Yearbook 1989–90*, pp 107–18.

MUNBY 1947. A N L Munby, 'Nathaniel Hone's Conjuror', *The Connoisseur*, Vol CXX, Dec 1947, pp 82–3.

MURPHY 1978. William M Murphy, *Prodigal Father: the Life of John Butler Yeats (1839–1922)*, Cornell Univ. Press, Ithaca, New York 1978.

MURPHY 1991. Antoinette Murphy, *The Paintings of Paul and Grace Henry*, Exh. Cat., Hugh Lane Municipal Gallery of Modern Art, 1991.

MURPHY 1992. Paula Murphy, *Roderic O'Conor*, Lives of Irish Artists, Dublin 1992.

MURRAY 1980. Peter Murray, 'George Petrie', M Litt dissertation, Trinity College, Dublin, 1980.

MURRAY 1992. Peter Murray, *Illustrated Summary Catalogue of the Crawford Municipal Art Gallery*, Cork 1992.

NETZER 1993. Nancy Netzer, 'Picturing an exhibition: James Mahony's watercolours of the Irish Industrial Exhibition of 1853', in Adele Dalsimer (Ed), *Visualizing Ireland: Images and Identity*, Boston 1993.

NEWMAN 1986. John Newman, 'Reynolds and Hone: the Conjuror Unmasked', in Nicholas Penny (Ed), *Reynolds*, Exh. Cat., Tate Gallery, London 1986.

NGI 1980–81. *National Gallery of Ireland: Acquisitions 1980–1981*, Dublin 1981.

NGI 1981–2. *National Gallery of Ireland: Acquisitions 1981–1982*, Dublin 1982.

NGI 1982–3. *National Gallery of Ireland: Acquisitions 1982–1983*, Dublin 1984.

NGI 1984–6. *National Gallery of Ireland: Acquisitions 1984–1986*, Dublin 1986.

NGI 1986–8. *National Gallery of Ireland: Acquisitions 1986–1988*, Dublin 1988.

O'BRIEN 1990. Kevin O'Brien, 'Harry Kernoff RHA', *Martello*, Spring 1990, pp 7–9.

O'CONNELL 1991. Daire O'Connell, *Mainie Jellett*, Exh. Cat., Irish Museum of Modern Art, Dublin 1991.

O'CONNOR 1974. Andrew O'Connor, 'James Latham: Two Portraits', *Burlington Magazine*, Vol 116, No 852, March 1974.

O'CONNOR 1975. Andrew O'Connor, 'James Latham: further documentation', *Studies*, Vol 64, No 256, Winter 1975.

O'GRADY 1974. John M O'Grady, 'Sarah Henrietta Purser', PhD thesis, National University of Ireland 1974.

O'GRADY 1977. John M O'Grady, 'Sarah Purser 1848–1943', *Capuchin Annual*, 1977, pp 89–104.

O'NEILL 1989. Máire O'Neill, 'Sarah Cecilia Harrison: artist and city councillor', *Dublin Historical Record*, Vol XL11, No 2, Mar 1989.

ORMOND 1968. Richard Ormond, 'Daniel Maclise', *Burlington Magazine*, Vol 110 (1968), pp 685–93.

ORMOND and TURPIN 1972. Richard Ormond and John Turpin, *Daniel Maclise 1806–1870*, Exh. Cat., Arts Council of Great Britain, London 1972.

ORPEN 1924. William Orpen, *Stories of Old Ireland and Myself*, London 1924.

PASQUIN (1796) 1970. Anthony Pasquin (John Williams), *Memoirs of the Royal Academicians and an Authentic History of the Artists in Ireland* (London 1796), revised edn with intro by R Lightbown, London 1970.

PAUL HENRY 1973. *Paul Henry 1876–1958*, Exh. Cat., Trinity College, Dublin 1973.

POINTON 1986. Marcia Pointon, *Mulready*, Exh. Cat., Victoria and Albert Museum, London 1986.

POINTON 1993. Marcia Pointon, *Hanging the Head: Portraiture and Social Formation in Eighteenth Century England*, Yale Univ. Press, New Haven, Conn., and London 1993.

POTTERTON 1974. Homan Potterton, 'A Director with Distinction', *Country Life*, 9 May 1974.

POTTERTON 1981. Homan Potterton *et al*, *National Gallery of Ireland: Illustrated Summary Catalogue of Paintings*, Dublin 1981.

POTTERTON 1993. Homan Potterton, 'Jack B Yeats and John Quinn', *Irish Arts Review Yearbook 1993*, pp 102–14.

PRESSLY 1981. William L Pressly, *The Life and Art of James Barry*, Yale Univ. Press, New Haven, Conn. 1981.

PRESSLY 1983. William L Pressly, *James Barry: the Artist as Hero*, Exh. Cat., Tate Gallery, London 1983.

PYLE 1966. Hilary Pyle, *Portraits of Patriots*, Dublin 1966.

PYLE 1970. Hilary Pyle, *Jack B Yeats: a Biography*, London 1970.

PYLE 1975. Hilary Pyle, *Irish Art 1900–1950*, Exh. Cat., Cork 1975.

PYLE 1986. Hilary Pyle, *Jack B Yeats in the National Gallery of Ireland*, Dublin 1986.

PYLE 1990. Hilary Pyle, *Images in Yeats*, Exh. Cat., Dublin 1990.

PYLE 1992. Hilary Pyle, *Jack B Yeats: a Catalogue Raisonné of the Oil Paintings*, London 1992.

PYLE 1993. Hilary Pyle, 'Jack B Yeats — a complete individualist', *Irish Arts Review Yearbook 1993*, pp 86–101.

ROBINSON 1948. Lennox Robinson, *Palette and Plough: a Biography of Dermod O'Brien (1865–1945)*, Dublin 1948.

ROYAL ACADEMY 1973. *Royal Academy Exhibitors 1905–70: a Dictionary of Artists and Their Work in the Summer Exhibitions of the Royal Academy of Arts*, 6 vols, Wakefield, Yorkshire 1973.

RUANE 1986. Frances Ruane, *The Allied Irish Bank Collection: Twentieth Century Irish Art*, Dublin 1986.

RUANE 1988. Frances Ruane, 'The Allied Irish Bank Collection', *The GPA Irish Arts Review Yearbook 1988*, pp 157–64.

RUSSELL 1971. John Russell, *Francis Bacon*, London 1971.

SEÁN KEATING 1981. *Seán Keating and the ESB*, Touring Exhibition 1981.

SEÁN KEATING 1989. *Seán Keating PRHA, 1889–1977*, Exh. Cat., Royal Hibernian Academy Gallagher Gallery, Dublin 1989.

SEWTER 1948. A C Sewter, 'Stephen Slaughter: a minor British painter of the seventeenth century', *The Connoisseur*, Vol CXX, March 1948, pp 10–15.

SHEAFF 1978. Nicholas Sheaff, *Iveagh House*, Dublin 1978.

SHEEHY 1974. Jeanne Sheehy, *Walter Osborne*, Ballycotton, County Cork, 1974.

SHEEHY 1980 (1). Jeanne Sheehy, *The Early Celtic Revival*, Exh. Cat., National Gallery of Ireland, Dublin 1980.

SHEEHY 1980 (2). Jeanne Sheehy, *The Rediscovery of Ireland's Past: the Celtic Revival 1830–1930*, London 1980.

SHEEHY 1983. Jeanne Sheehy, *Walter Osborne*, Exh. Cat., National Gallery of Ireland, Dublin 1983.

SHEEHY 1991. Jeanne Sheehy, *Walter Osborne*, Lives of Irish Artists, Dublin 1991.

STEVENSON and THOMSON 1982. Sara Stevenson and Duncan Thomson, *John Michael Wright: the King's Painter*, Exh. Cat., Scottish National Portrait Gallery, Edinburgh 1982.

STEWART 1984. Ann M Stewart, *Fifty Irish Portraits*, National Gallery of Ireland, Dublin 1984.

STEWART 1985–7. Ann M Stewart, *Royal Hibernian Academy of Arts: Index of Exhibitors 1826–1979*, Dublin, Vol 1 1985, Vol 2 1986, Vol 3 1987.

STEWART 1990. Ann M Stewart, *Irish Art Loan Exhibitions 1765–1927*, Vol 1, Dublin 1990.

STOKES 1868. William Stokes, *The Life and Labours in Art and Archaeology of George Petrie*, London 1868.

STRATTON-RYAN 1990–91. Mary Stratton-Ryan, 'Augustus Nicholas Burke, RHA', *Irish Arts Review Yearbook 1990–1991* pp 103–110.

STRICKLAND 1913. Walter Strickland, *A Dictionary of Irish Artists*, 2 vols, Dublin and London 1913, reprinted with an intro by Theo Snoddy, Irish Academic Press, Dublin 1989.

SYLVESTER 1987. David Sylvester, *The Brutality of Fact: Interviews with Francis Bacon*, London 1987.

THADDEUS 1912. Henry Jones Thaddeus, *Recollections of a Court Painter*, London 1912.

THIEME and BECKER 1972. Ulrich Thieme and Felix Becker, *Allgemeines Lexicon der Bildenden Künstler von der Antike bis zur Gengenwart*, 37 vols, Leipzig 1923, reprinted Zwickau 1972.

TURPIN 1970. John Turpin, 'The Irish background to Daniel Maclise', *Capuchin Annual 1970*, pp 177–94.

TURPIN 1979. John Turpin, 'William Orpen as student and teacher', *Studies*, Vol 68, No 271, Autumn 1979.

TURPIN 1985. John Turpin, 'Maclise as a book illustrator', *Irish Arts Review*, Vol 2, No 2, Summer 1985, pp 23–7.

TURPIN 1986. John Turpin, 'The masters of the Dublin Society's School of Landscape and Ornament 1800–1854', *Irish Arts Review*, Vol 3, No 2, pp 45–52.

TURPIN 1987. John Turpin, 'Continental influence in 18th century Ireland', *Irish Arts Review*, Vol 4, No 4, Winter 1987, pp 50–57.

TURPIN 1988. John Turpin, 'The National College of Art under Keating and MacGonigal', *The GPA Irish Arts Review Yearbook 1988*, pp 201–11.

TURPIN 1989–90. John Turpin, 'Irish History Painting', *The GPA Irish Arts Review Yearbook 1989–90*, pp 233–47.

TURPIN 1991–92. John Turpin, 'The RHA Schools 1826–1906', *Irish Arts Review Yearbook 1991–1992*, pp 198–209.

USHERWOOD 1987. Paul Usherwood, 'Lady Butler's Irish pictures', *Irish Arts Review*, Vol 4, No 4, Winter 1987, pp 47–9.

USHERWOOD and SPENCER-SMITH 1987. Paul Usherwood and Jenny Spencer-Smith, *Lady Butler: Battle Artist 1846–1933*, Exh. Cat. National Army Museum, London 1987.

VERTUE 1810. George W Vertue, *A Dictionary of Painters, Sculptors, Architects and Engravers*, London 1810.

WATERHOUSE 1953. Ellis K Waterhouse, *Painting in Britain 1530–1790*, Harmondsworth, Middlesex 1953.

WATERS 1975. Grant M Waters, *Dictionary of British Artists Working 1900–1950*, 2 vols, Eastbourne, Sussex 1975.

WEBSTER 1970. Mary Webster, *Francis Wheatley*, London 1970.

WHITE 1958. James White, *Evie Hone*, Exh. Cat., Municipal Gallery, Dublin 1958.

WHITE 1970. James White, *The Irish*, Exh. Cat., National Galley of Ireland, Dublin 1970.

WHITE 1972. James White, *John Butler Yeats and the Irish Renaissance*, Exh. Cat., Dublin 1972.

WHITE 1974. James White, 'A century and a half of Irish painting', in *Aspects of Irish Art*, Exh. Cat., Columbus Gallery of Fine Arts, Toledo Museum of Arts, St Louis Art Museum 1974.

WHITE 1976. James White, *Irish Watercolours 1675–1925 from the National Gallery of Ireland*, Exh. Cat., Museum of Fine Arts, Dallas 1976.

WHITE 1988. James White *et al*, *The Stained Glass of Harry Clarke 1889–1931*, Exh. Cat., the Fine Art Society, London 1988.

WHITE and PYLE 1971. James White and Hilary Pyle, *Jack B Yeats 1871–1957: a Centenary Exhibition*, Exh. Cat., National Gallery of Ireland, Dublin 1971.

WHITE and WYNNE 1963. James White and Michael Wynne, *Irish Stained Glass*, Dublin 1963.

WHITE and WYNNE 1965. James White and Michael Wynne, *W B Yeats: a Centenary Exhibition*, Exh. Cat., National Gallery of Ireland, Dublin 1965.

WILSON 1981. Judith Wilson, *Conor 1881–1968: the Life and Work of an Ulster Artist*, Belfast 1981.

WOOD 1984. Richard Wood, 'The landscape paintings at Fota', *Irish Arts Review*, Vol 1, No 4, Winter 1984, pp 47–55.

WYNNE 1972. Michael Wynne, 'Thomas Frye (1710–1762)', *Burlington Magazine*, Vol 114, Feb 1972, pp 78–85.

WYNNE 1977. Michael Wynne, 'Thomas Roberts, 1748–1778', *Studies*, Winter 1977, pp 299–308.

WYNNE 1982. Michael Wynne, 'Thomas Frye (1710–1762) reviewed', *Burlington Magazine*, Vol 124, Oct 1982, pp 624–8.

WYNNE 1983. Michael Wynne, *Fifty Irish Painters*, National Gallery of Ireland, Dublin 1983.

WYNNE 1984. Michael Wynne, 'Elegant Travellers from Fermanagh', *Irish Arts Review*, Vol 1, No 3, Autumn 1984, pp 44–6.

WYNNE 1991. Michael Wynne, 'Acquiring Irish paintings', in Brian P Kennedy (Ed), *Art Is My Life: A Tribute to James White*, National Gallery of Ireland, Dublin 1991, pp 196–205.

INDEX OF ARTISTS

INDEX OF WORKS